PRAISE FOR *RISE*

"Lindsey Vonn's story is an unfiltered, honest look at the mountains that need conquering for a female athlete to forge her own path, no matter how good she is. Powerful and evocative, *Rise* showcases Lindsey's achievements on the hill and her emotional work off of it."

—**Billie Jean King**

"Lindsey Vonn is a true American icon in the world of sports and will be remembered as one of, if not the greatest, of all time. But more important than her historic accomplishments, the Lindsey I've become close with is a good, solid human being with a heart that knows no boundaries. And that's her greatest accomplishment of all."

—**Dwayne Johnson**

"Lindsey's twenty-year career in professional skiing is a testament to what it takes to relentlessly pursue greatness. She rose to the top of her sport and had incredible longevity in the face of countless setbacks, not only persevering but also succeeding at the highest level. This memoir is an honest and inspirational story of the sacrifice, hard work, and adversity she faced, and embodies what it means to be a true champion."

—**Tom Brady**

"Lindsey has overcome many injuries and setbacks in her career and always fought her way back. Despite what she went through, she was able to stay at the top of her sport for over a decade. Her story is inspirational, not just for athletes like myself, but to anyone facing an obstacle in life."

—**Roger Federer**

"Lindsey Vonn is the embodiment of what it means to be More Than An Athlete. She is someone who not only spent more than twenty years dominating and elevating her sport, but also empowering and uplifting women's sports and everyone around her while doing it. In the process, she's transcended sports to become one of the best in business. She's been incredibly smart and creative in her dealmaking and partner choices, which has helped forge a path that all athletes can follow."

—**Maverick Carter**

RISE

ALSO BY LINDSEY VONN

Strong Is the New Beautiful

RISE

MY STORY

LINDSEY VONN

DEYST.

An Imprint of WILLIAM MORROW

DEYST.

Photos are courtesy of the author unless otherwise noted.

Photos on following insert pages are used with permission of U.S. Ski & Snowboard: 11, 13 (top left, bottom), 15, 16.

HarperCollins books may be purchased for educational, business, or sales promotional use. For information, please email the Special Markets Department at SPsales@harpercollins.com.

A hardcover edition of this book was published in 2022 by Dey Street, an imprint of William Morrow.

FIRST DEY STREET PAPERBACK EDITION PUBLISHED 2023.

Library of Congress Cataloging-in-Publication Data has been applied for.

ISBN 978-0-06-288945-4

23 24 25 26 27 LBC 5 4 3 2 1

This book is dedicated to my mother. She is my inspiration not because of what she did for my skiing career, but how her perpetual positivity shaped me into the person I am on, and most importantly, off the slopes. Every adversity I have faced, I found perspective and inspiration from her. Throughout the many hardships in her life, they only made her stronger, kinder, and more humble. That type of grit is what shaped me since I was a child; whether I knew it then or not, I know it now.

Mom, I hope I am one day as tough as you are. I hope I will approach every day with as much energy and optimism as you do. I hope I will one day raise my kids to be as incredible as you are.

I love you.

I love you in this way because I do not know any other way of loving, but this

—PABLO NERUDA

CONTENTS

RISE

PROLOGUE

I am more nervous than I've ever been before a race.

I'm on the bike, trying to activate my leg. I feel decent. Not great, but decent.

I'm doing my thing, listening to my prerace mix, trying to honor the magnitude of what's about to happen while at the same time trying to ignore the magnitude of what's about to happen. This is my last race—ever, ever—so I am deep into all-or-nothing mode. I am engaged in a delicate balancing act between psyching myself up and psyching myself out. I tell myself it's just another race, but at the same time, I know that it's not.

It is everything, really. My chance to write how it all ends.

My goal, right now, is to get myself as jacked up as possible, so that I can put everything I have into my final moments as a professional skier. This is it. The last thing I want is to crash and have that be how people remember me. The next-to-last thing I want is to cross the finish line after a clean race and feel like I could have pushed harder, like I didn't give it my all.

The night before a race, I always go to bed visualizing the course—every gate, every bump, every piece of terrain. I visualize it over and over again until it feels like it's a part of me. When I wake up, a lot of times I feel tired, because if I'm being honest, I'm not a morning person. But as soon as I get on the bike, I start to feel better. That's when I start to get into my laser-focused mental state.

Today, though, it's another story entirely. I've only been on the bike for about ten minutes, and already I'm feeling like I've put in enough time. I want to press fast-forward on my morning. Don't get me wrong, I don't want the race to end or for my career to be over, but at the same time, I'm anxious to be on the snow, to inspect the course, to step into the starting gate.

I'm in Åre, Sweden, for the FIS Alpine World Ski Championships, a place where I've raced what feels like a million times before. I rented a house just outside of town, so my family could be here with me for this last race. After everything they've sacrificed over the years, all the ways they've shown up to support me, it seems only fitting that we end this run together, under the same roof.

It's ten minutes from the house to the hill for the downhill race. I make the drive with my trainer, Alex Bunt, my physical therapist, Lindsay Winninger, and Claire Brown, one of my oldest friends, who's been an enormous help to me this season. I go to inspect the course while Lindsay and Claire stake out my spot in the lodge. Lindsay's been with me for nearly five years at this point, and she knows my routines. She knows exactly where I want to be at each venue—off to the side, away from the other girls, where I can focus. Here in Åre, there's a nook I always claim, so Lindsay makes camp there while Claire sees to some last-minute logistics and I make my way up the mountain.

Outside, up here, I quiet my nerves. It's windy and cold, but I only notice the weather enough for it to register. I am in my el-

ement. For me, this is where my race begins. When I'm inspecting the course, there is no room in my thinking for anything else. I don't talk to anyone. I am focused, calm, almost clinical in my approach. There is only me, this start, these gates. There is only what is right in front of me. For a few quiet moments, I let nothing else in.

The wind continues to rip at the top, but the coaches on site tell me the race is due to go off as planned. There's been talk they might lower the start to escape the worst of the wind, but no decision has been made, so I head off for a couple of warm-up runs. I don't ski the course, but the free runs let me feel the wind in my face, let me feel my body position. That's all I really want to accomplish as I move up and down the mountain. I want to ski.

I head back inside the lodge, back to all the boxes I need to check off before I'm ready to race. My routine is always exactly the same, a sequence that feels safe and familiar. I've been skiing these same hills for the past however many years, so at this point I know what I like, what's worked well for me in the past, what's maybe brought me a bit of luck, and I repeat these things into the ground. In ski racing, there are so many variables. It's not like swimming, where the pool is always the same length. It's not like tennis, where the court is always the same dimensions. In ski racing, there are no constants. I can't control the snow or the ice or the wind conditions. I can't control the light or the visibility. I can't control the competition. I can't control the risk. My preparation is the one thing I can control, so I've always controlled it to a T. It's not superstition as much as it is comfort.

I slip my headphones back on, close my eyes, and try to visualize the course. Here at Åre, the athletes are assigned their own area of the bottom floor, but I like to do my warm-up in my own space, away from distraction. There's a huge open area

where the tram unloads, so I stake out a private spot there to do my thing.

Then it's on to a physical warm-up, to activate my leg. You *don't* want to run into me during my warm-up. Usually, I'm pretty cool, I'll give anyone an autograph or a picture, but while I'm in the lodge, don't even look at me. From here, I start to slowly amp myself up. Usually, it's a progression—you don't want to get hyped too early, because then you'll expend too much energy and not have enough left for the race. Today, though, I'm starting to embrace the idea that from this moment forward there is nothing to be gained by holding back. I don't think about tiring myself out or doing too much. These things no longer matter. There is no reason to save myself for what comes next, because this race is the last of what comes next.

As I complete my warm-up, we get word on the radio that the start has been moved down the hill to the third reserve start—the same place we started the super G on Tuesday—which is a dramatic shift. The new start is pretty far down the hill and shortens the course by a lot. This is a good thing for me, because the top part of the course has been the hardest stretch for my knee.

On the downside, the lower start means it'll take longer to get there from the lodge. There's a cat track you have to hike up for a stretch, and it's a huge pain in the ass, so I start growing anxious and leave for the start way too early. Normally, I like to get to the start fifteen or twenty minutes ahead of time, but here I am, forty minutes out, which is a huge amount of time to sit in the cold and obsess about the race. The clock can't tick fast enough.

Around three people before I go, I step into my skis. Then I start the jumping and the stomping. I've always naturally done that. Apparently, when you slam your feet on the ground, it gets the neurological response going, gets your brain and your

nerves firing. I'm also a spitter. I know, it's gross, but when I'm in the starting gate, I spit a lot. That's a trigger for your body to produce a natural boost of testosterone; it's why a lot of athletes spit. For anyone watching, it probably looks like I'm about to kill someone. People have told me this throughout my career, and now I imagine this is especially so. I quicken my breathing, getting more and more aggressive. But I always save the extra 5 percent for when I'm actually in the starting gate.

I go through the same self-talk I have since I was a kid. *I've got this. I can do it. No holding back.* Today, I add another thought into the mix: *There is no second chance.*

I tell myself I need to annihilate this course. It's almost like I'm overcompensating for my knee, trying to get my mind to overpower what's missing in my body. The truth is, I'm not strong. I'm literally on my last legs. But in my mind, I will it so. The course spills out before me.

I am in my skis early. I am focused. I am determined.

A mantra emerges in my head: *I can do this, I can do this, I can do this.*

Right before it's my time, I go blank. I slide into the start and just focus on my breathing. When I start breathing hard, that's my cue. That's when I get into my race state of mind. At that point, you don't want to have any clutter in your mind. Whenever I focus on my results, or look at the finish line, it takes me out of my body, and I forget that I'm in the starting gate. You don't want to think about anything in that moment. Think about it: You go from zero to eighty miles per hour in a matter of seconds. If you're not focused, if you're not totally in the moment, how can you possibly react fast enough? You have to be clear in the mind.

This is what it's all for. You prepare, you prepare, you prepare, so that everything becomes automatic. You prepare so that when you're in the gate, you just do the right thing.

In ski racing, there's very little room for error. The margin is there, but it's small. In a split second, you can go from winning the race to being tangled like a fish in the nets. One little bump, and suddenly you're doing the splits and your knee's blown out. (Believe me, I know.) There are a million different things that can go wrong. One time, this guy fell and when he hit the fence, it wasn't secure in one spot, and he went underneath it. He kept moving, hit a tree, and was paralyzed from the waist down. So, in a sense, it's also about luck.

This all plays into the inspection and visualization. Can you read the way the course is set up, plus the weather and snow conditions, as well as how fast you're about to be going? Because that determines the line you're going to take. It's difficult to gauge speed, but before an event, I can visualize a course within a few seconds of my race time. Some people are good at visualization, and some people are not. It's not a given that every athlete can do it.

Being robotic doesn't work in skiing. There has to be this understanding with the mountain. It's hard to explain; you have to intuitively know the fastest way down. That ability isn't something that a coach can give you. Sometimes, if you practice enough, you can kind of force it. But then you're also fighting against your body. It's not as powerful as when you instinctively know where to go.

Let me put it this way: Say you're a race car driver. You're not the best, not the most skilled, but you're pretty good. You go to Daytona and you practice, practice, practice. With that much practice, you're going to become excellent at going around in a circle. You're going to be an expert at Daytona, because that's what your body has learned, over and over again.

But then, suddenly, you have to perform on a different track, with no practice.

If you can jump in a car and be good anywhere—if you can

translate your skill so that you can perform on any course—that's a talent. Some people are excellent at executing anywhere. Some people naturally arrive at that point, without practicing. At the same time, I know athletes who have way more talent, but never worked hard enough to make it. It has to be a combination.

An individual sport like skiing is mostly mental. When you get to a certain level, especially in downhill and super G, the difference between winning and tenth place is all about mindset. The difference is whether or not you're willing to push yourself to the limit. Your mental strength has everything to do with your success. It takes a certain mentality to be a speed skier. You need to be fearless in so many ways. It's inherently dangerous. There is always a risk. That's part of what makes it exciting. You can see there's a very distinct set of characteristics speed skiers have that technical skiers don't; it's an entirely different way of approaching the sport.

Early in my career, some of the older girls would try to mess with me, saying things like, "It looks really scary, the conditions are so bad that I don't think we're going to race today." They would try to get in my mind.

"Okay," I'd say. Then I'd disregard them and go win.

I thrive in situations like that. I love mentally playing that chess game. *Who can throw themselves down the mountain the fastest?* I'll think, and hope the answer is me. That's something that definitely separates me from everyone else: I have no fear. I am never afraid of anything, including crashing. This is my strength and also my downfall.

Once the clock starts ticking down, it's game fucking on.

From the moment you put your poles over, you have twenty seconds. That may not sound like a lot, but twenty seconds in that state of mind is a long time. So, I do this weird thing where I play with my pole straps, to distract myself from what's going

on around me. It always worked really well, so I stuck with it. Again, there is comfort in the routine.

The countdown beeps at ten seconds, and again at five, four, three, two, one.

It's hard to go exactly at one. But I want to be number one, so I always try.

That's when I say, *Fuck it.*

And like that, I'm gone.

Everyone screams—my team, everyone at the start house—and I love it.

I always encourage everyone to yell, because it helps you get amped up. The louder people cheer, the better it is. It helps bring my energy up without having to *think* about bringing my energy up. Because again, the less you can think, the better.

When I am in the moment, on the course, I'm not thinking about what this race means. I'm not worried about my knee, or what my legs can handle. I'm not thinking about crashing, or about holding back.

I am only skiing.

PART I

GOALS

CHAPTER ONE

Everyone always asks me where my drive comes from, and the truth is I don't really know. It's not a simple answer, kind of like motivation isn't a simple thing. Different things drove me at different phases of my life—it wasn't the same throughout the beginning, middle, and end. In the very beginning, what drove me was mostly the fact that skiing was the only thing I was good at.

When I was three, my dad enrolled me in gymnastics, but I couldn't really do anything they expected of us. I stuck with it for a few years, until the coaches told my parents I was too tall. When I was six or seven, I tried soccer, where I discovered that I was totally uncoordinated. My dad took me to play tennis with him, and I couldn't hit the ball over the net. Finally, there was figure skating. I think I had three lessons before my dad pulled me out. By that point, though, I was already in love with skiing, so nothing else really had a chance.

In my family, there was never a question of *if* you skied—all

of us did it. I wish I could remember the first time I went skiing, but I mostly just remember being cold. I was in my dad's backpack when he was coaching, and I can vaguely recall the feeling of going down a run with him. I remember the smell of fresh snow, the crispness of the air, how it felt to move on skis.

The first time he put me on skis, I was two and a half. I don't remember this, either, but I must have liked it enough to want to keep going. My first real memories are from a couple of years later. I would always hit his hand away whenever he tried to help me, saying, "I can do it myself!" Even then, I was stubborn, and I wanted to do it on my own. Once, my dad and I were going down a run together when I took off ahead of him—just excited that I could even do that. I went speeding down the hill, and he let me go.

That was my first taste of it—the speed, the power, the adrenaline. For anyone who's never done it before, I always give the analogy: It's like if you drive your car on a highway, in a place where the speed limit is legally seventy-five miles per hour, and then you stick your head out the window. That's how it feels, except when you're ski racing, there is no car. There is only you.

Likewise, when you crash, you're jumping out of that same car with nothing on. Or your car slams into a post while you're going seventy-five or eighty, because that's how fast we're moving. Unlike other sports, where you're wearing heavy pads or protection, we're just out there on the mountain with minimal gear. You're going to crash; that's just part of the job. It's basically as dangerous as it gets. If you ask anyone who's an adrenaline junkie, they'll tell you the risk is what makes it exciting. Even going eighty-five miles per hour is not that exciting if you know you'll land in a pile of pillows.

That's the adrenaline component—pushing yourself to the very edge, to where you almost lose control. There's also the

speed component—the wind in your face, the world going by you in a flash. The combination of the two is the thrill that really excites me. It's a feeling unlike anything else. Even now, it's hard to explain what I love about skiing, because it was, and always has been, so inherent to me. I never questioned its value or why I did it—I just did. Every time I tore down the mountain, it made me feel centered and alive, like nothing else ever has.

Since my dad was a skier, I grew up surrounded by ski culture and supported by his guidance. He'd been a world junior champion and skied for the U.S. national junior team, and he was a pretty big deal up until he blew out his knee when he was nineteen. His doctor put him in a straight-leg cast, something they would never do today, and after that he couldn't bend his knee more than sixty degrees. But even though he couldn't compete anymore, he never stopped skiing.

I'm lucky that skiing was a shared passion. It gave us a special bond, and I know my dad was happy that I took to it as strongly as I did. Over the years, no matter how things shifted and developed between us, skiing always brought us together. But when it came down to actually pursuing it, he never pushed me. It was always my own determination that made me want to be a ski racer—he just guided and encouraged me however he could. The most important thing was always that I loved it.

Growing up, we skied at Buck Hill, a tiny ski area in Burnsville, Minnesota, just outside of Minneapolis. When I say tiny, I'm not exaggerating. There were two rope tows and three chairlifts, and the total vertical was 262 feet, with a top elevation of 1,211 feet. (Compare that to Vail, where the vertical drop is 3,450 feet with a top elevation of 11,570 feet, and you start to get the sense of what I'm talking about.)

The Buck Hill racing program was run by Erich Sailer, a legendary coach from Austria who had been my dad's coach back in his competitive days. In those early days when I was

riding in my dad's backpack, he worked for Erich as a part-time ski coach to help pay for law school. Incredibly, Erich was still coaching when I was old enough to join the ski team at age seven. For both my dad and for Erich, it was definitely a full-circle moment.

Erich Sailer has been exactly the same for as long as I can remember him. He moved to the U.S. from Austria in 1955 and quickly settled in Minnesota, where he created his program at Buck Hill. The story goes that when he first arrived, he had thirty-five dollars in his pocket and the only word he knew how to say in English was "hamburger." You'd think that after living in the United States for almost seventy years, his accent would have gone away, but it's as strong as ever. When I picture him, the first image that pops into my mind is of Erich standing at the top of the hill, in his little race hut, with his stopwatch in his hand.

Buck Hill may have been tiny, but Erich used the size to his advantage. "You don't need a huge hill to be a good skier," he would always say. "You only need fifteen gates."

A normal course in slalom is maybe sixty to a hundred gates and takes around forty-five seconds to complete. At Buck Hill, our courses had around twenty or thirty gates and took maybe twenty-five seconds. The idea, though, was that you could train at a very high volume at a place like Buck Hill. Because the course was shorter and not as steep, you could drill your technique without getting tired. It's kind of like if you kept doing the forty-yard dash to hone your running technique, without getting as tired as you would if you were running a mile.

I didn't come out of the gate being good at skiing, but unlike every other sport I tried, the more I worked at it, the better I got. It was an addictive feeling—skiing well and skiing fast—and as an added bonus, I also fit in better with the kids who skied than with the kids from any other sport. I felt more

at home on the hill than I did in a classroom or even hanging out with friends. The ski slope was where I belonged—life just made more sense when I was going downhill fast, so I spent as much time doing it as possible.

We skied almost every weekend, but most of my training at Buck Hill happened under the lights, after school or at night. The setup was actually perfect, because I could go to school, train at Buck Hill in the evening, and get a lot of repetition in without even realizing it. When you go to a place like Vail, the chairlift ride alone takes ten or fifteen minutes, so you're talking thirty or forty minutes per run. On the back end of my career, when I was doing a training session in Vail, I might get five runs in, where at Buck Hill, I could do twenty or twenty-five runs a night. I was there almost every night—the first one on the rope tow, and the last one to go home. I found a sense of achievement in that, because I knew I was working harder than other people. That feeling—the satisfaction that comes from outworking everyone—drove me for a long time. From the time I started racing at age seven up until age sixteen, chasing that feeling was all I thought about.

When you're first learning something, you need to log those hours, you need that repetition. If you want to be great, the quantity of training matters as much as the quality. Once you hit a certain level, the muscle memory takes over, and it becomes a part of you.

At Buck Hill, we focused on the fundamentals. There was no free skiing, we just trained. We worked on our technique, we did drills, we raced. We loved to be in the gates, because that was all we knew. Erich's thing was the thousand gates—on weekends, we would do a thousand gates a day. It gave me a good technical base, which served me well for my entire career. Since the only thing we could do was train, I learned how to love it.

The results spoke for themselves. Before Erich took over the Buck Hill ski team in 1969, I'm pretty sure they'd never won a single race. But under Erich's guidance, the Buck Hill team became a force. From his very first year as coach, they started to win a bunch of races and went on to become a premier team. Before long, Erich developed this reputation for turning kids into champions. Over the years, our tiny hill in the Minnesota suburbs went on to produce a ton of top skiers, with an impressive lineup of World Cup racers and six Olympic athletes, including me.

He also brought in these amazing skiers to help us work on our technique, like World Cup racer Kristina Koznick. She was originally from Buck Hill, and she'd come train with us sometimes, demonstrating the fundamentals and doing drills with us. It was helpful to have access to these real athletes, some of whom had the same foundations as we did, who we could see and emulate.

Erich had (and still has) so much energy and enthusiasm for skiing, and whenever you were in his presence, you couldn't help but absorb it. It's a word you hear a lot, but in this case it's true: Erich inspired people. Yes, he held us accountable and made us do drills, but more than anything, he transferred his enthusiasm. People wondered what he was doing over at Buck Hill to produce all these top racers. They didn't understand that it's not that he did anything different in terms of what he told the kids, it was all about how he motivated them. Everything he said was always kind, even when he was telling us that we sucked. (During my early years, he used to make fun of me, calling me a turtle. "You poor man," he would say to my dad. "You have a turtle for a daughter.")

I think part of Erich's magic was that he saw the talent inherent in people and helped them to develop it. He tried to make us the best that we could be, pushing us to the limits of

our ability without changing who we were. When I was young, a couple of people told me that I should change my technique. On every turn, every time, I would lean in with my inside shoulder, kind of like the Leaning Tower of Pisa. Everyone thought I was really tippy and told me I should straighten out, but not Erich. "Don't change," he told me. "You're fast the way you are."

Even when my dad would say, "We should work on her technique," Erich just shook his head. "She's fast," he replied. "She's fast for a reason. You can't change what someone naturally wants to do."

The leaning did cause me problems, in slalom in particular. But it's also why I was so successful in downhill and super G. I leaned in, and that's what made me fast. When I watched a lot of the great downhillers, I noticed a lot of them did it, too. You can't really teach that. Some things are naturally there, and that's exactly what Erich always wanted me to know.

You're fast the way you are. That's the best piece of advice he ever gave me.

When I was young, I was lucky to have the right team of people to guide me. I think it was a perfect combination between Erich, my dad, and my other coach, Tony Olin. Where Erich was the motivator, Tony and my dad focused on the technical stuff. In his days as a competitive skier and then as a coach, my dad had studied the world's best racers and learned from experienced coaches. To this day, he is still one of the best I've heard at explaining the technical aspects of the sport. My dad also taught me the importance of the psychological components: visualization, preparation, and focus. He was a tough coach, but I could always rely on him for guidance or advice. For his part, Tony was more about technique, but in their own ways, each of them helped me develop—as a skier, as an athlete, and as a person. The three of them balanced each other really well.

One thing I've always loved about sports is that every day, you can set a tangible goal, and every day, you can meet that goal. That feeling of accomplishment is hard to replicate in other parts of life. As an athlete, I think you need an element of success, of measurable progress, to really stay engaged. After all, even if you love something, if it feels like you're always hitting up against a wall, there's only a certain amount of negativity that you can take. Especially as a kid, I found gratification in this cycle of working hard and seeing results; setting goals and accomplishing them became almost compulsive. From those early days of training throughout my entire career, I thrived inside a cycle of always trying to outdo myself.

As I worked, I kept getting better. Eventually, as I started to do well, the positive reinforcement from my dad and my coaches definitely helped. Even if I wasn't winning, just having my coach or my dad or a friend say, "Wow, that was a great run"—that feeling is addicting. You feel that sense of accomplishment and it makes you want to keep going. Their encouragement helped fuel me, and I took pride in pleasing them. I always wanted to make them all proud.

Starting when I was seven years old, I competed in local races, often waking up before sunrise on weekends. My dad would carry me to the car while I was still asleep, then place me gently in my sleeping bag in the back seat, where the heat was already on full blast. Back when I was growing up, Minnesota was fucking cold. Sometimes back then, temperatures would reach minus sixty with the wind chill. We had races where they wouldn't let you take your jacket and pants off. You'd have to race wearing every piece of clothing you had. I vividly remember getting frostbite—pins and needles followed by numbness—especially in my toes, which was a common thing in Minnesota.

When it got too cold, we'd head to the lodge for doughnuts and hot chocolate. I'd love to know how many gallons of hot

chocolate I've had in my life—all I can say is that it's an extreme amount. When we got inside, my feet would be frozen solid, and my dad would take off my boots and rub my feet with his hands to warm them up. He eventually got me some boot heaters, which was probably one of the best Christmas presents ever. When my hands were cold, as they often were, my dad would take my mittens off and put my hands in his gloves. Then he would blow hot air into my mittens and quickly swap them back, so my hands would be nice and toasty for a few minutes.

I know it's kind of ironic, but I hate the cold. The cold is nice when you're totally bundled up and it's beautiful and sunny and you're standing at the top of a mountain on a crisp morning. But the second I *feel* cold, it's like, "Eh, where's the lodge and where's the hot chocolate?"

Once, after racing in Giant's Ridge, my dad had just gotten a new Chevy Suburban. The best thing about it was that he could press the car keys and turn the car on from a distance, so the heat would start blowing before we got there. I raced down to the car, not even stopping in the finish area, and hopped straight inside. Getting down the fastest also meant getting warm the fastest.

CHAPTER TWO

Everything started with my grandpa Don. He's the one who taught my father to ski, so technically he's responsible for getting our entire family into it. He'd been skiing for decades, since the days of ground lifts and lace-up boots. When I was little, the whole family would go on these big group ski trips to Steamboat or Keystone in Colorado. Back then there were no other kids, and I relished the attention. My grandpa didn't ski much later in my life, but I always felt grateful that as the oldest grandchild, he and I got to have that time together. I remember how excited he was to be out there with me, to be sharing this thing that he loved. He wasn't in any way a coach figure—that role was filled by my dad—he was just incredibly proud. He and my grandma Shirley would come to my early races in Minnesota and Wisconsin, and the whole time, he would be beaming.

Grandpa Don's influence on me went far beyond skiing. We had a special connection, and a lot of who I am started with him. I grew up hearing these stories about how hard he'd worked to

build his life. When he was twelve, his father died unexpect-
edly while they were in the process of building a new house.
From that point forward, the family lived in the garage while
my grandfather finished building the house himself. He went
to school by day, then came home and kept on building—by
lantern—at night. He even dug up the sewer line himself.

As a young man, my grandfather served two years in the
Army Corps of Engineers during the Korean War. After that,
he worked in excavating his whole life. To get his first job, he
demolished and repoured the sidewalks of an entire town all by
himself. That's how he got his start. He took that one job and
grew it into a construction company. Every day, he came home
from work sweaty and smelling of oil and grease. That's how he
made it work—by outworking everyone.

I grew up seeing his hard work all around me, and it gave
me a certain level of perspective from a young age. He didn't
complain, so why would I? Because I saw how hard my grand-
father labored for everything he had, I never felt entitled. I ap-
preciated everything our family had and always tried to stay
humble.

Later in life, my grandpa had to retire, following a couple
of strokes and a triple bypass surgery, and my grandma Shir-
ley went to work at Walmart. She often had the late shift. She
wouldn't get home until midnight, where she'd find my grand-
father waiting up for her with a bowl of ice cream. They had
their bowl of ice cream together, every single night, without fail.
That kind of care went both ways. When Grandpa Don used
to go to work at 4:00 A.M., Grandma Shirley would get up and
pack him a lunch in his little tin lunchbox along with his giant
thermos of coffee.

When I was growing up, Grandma Shirley was the defini-
tion of a kind, overly generous grandma. She'd have my favorite
Swiss Miss chocolate pudding waiting for me whenever we vis-

ited. She took us kids to the Wisconsin Dells water park every year and bought us ice cream. Even though they had no money, she would send us all cash for our birthdays. My grandma couldn't hurt a fly. She is the sweetest person you could ever hope to meet.

Later on, my grandparents always followed my skiing career, getting up at 3:00 A.M. to watch my World Cup races, and whatever else they could, on television. My grandma would close her eyes and pray for me, while my grandpa yelled at the TV for me to go faster. My grandpa remembered all my race times, which didn't matter, because there were new ones every day. But it was very endearing. He also kept track of my competitors and who was doing well and whether I would make the Olympics. He paid attention to whatever I did and took a lot of pride in my success. They were always proud of me, even if I had a bad day, offering me unconditional love and unwavering support, which I came to rely on, especially as a kid. My grandma was always the one to say, "Oh, sweetheart, it's okay. You don't have to win every race!" while my grandpa would yell, "Yes, she does!" They were quite a team.

As an adult, I often think I'm a combination of my grandparents—my one-liners aren't as good as my grandpa's, but I try. I've inherited his fearlessness when it comes to speaking my mind, though I definitely have a soft side like my grandma. I may not always show it—especially where skiing is concerned—but behind closed doors, I'm actually pretty soft.

Still, as much as I take after my grandparents, I'm also a combination of my mom and dad. My dad, Alan Kildow, grew up in a small town in Wisconsin. He's always been Big Al, and he's a very big presence. He's a trial attorney, a litigator, so he's great at telling a story. Raised in a middle-of-the-cornfields, blue-collar town, he's intelligent and charismatic and always commands the room. When I had sleepovers at our house as

a kid, he was the dad who made a huge dinner and ice cream sundaes. He knew exactly how to make everyone feel welcome and at home—he has that way about him.

My mom, Linda Krohn, grew up in a small town in Minnesota and met my father while she was in law school. She was part of the generation of females that didn't have the opportunity to participate in college athletics, but still, she played squash, skied, and even got a presidential award for swimming, something she still does every day at the age of sixty-eight. When I was a kid, my mom worked as a public defender, and now she works with people who are in rehab. Helping others is engrained in her.

I am the oldest of five—me, my sister Karin, and the triplets, my sister Laura and my brothers Dylan and Reed. Given that my birth didn't go as planned, I probably should have used up my lifetime worth of hospital drama right there. On October 17, 1984, my mother went to the emergency room at 10:30 P.M. for a very bad headache. Four hours later, she suffered what doctors would later determine was a stroke, and I was born by an emergency cesarian. In a coma, my mother was given a fifty-fifty chance of surviving.

"That's not good enough," my dad told the doctors.

They were given a choice between two doctors. One was an experienced doctor who said he would do the best he could, but the odds were slim. The other was a young doctor who wanted to try something different that had a shot at working, although if it didn't, it could kill my mother in a matter of hours. I can only imagine how difficult that decision was for my father, but I think it's human nature to choose hope, which my dad did. As it turned out, the second doctor saved my mom's life. When she woke up, they told her she had a little girl, and not only could she not remember my name, she didn't know I'd even been born. (My parents had decided on my name while my mom was

still pregnant. They'd intended to name me "Lindsay," but my dad misspelled it on my birth certificate, and I've been "Lindsey" ever since.)

Even though my mother survived, she was going to require extensive physical therapy. My dad's entire family came to stay with us and help. My uncle Jeff came all the way from Germany where he was stationed in the army. While my mom went to physical therapy every day, my dad had to keep working full-time—I still don't know how he did it. Gradually, she recovered far beyond what the doctors expected, probably because she was so young, at age thirty-two. Beating the odds, my mom did walk again—I've always imagined my mother and I both took our first steps together.

Still, my mom never fully recovered from the stroke. She was able to go back to work, and to have four more kids, and to be an incredible mother. But in some ways, she was never the same. She has a hard time balancing, and she could never ski with me, or ride a bike, or run and play with us kids. Sometimes she still struggles physically, and that can be hard to see, because she's such a good person.

I've carried her struggles with me ever since I first learned about her stroke. It's hard to tell if her pregnancy gave her the stroke, or the blood vessels that burst on the left side of her brain were always iffy and I saved her life by getting her to the hospital. Of course, regardless, it wasn't my fault that it had happened, and there was nothing I or anyone else could have done. I understand all that logically. Emotionally, though? That's a different story. It's hard not to feel guilty, not because anyone said, "It's your fault your mom had a stroke," but because my name is forever a part of that story. Whenever I got injured, I'd think about my mom, and it was impossible not to feel a sense of obligation to her, a duty to fix myself, no matter how hard it was. Because my injuries were *fixable*—they were things I could

overcome, with hard work and the right mindset. She never had that luxury, so I always felt a sense of responsibility to her to pull myself up, get better, and do it all without complaining. After all, how could I possibly complain if she never did?

Despite her physical setbacks, my mom remains one of the most upbeat and positive people I know—honestly, she's incredible. We have a family text chat, with my mom and all of my siblings, and my mom writes us these little poems every day. She's constantly sending around positive affirmations. Sometimes, as with any group text chat, I'm like, *Okay, that's enough,* but it's fucking awesome that she does that. She always tries to lift our spirits. She chooses to be happy every day. I know she has a hard time, but she doesn't vocalize it. Now, maybe sometimes she should, but still, that kind of toughness is hard to come by. There are a lot of strong characters in my family, all of whom taught me the value of toughness, and my mom is just as resilient as any of them. Her strength is immeasurable.

Despite all their trials, my parents got the big family they both wanted. The family grew, first with my sister Karin four years later, and then, wishing for a boy, they got surprise triplets—two boys, Dylan and Reed, and a girl, Laura. It turned out that my mom had a hard time getting pregnant a third time, so she had tried hormone treatments. One of the side effects is a possibility of having multiple children. Back then, the science of fertility was not like it is now, and was very much a guessing game. It felt to me like we went from this small family, with just me and my parents and everybody else pitching in, to this bustling household. Me along with Karin and the triplets.

In those days, Burnsville, Minnesota, was a pretty picture-perfect place, your typical Midwestern suburban town. When I was growing up, we moved a couple of times, but the house that really sticks in my memory was this stunning house—the red-

brick house, we called it—that my dad designed from scratch. It was in a nice neighborhood near the school and even closer to Buck Hill. I was so excited that I actually flunked my math test the day we moved in; I got bumped to a special-needs math class and had to retake the test to prove that I belonged in the standard one. It was a kid's dream house. The backyard had a jungle gym and trails that led to Alimagnet Lake. We made forts everywhere—there was even a little space under the staircase where we could hide out. My dad poured the concrete for the driveway by himself and we all put our handprints in it. That home was truly ours.

One thing I learned having four little siblings was how to remain calm through chaos. Because my mom couldn't run or ride a bike, I would often be the one in charge. If we went to the lake near our house, I was responsible. When I was little, I changed the triplets' diapers. As we got older, I made them lunches, and when I got my license, I drove everyone to school and wherever else they needed to go. We were a unit.

Like a lot of families, my siblings and I tortured each other growing up. Or rather, I should say, I tortured them. We performed these elaborate choreographed dances to the music from *Cats* and *Joseph and the Amazing Technicolor Dreamcoat* and various Mariah Carey albums. I really can't tell you why. But it was always my vision, and I dictated everything, from the choreography right down to the costumes and the lighting design (which consisted of setting up flashlights as stage lights). Then I'd sit my parents down to watch the show. Sometimes, when I'm doing an interview or I have to be entertaining on camera, I think back on those dances and how it all started there. I guess I've always been a character that way.

I also produced photo shoots, inspired by Glamour Shots, the over-the-top mall photography studios that were all the rage

at the time. My dad let us use his nice camera, and I made Karin and Laura wear makeup, styled their hair, and dressed them up in my clothes. We still have those pictures, and to be honest, they're pretty awesome.

Unfortunately, I was also the one in charge of all my siblings' haircuts. And some of them were, shall we say, less than ideal. I once gave Karin a terrible, short bowl cut with bangs. It looked like I'd put a bowl over her head and kept cutting around it. Another time, I shaved my brother Dylan's head completely bald. That wasn't my creative vision—I kept making mistakes, and as I tried to course-correct, it got shorter and shorter and shorter. Eventually, I was like, "Why don't we go Michael Jordan style?" He wore a hat to school the next day, and the teacher made an example of him about not wearing hats indoors. He had to take off his cap in the middle of class, at which point everyone discovered he was bald. I'm pretty sure I traumatized him for life.

But I'm not one to talk. Up until I was four of five, I had a legit mullet. It was a bowl cut up front, with a super long party in the back. (This was not my idea.) I also had a signature look: matching turtlenecks, OshKosh B'gosh overalls, and high-top sneakers. In every color of the rainbow. (Also not my idea.) It was a thing back then, but it certainly wasn't stylish.

For Christmas, my dad liked to make a family photo card. He loves Dale of Norway sweaters—those thick wool sweaters with traditional Norwegian patterns. He and my grandpa always wore them. I think they thought it was a cool, European thing to do. Every year before the holidays, the whole family dressed up in our Dale of Norway sweaters and lined up for the camera. We didn't match each other exactly, but we were pretty damn similar. One year, we went to this camping site on a river in Colorado that had a crazy-scenic background. My dad made us

walk out to the middle of the river, to get a better scene for the card, and we almost fell into the water, which was only half frozen. But luckily, we got the shot.

When I was younger, my siblings and I spent every summer at my grandparents' house. My parents dropped us off for six weeks, or however long my grandparents could keep us. I loved going there so much that I would try to time my ski camps so I wouldn't miss the time with Grandma Shirley and Grandpa Don.

My grandparents had a golf cart, and I took every opportunity to max it out. My grandpa was missing the index finger on his right hand, which he lost in an accident while he was working construction. I remember him yelling at us to slow down, waving his nub finger as I sped past. He had to change the engine to make it go slower and slower. We always drove the golf cart down an old railroad track that ran behind my grandparents' house. We'd take it to the gas station, where we'd get slushies for fifty cents. (My grandma would always be the one to slip us five dollars for our gas station runs.) When we got back to the house, the people who ran the gas station had already called to tell my grandparents we'd been there. That's what happens in a town with a thousand people; everyone knows what everyone else is up to.

We have such a tight relationship, my siblings and me. We were a posse, our own little Kildow crew, able to find fun wherever we were. Throughout our lives, we've always remained united by our love for each other, and for skiing. Skiing was a constant, something we could do together, and also something we could do with the rest of the Kildow family. That's the great thing about a sport like skiing: If you are born into it, it becomes a part of you. It's knitted into the fabric of the life of your family. It connects generations.

I have so many fond memories from my childhood, but one of the greatest, most validating moments of my little life came the first time I bombed down a hill ahead of my grandpa Don.

At the bottom, he skied over to me and said, "Oh, my! You're fast!" He was beaming.

He didn't say I was fast "for a girl."

He didn't say I was fast "for a kid."

He didn't qualify his pride or astonishment in any way. He just said it like it was fact.

CHAPTER THREE

A re you sure this is what you want?" my dad asked me.
It was a weeknight, and my dad and I were alone in the kitchen of the red-brick house. The dinner dishes had been cleared; the voices of my siblings echoed from the living room. As we sat at the big wooden table, next to the kitchen island with the matching wood stools my siblings and I were always finding some way to tip over, I heard the string of unreasonable words exit my mouth. I'd just told him I wanted to ski in the Olympics in 2002.

If my dad was surprised, it didn't register. In fact, he didn't even flinch. He looked at me, his face calm and serious, taking it all in stride.

"Yes," I said. "Very sure."

"Okay," he answered, without missing a beat. "Then this is what you'll need to do."

In my defense, there was solid nine-year-old logic behind this goal. The International Olympic Committee had just

announced the 2002 Olympics would be held in Salt Lake City. When I heard that the Olympics would be here, in my home country, in eight years, my nine-year-old mind thought that meant somehow, I would have a better shot at making it.

I didn't overthink it; it made perfect sense to me. And thankfully, my dad seemed to think it did, too. As soon as my admission was out in the open, he told me how much work such a goal would take—just as tall an order as the words I'd just shared. What felt like a simple statement ushered in a complex plan. But because he didn't flinch, neither did I. I had total confidence in my goal, which only grew stronger now that my dad was in my corner.

It might not have been sensible, but it wasn't just childhood reasoning that led me to blurt out this goal to my dad—I believed in myself, that I was capable. I can't explain why, at nine years old, I said, "I'm going to be the greatest skier in the world," and decided to actually pursue it. I wasn't the most talented skier, especially at that age. I wasn't the fastest. All I know is that from the moment I set my sights on it, I always believed it. There was never a point where I doubted my dream, never a point where I thought, *Maybe this is wrong*. I simply felt like that's what I was made to do. Now my father knew it, too.

For as long as I could remember, I'd wanted to be a skier, but if I had to pinpoint when I first *knew*, I'd say it happened at age seven. To be clear, at that time, I had no idea what a professional skier actually *did*. I just knew that I wanted to ski, the same way a lot of kids say they want to be a baseball player or an actor or a superhero. But that vague desire came into sharper focus a couple of years later, when I met Picabo Street. Meeting her changed everything.

Every year, the best skiers in the country came to Pierce Skate & Ski, our local Minnesota ski shop and one of the larg-

est ski shops in the country. It's a great family business, and my dad was friends with the owners, John Pierce and his son, Bart. In the summer of 1995, Pierce announced they would be hosting an event with Kristina Koznick and Picabo Street. I was already acquainted with Kristina from skiing at Buck Hill, but I didn't know much about Picabo. Back then, there was very little ski racing on television, and I wasn't yet familiar with a lot of skiers. I just knew she was the best.

I remember the whole thing clear as day. There were so many people waiting to meet her, at least a couple hundred, and I stood in line for what felt like forever but was actually around two hours. I had just gotten my ears pierced, and I was especially proud of my earrings, which I wore along with a white Esprit sweatshirt and jeans. I still have the photo of the two of us together, and it's one of the few pictures I have from that age where I look decently cute.

I was nervous as I walked up to her—I didn't have high or low expectations, it's more that I didn't know what to expect. But all that melted away the moment I met her. Picabo was just so vibrant. She had this charisma about her that was tangible and infectious. Everything about her captivated me. She was really kind and gracious, in the way she conducted herself and in everything she did, and that put me at ease. I wanted to be just like her.

That meeting was what pushed me over the edge, in terms of my motivation and drive. Before it, I knew I wanted to be a skier—but wanting to be good, wanting to win races, that's one thing. Seeing Picabo brought it to a whole different level. Skiing didn't look like an actual *job* until I saw her. She wasn't just a skier; she was a personality. She had a Rossignol sponsorship. She had a Nike sponsorship. I mean, she had a shoe named after her. Things like that didn't usually happen to ski racers.

To see someone who had built so much—who was well

known and popular and had medals and trophies—was like encountering a superhero in real life. Meeting her made everything I wanted real. It was like, *Wow, this is possible. It exists and I can do it.* When Picabo signed my poster, she wrote, "Follow your dreams." Looking back, I'm sure she put that on everyone's poster, but I didn't know that at the time. She told me to follow my dreams, and that's exactly what wound up happening. That was the day my dream went from being some amorphous thing to actually taking form: I wanted to be an Olympic champion.

After I got Picabo's autograph, I was on my way to the bathroom at Pierce when I saw Diann Roffe-Steinrotter, another Olympic medalist and a big star. I asked for her autograph and she flat-out said no. No explanation, no niceties; it was like she didn't have the time. That was traumatizing to me. On the same day, I had one really inspiring experience and one traumatic one. I never forgot it. I learned that you can positively impact someone in a minute and a half, or you can negatively impact them by just saying no. It's pretty simple to do either; you have to choose. Years later, anytime a kid asked me for an autograph, I remembered that day. Even if I couldn't do it, I would tell them, "Listen, I'm so sorry, but I'll grab you after the race." It's always worth it to be kind.

From that day forward, everything became clearer. Picabo had inspired something in me—a dream where I could make a difference. I still have that autographed poster. My dad later had it reframed, and it hangs in my bedroom in Utah to this day.

Not long after meeting Picabo, I sat at the kitchen table and told my dad that I wanted to ski in the 2002 Olympics. To his credit, he didn't bat an eye, or make a joke of it, or dismiss it as some kind of childhood fantasy. He didn't pat me on the head and say, "That's nice, honey, go play with your brothers and sisters." He didn't condescend—he took my words as seriously as I intended them, which is not always an easy thing

when you're talking to a nine-year-old. Instead, he gave me his honest reaction.

"You'll be seventeen then," my dad said, "and it's going to be a little bit lofty."

Of course he was right, but that didn't stop him from rolling up his sleeves to devise a game plan. My dad saw that I had talent, and he wanted to do everything in his power to help me rise to meet it. He recognized that sense of drive and ability in me. He took me, and my lofty goal, totally seriously.

Together, we sat down and created a ten-year plan leading up to the Olympics and beyond. We didn't have the internet back then, so we looked through ski racing magazines to see which athletes were getting which points by what age. From there, we worked backward from the date of the Olympics, to set benchmarks for me to hit along the way. The whole thing was super thorough and quite detailed. Because my dad is a lawyer, he had a way of making the plan visually impressive, too. He's got this really fancy cursive handwriting, and he highlighted it with different colors. We had multiple folders for all the various parts. It was honestly pretty awesome.

Later in my career, people always asked me how I managed to stick with skiing from the time I was so young. A lot of kids play sports, and a lot of kids say they want to make it to the Olympics one day. But so many of them encounter speed bumps and distractions along the way. For girls, especially, many stop playing sports during the teenage years, when social and societal pressures can often get in the way. How was it possible, parents want to know, that my commitment never wavered?

The answer, in part, is that my dad was vital when it came to helping me see the bigger picture. I was treated like an adult with an adult goal—almost like we were business partners. He made me understand how all our decisions have a domino effect that will either lead us to our goals—or not.

"If you want to go down this path toward the Olympics," he explained, "you will only get there if you're willing to do things others won't." He laid it all out, in terms of the pros and the cons. "You will miss sleepovers. You will miss prom. You will miss out on a lot of things other kids have, but you'll get many other things in return." Was traveling the world and working hard more important than going to parties? For me, the answer was yes. So, I took the steps I had to take to get there—but he was crucial in helping me see not just where I was on that path, but everything that lay further ahead. I'd asked him to be straight with me, and he took me at my word, so he no longer spoke to me like I needed to have my hand held.

If you're reading this and thinking that this was some kind of Andre Agassi–type relationship, where my overbearing coach of a father pushed me into a sport I didn't love, it was nothing like that. No one was forcing me to keep going. I didn't have that kind of talent; it wasn't like my dad had dollar signs in his eyes—it was actually the opposite. I wasn't naturally that good, I just loved skiing enough to keep working to get better.

I'm a big fan of the psychologist Angela Duckworth, who I'm also happy to call a friend. She makes a lot of excellent points in her book, *Grit*, but the main one is that the most successful people are the ones who work the hardest, and also the ones who make the most sacrifices. Grit, she says, is "a combination of passion and perseverance for a singularly important goal." The goal isn't to have it all; it's to get really clear on the things you do want, so you can make the right choices.

Well, at nine, I didn't have the ability to make the right choices to shape my future—I just knew what I wanted to achieve. My dad understood how to make that happen, not just on the slope, but off it, too.

"This is a big step if you want to make this your job," he told me. "If you want to be a skier, you don't want to be a ski bum."

Not being a "ski bum" was a thing for him. Over the years, he would hit that chord repeatedly. In some ways, the ski world can be a little like Neverland. You grow up away from home, training and competing in an environment without parental supervision. Sure, you have your coaches, but they're not the same as schoolteachers. You learn the discipline it takes to be an athlete, but you miss out on the direction young teenagers need, especially when it comes to things like developing social skills and navigating the way the larger world works. For a lot of kids who grow up in skiing, it can be easy to fall into the racing bubble and never get out.

There are a lot of skiers who have followed this road, skiers who are good, and make a career out of it, but never really grow beyond skiing. After their competitive days, they remain in the ski world, where they might become ski instructors or coaches. This was the case for a lot of people my dad grew up racing with. We would see them on ski trips in Minnesota or Colorado, and a lot of them still carried around their medals, as many Olympians do.

That's not to say that's a bad path. You can still have a nice life in the ski world; my dad has one friend who won a couple of World Championship medals and now makes good money as the ambassador of a ski resort, where he gets to ski with all different people. But my dad took pride in the fact that he'd become a lawyer, and that in order to get there, he worked full-time and went to law school at night. He believed in education, in being well rounded, in having knowledge and goals beyond the sport. Plus, he worried that if skiing didn't work out, I could be left flat on my face.

It was all his way of trying to explain that I needed a plan B in case skiing didn't work out. I needed a backup, and I needed to be smart. If I was going to pursue a career as an athlete, I couldn't be *just* a skier.

"But what is your *job* going to be?" he would ask.

"I'll be a ski racer," I'd say.

"And after that? Do you want to be doing that your whole life?"

To which I would reply, "But I want to be the best."

But my dad knew that being the best was never enough—in fact, it was just the beginning. He cut out magazine clippings of strong female athletes across different sports. There were Mia Hamm and Steffi Graf, who, in addition to being amazing athletes, got huge endorsement deals and marketed themselves well. My dad wanted me to know what was possible, and to help me visualize it.

"You have to be smart, business-wise," he told me.

It wasn't just about wins, though they were definitely the main part of it; it was also about having these different components—performance, media, endorsements—all come together at the right time. Pursuing a career in sports is about so much more than the sport itself, and my dad got me thinking about it in a business sense from a young age. Skiing, at face value, isn't a marketable sport. It's not on television in the U.S., and it's only really popular in Europe. It's not like football or basketball or baseball, where players sign these huge contracts. Even the most successful skiers don't really make money unless they get endorsement deals. So, he also broke it down financially. How was I going to make money from this? What would it take? To factor that into the ten-year plan, my dad went through all these articles to figure out, roughly, how much Picabo made.

"If you want to have enough money," he would say, "this is what your ski contract needs to look like five years from now, this is what it needs to look like ten years from now . . ."

To that end, he also got me thinking about marketing, and how I could be more than a skier. A few years later, when I was

fifteen, my dad had the idea to make me a website, which was pretty forward thinking at the time—at least for the ski world. To get photos for the site, we asked the local ski shop if we could borrow high-end clothes for the photo shoot and promised to give them back when we were finished. Of course, this is what stylists do all the time now, but back then it wasn't done. He hired a photographer he knew to help us out with pictures, and we all spent a couple of days in Vail, getting professional-quality shots. I still don't know whether the website actually led to more endorsement deals or not, but it definitely set the tone for how we approached my career.

As my dad pointed out, athletes have a very limited career span. You have a finite window to get in, make money, succeed, and get out . . . before your body falls apart. He instilled in me that I had to maximize every opportunity.

That's why, whenever anyone wants to know if I have any wisdom to pass along for their children, I tell them it all comes down to helping kids see the bigger picture the way that my dad helped me. Everything is interconnected, and one of the best things you can do is show your kids that every decision they make will affect their future. You can't teach someone to be gritty or determined. DNA and personality also factor in, to some degree. But as my dad always did, parents can point out the consequences of quitting. If you quit one thing, what will you be missing out on? What future possibilities might you also be forfeiting? Will it set a precedent? Kids don't have the perspective to understand the ramifications of the choices they make when they're young. How could they? They've only lived twelve, fifteen, seventeen years (or, in my case, nine). It's hard for anyone at that age to understand the ripple effects of their choices.

Perhaps more important than any of this, though—more than the ten-year plan, the big picture, the marketing lessons,

the focus on becoming a three-dimensional athlete—what my dad helped me grasp was the simple fact that I loved skiing. Fully, completely, passionately. It isn't enough to simply show kids what could happen further down the road—you also have to help them discover what they love, and then show them *why* they love it. Help them to uncover *why* they do it—and make sure that they continue to answer that question of why over and over again. You can't just ask it once and consider it settled—it's a constant dialogue, and there always needs to be an answer. Maybe it's just one answer, or maybe there are several. Maybe the answer changes over time. In the end, the specifics don't really matter, what matters is that it's a process of questioning that leads kids to affirm their choices. Because there will be times when they need to sacrifice—they will have to choose the hard thing (waking up before dawn) over the fun thing (hanging out with their friends). And they need to know why they are making that choice. If they have an answer to that question of *why,* it won't make the sacrifice itself any easier, but it will make it clearer.

In many ways, I benefited from having an oddly objective view of my purpose from a young age. Ever since I was nine years old, I knew I wanted to go to the Olympics. Period. That was the goal, and it was always in my mind whenever I made any decision. Even when that goal felt far away, I kept it in the front of my mind as I asked myself, *Do I want to go out tonight? Or do I want to wake up, go to this race tomorrow, and win?* Over the years, I can't tell you how many social events I missed. I can't tell you how many times I was the only one left in the hotel when everyone else was out partying. But skiing occupied so much of my focus that it didn't leave room for much else, including a lot of the struggles that kids encounter. I kept the Olympics in mind in that singular way and put my blinders on when it came to everything else. Like most things in life, it was a trade-off. But I never doubted that it was worth it.

The irony of all this? Years later, I learned that when I first came to my dad with my goal, he didn't actually think I could do it (thankfully, he's got a good poker face). I mean, it's understandable—it was a big goal and a big plan, and I was only nine. I think, at that time, he saw that I loved skiing and was competitive, but I don't think he ever contemplated "future Olympian" for me. He was probably thinking along the lines of "college scholarship." Even so, his initial assessment changed soon after, on a ski trip in Oregon.

During the ski season, I trained at Buck Hill, but during the summer months, I would go away to these ski camps, at Mount Hood, in Oregon, and later on, at Keystone and Vail, in Colorado. In addition to the team at Buck Hill, Erich Sailer ran the camp at Mount Hood, which was considered the premier summer ski camp. His program attracted some of the best kids from all over the country, and even all over the world.

If you've never been to Mount Hood, you might recognize it from the movie *The Shining*. The Overlook Hotel, where the movie takes place, is actually the Timberline Lodge, which sits on the lower side of the mountain. It rains all the time in Oregon, and on a lot of days, the landscape can look as dark and creepy as it does in the movie.

One day when I was nine or ten, I was out there skiing when it started to pour. The chairlifts stopped running, because there was lightning, and everyone went inside. Everyone except me, that is, who was thrilled to have the run all to myself. And Erich, who was still standing out there with his stopwatch.

I *hated* hiking, I'll tell you that right now, but I saw this as the perfect training opportunity since no one else was out there. Because there were no chairlifts, I went out, skied the course, and hiked back up to the top of the mountain. Then I did it again, and again, and again. I was wearing this poncho that looked sort of like a trash bag, my goggles were fogged, my

gloves were soaked. It was raining so hard that if you took off one of my gloves and squeezed it, water would come pouring out. My feet were freezing, my fingers were pruned. But I didn't care about any of that. I just wanted to keep going.

Normally, my dad didn't come to the camps with me, because Erich was there and my dad had to work, but he would sometimes come check in on the weekends to see how I was doing. This was one of those weekends, but as I skied alone in the pouring rain, I didn't realize he'd arrived yet. I had no idea my father was on the hill, watching me the whole time as I hiked up and skied down in the pouring rain, all alone.

That was the day he changed his mind about our plan. Much later, he told me he looked at me out there, hiking up the course and racing back down, lap after lap after lap, and said to himself, "Well, maybe she does want this. Maybe there is something there."

CHAPTER FOUR

Given my dad's professional approach to, well, everything, it should come as no surprise that he brought this same level of detail to his role as a ski team dad. Skiing quickly came to dominate my life, in season and out. For the most part, I continued doing everything I was already doing—training and drills and camps and races—but now it all felt a little more serious, a little more intense.

In Alpine skiing, there are four different disciplines: slalom, giant slalom (GS), super giant slalom (super G), and downhill. Downhill and super G are speed events, where the course is designed with longer runs and more distance between gates. Slalom and giant slalom are considered technical events, with more gates and turns.

At Buck Hill, I was good at skiing slalom, because that's what we did. Growing up in Minnesota, that was my specialty. You can't ski GS in Buck Hill, the hill simply isn't long or big enough. You can do five or six gates, and that's it. Since Buck

Hill is pretty flat, I learned to be especially good at skiing on flats. Anytime I encountered a flat section on a course, I was really fast, because I learned to generate speed when there wasn't any slope to pull you down.

Looking ahead, my dad and I tried to figure out where I should set my sights to have the best chance of making the Olympic team, and we settled on the combined—a hybrid event that's a mix of downhill and slalom, where you ski one run of each and add your times. Our reasoning was that the combined had the least amount of competition for spots, and it featured what were my two best events at the time.

My dad explained how the point systems worked, what races I'd need to go to, and what ranking I'd need to hit at all these different benchmarks along the way. He told me how old I'd need to be to quality for events through the USSA (U.S. Ski and Snowboard Association), which governs both Olympic skiing and the junior racing circuit, and the FIS (Fédération Internationale de Ski), which governs international racing.

For USSA, the way it worked was that you couldn't earn points until the year you turned thirteen. Your age for the season was determined by your age at the start of the season, which usually falls in November. Since my birthday is in October, that meant I was often going up against girls who were almost a full year older than me.

FIS, meanwhile, worked differently. When you turn fifteen, you become eligible for FIS points, which is the main system for racers. You start with 990 points and the goal is to get to zero—at the end of each season, whoever is ranked number one in the world has zero points. There's a complicated system they use to calculate everyone's points from first place down, but the gist is this: In order to get a good result and move up in the rankings, you need to be racing against people who are ranked well.

Essentially, this means your points are based not only on how you finish, but also who you're competing against. It's not enough just to win if no one who's ranked well is there. That's why skiers have to travel so much to get good results—you have to ski where the field is. As soon as I was the right age, my dad started sending me to races where I could earn the best points, so I could move up in the rankings. You need to be strategic about where you go and who's going to be there. (Sometimes you don't know who will be there, and then you have to dig around and ask their coaches.)

My dad kept track of *everything*—even before it was technically necessary. A lot of times, when you're younger, they don't really keep track of your times. But my dad would be on the side of the hill, timing me and offering advice. He wasn't overbearing at all—he wasn't in anyone's business, like one of those obnoxious Little League dads. He was actually pretty reserved. He was just thorough. After every run, he gave me a gauge. Was I too fast? Was I too slow? Where was I making mistakes? How was I finishing? I always knew where I stood.

It wasn't only my performance he was concerned with. He always kept his eye on the competition. What were the kids doing who were one, two, three years older than me? How could I get to the next level? What was missing from my repertoire that I would have to train hard to master? When we sat down to study our plan, we discussed other girls my age who were skiing well in different parts of the country. We mapped out who I needed to look out for and which races I needed to enter.

When I started beating everyone in my age group—the nine-to-twelve-year-olds—my dad got me bumped up to the next bracket, so I would have tougher competition. It was great, even if it meant that I wasn't around kids who were my own age.

He was perpetually looking ahead, always looking for ways to improve. He bought me tapes of the World Cup winning

runs, which was the only way you could watch skiing back then, unless it was an Olympic year. I watched them intently, looking for anything I could use to help me with my strategy or technique. He taught me how to wax my skis and sharpen my edges, although he would continue to help me with this whenever he had the chance. He even got me set up with my first sponsorship deal.

As it turned out, a Rossignol rep named Thor Verdonk had seen me skiing at Mount Hood. He and my dad got to talking, and the next thing I knew, Rossignol agreed to outfit me with some free gear and offered a discount on everything else. I went on to ski with Rossignol for many years, until I switched to Head in 2009.

My dad also had a different philosophy when it came to things like nutrition. Back then, I used to eat a shit ton of pasta before my races, and he was the first person to say, "It sticks to you. It weighs you down." Sure enough, later in my career, I changed the way I ate before a race (usually eggs or a protein shake) and discovered he was right. When I first started going to Europe for training and racing, he got me a fanny pack for my water bottle and snacks, so I would stay hydrated on the hill. A lot of the time while you're training, you're not eating and drinking, so he gave me protein bars so I wouldn't get hungry. In that way, he was ahead of his time. Now, of course, this seems obvious, but no one was doing that at the time. General wellness wasn't a thing back then the way it is now.

We also took a different approach when it came to fitness. With my father's guidance, I focused on how to be a better athlete, outside of skiing. When I was around thirteen, I started trying to make the U.S. Ski Team development team (which I did, a year later). There is this thing called the Medals Test, where you have to do the mile, the one hundred, the four-forty, box jump, hex jump, push-ups, sit-ups . . . a whole array of dif-

ferent exercises. So, we would train for that. I would do a hundred push-ups and sit-ups a day. Every weekend, I would run a mile on the track. (Even though I hated running, something that has always physically hurt me.) What twelve-year-old wants to run a mile every weekend? No one. But I inherited my dad's and my grandfather's mentality—if you want to do something, then you do it. You work hard for it, and you don't complain.

We even found a trainer at the local health club, where I started weight training. I didn't really know what I was doing—I honestly can't tell you if I was working hard, because I was so young, I don't remember. But it definitely set the tone for becoming a stronger athlete—if you want to be better, you have to work both on the hill and off it.

All of these changes in priorities and focus were just a prelude to the bigger sacrifices to come. By the time I was twelve, my plan to become an Olympic skier was well underway, and it was then that my dad announced if I was *really* serious about being a skier, I needed to go to Colorado. Vail had the best program in the country for young racers in all disciplines, so if I ever wanted to be taken seriously at more than just slalom, that's where I needed to train. In order to grow as a skier, I would have to learn to ski speed, even if it meant moving to a different state.

I honestly didn't know that was the plan, although I suppose it wasn't a huge surprise. All along, I figured that eventually I would need to train at a higher altitude, with longer runs and more challenging terrain. Still, the news was a lot to process— it's one thing to know about some distant eventuality and quite another for it to become real. But if I was going to make it to the Olympics, Vail was the place to be.

Initially, only my mom and I went out there, where we lived in a little apartment in town. We stayed there for a couple of months while my dad took care of the rest of the kids at home.

Every time I had a race, I would travel with Ski Club Vail. We'd go down to Telluride or Winter Park or Steamboat, while my mom stayed back at the apartment.

The next year, my mom and I went back to Vail, where we extended our stay by a few months. This time, Karin and Reed came out there with us, while Dylan and Laura stayed back in Minnesota with my dad. For Karin and Reed, I know that was a pretty anxious time. They'd never gone to school in Vail before and the change happened pretty abruptly. My dad was still working in Minnesota, but as I went to more and more races, he would often try to come, so he could tune my skis and keep an eye on me (and the competition). It was his passion, too, so of course he wanted to be there as much as he possibly could.

In the end, a few weeks in Colorado turned into a few months, which turned into forever. Finally, it got to the point where we couldn't have a big house in Minnesota if no one was there. Vail is not a cheap place to live, so my parents had to make a decision. They decided the whole family would move to Colorado, permanently—a choice that was made without consulting us. In fact, they didn't say anything about it until they had already sold the house. My parents sat us all down one night after dinner and told us they had some news. We were under the impression that Vail was only temporary, so all of us were stunned. As soon as the words were out, my siblings and I burst into tears.

It was a dramatic moment in the life of our family. This wasn't what I had in mind when I said I wanted to get to the Olympics. It seemed such a harsh punishment for everyone in service to my goal. We loved that house, we grew up in that house, and suddenly, without a goodbye, it was gone. It was also rough having all these plans decided for you—especially the younger kids who didn't quite grasp that my overarching goal had turned into the family's. When we were all cried out, I

looked up and saw that my mother had been crying right along with us.

At first, all seven of us lived in a three-bedroom condo. The kitchen setup was more like a vacation rental than a home, with a mini-fridge and a two-burner stove. We would take turns sharing the beds—I shared a bedroom with Karin and Laura that only fit two beds, and we would draw straws to see who got to sleep solo. It worked for a while, and the next year we found a slightly bigger apartment. Two years after that, we got a town house where we stayed for the next few years.

Moving was emotional for all of us, but it was hardest on my siblings, who didn't want to leave Minnesota. The whole family had relocated so that I could ski, and that was difficult for me to live with. I didn't want to be the reason that everything changed. I didn't want to be the reason everyone was uprooted from their lives. My family mostly liked it in Vail, but it was easier for some of my siblings than for others. It wasn't a situation they chose, and some of them didn't make friends easily. Despite their troubles, my dad always said, "It's not hard to live in Vail." He'd remind us that it was a privilege to be there, and that it was a place where a lot of people wished they could live. And throughout all the tumult and uncertainty, there was always something comforting about the fact that we were together. Wherever we were, my siblings and I remained a unit, able to transform our home into our own little world.

Whatever we lacked in a living situation, Vail more than made up for in skiing. During the season, Ski Club Vail took up all day Saturday and Sunday, plus after school on Wednesdays and Fridays. It was difficult at first, because at the time I was skiing better than anyone my age, so I got put into training with the older kids. I was this nerdy twelve-year-old skiing with girls—and boys—who were four, five, six years older than me, and I definitely didn't fit in.

Though it wasn't easy socially, I loved skiing there. It was great training, and by every outward measure, I was thriving. I really liked some of my coaches, and I learned a ton. More than anything, I learned how to ski speed. Normally, when you're speed training, you don't get a ton of reps, because the course is difficult to set up and it takes a lot of coaching staff. It also takes a certain mountain. In Vail, we had all of that. It's pretty rare to get to experience that, especially at a young age, and honing my speed skills there definitely paid off later.

Moving to Colorado was the beginning of a shift for me. I was expanding my skill set and becoming a more well-rounded skier, improving quickly. But it all came at a cost to our family. When my father and I had embarked on this goal, I'd always thought of it in terms of what I had to sacrifice to get there—time, sleep, friends. Prior to my family's uprooting to move to Colorado, it never occurred to me that my sacrifice would become everyone's. Often when my siblings had a hard time, I felt guilty that it was my fault, which put a lot of pressure on me. Suddenly, there were actual stakes to the choices I had made, and I could see them firsthand when one of my siblings had a bad day at school. Failure or disappointment on the hill now meant something that it hadn't just a few months earlier. Everyone had changed their lives for me; I needed to win—not just for me, but for them.

Until then my *why?* when it came to skiing had always been about me; now it was also about my family.

CHAPTER FIVE

From the moment we drove up to the Holiday Inn, I could feel a buzz in the air. From the back row of a passenger van, surrounded by a dozen other kids bound for Erich's ski camp, I gazed out the smudgy, tinted windows at Mount Hood, Oregon, which would be my home for the summer. For weeks, I'd been excited for camp, a chance to hone my skills and ski in a new setting. I'd firmly established myself as one of the fastest kids at Buck Hill, and I expected this would be no different.

As I unloaded my bag from the back of the van, I looked across the parking lot over to a where a group of kids—a few boys and one girl—was playing a game of hackie sack on the lawn. I stood, watching them kick the little bag back and forth, and my stomach dropped. The girl was beautiful, with chestnut-brown hair and blue eyes. As she laughed, effortlessly holding her own with this group of boys, it was clear that she carried herself with confidence (something I couldn't say for myself, especially when it came to casual social interactions). Though it

was the first time I'd seen her, I knew exactly who she was. Her name was Julia Mancuso, and at that point, all eyes were on her.

Erich's ski camp was widely regarded as the premier summer ski camp in the country, and since anyone could sign up, there were kids from the East Coast, the West Coast, and all over Europe. This also meant that all the best young skiers my dad had been keeping track of would be there, including Julia. Before I left for camp, he said, "Keep an eye out for Julia. See what she's like and how good she is." It seemed I wouldn't need to look very far.

To my twelve-year-old eyes, everything about Julia was just so *cool*. She was one of the West Coast kids, from Squaw Valley, California. She was pretty, she was talented, and she had big boobs, which was a huge deal at that age. Even though she was only seven months older than I was, Julia had a sophisticated air that made her seem more adult, and thus more intimidating, than any of the other kids. She marched to the beat of her own drum, and all the boys followed—for years, every boy I had a crush on always liked Julia. Up until that point, I thought I was decently cool (at least when it came to my Minnesota clique), but as soon as I met her, it became clear to me that I was not. I was shy, I had a perm, and I was just finding my footing. Whenever I was around Julia—which was pretty much all the time—I felt my bubble burst, my confidence deflate. Everyone knew me well enough to know that I was good at skiing, but the social scene really wasn't my thing.

One night, a few of us went to the indoor hot tub at the Holiday Inn, one of those rank indoor tiled situations. Julia wasn't there, but I was with some of the other girls who made up the cool group. I stuffed my bra, because I was trying to be like Julia, and while I was in the hot tub, one of my tissues came floating out. It was horrifying. Word got out, and from that point on, I was officially not cool.

Normally, at Buck Hill, I liked being the first person on the

course, but as soon as I got to Mount Hood, I developed a habit of waiting behind so I could see Julia ski. Over the course of that summer, I watched her like a hawk. She had a much different technique than most, which was driven by her unbelievable athleticism. Erich loved the fast kids, and he always praised Julia for her speed. It felt like every time she skied, he'd look up from his stopwatch beaming. In hindsight, he didn't offer Julia any higher praise than he gave me, but it bothered me all the same. I wasn't used to sharing the spotlight.

Whenever my dad called to check in, the conversation involved Julia. Erich told him that Julia was a competitor for me, which only made my dad track her performance more closely. From that point on, my dad offered me specific guidance on how to beat her, cementing the rivalry even further.

Julia wasn't only beloved by the kids our age, she was popular with the other kids in the first ski group—the fastest group—all of whom were older. That was the ultimate stamp of approval, like getting a seat at the cool kids' table. She was mature, she was sophisticated, she passed. Maybe it's because girls mature faster than boys, but the social dynamics were definitely different for us at this age than they were for the guys. The boys all seemed to be good friends, their relationships not tainted by the intensity of competition or comparison, on or off the hill.

Meanwhile, it felt like being fast was the only thing I had going for me. That was my "in"—what got me into the first group of skiers and helped bring me into the fold. My speed was the only thing that offered me a taste of how it felt to be accepted, so everything hinged on maintaining it.

When it came to Julia, there were so many things stacked against me. The biggest one was that, in terms of skiing, she was definitely ahead of me at the time. I was still trying to figure out my balance and my height. We both made the National Development Team the year I was fourteen, which coincided with a major

growth spurt for me. I grew a foot in a year and had literal growing pains—my knees hurt, and I got hairline fractures in my heel and ankle bones from all the running I was doing.

Meanwhile, everyone pegged her as the next big thing. She was on fire at such a young age, and I was an afterthought in comparison. In those early days on the team, no one paid too much attention to me, because they didn't really think I was going to be anything. They already had their golden goose.

I think everyone has someone like this come into their lives around this age, a person who, perhaps through no fault of their own, just makes you feel . . . differently about yourself, more critical, somehow less than. A person who makes you doubt yourself before you've even figured out who you are. Part of it was that I was actively competing against her, but also, being a teenager makes it impossible not to spend time comparing yourself to others. Meeting Julia was important not only because she'd been tagged as the next big thing, but also because, at the age when I met her, I was particularly vulnerable to all these insecurities.

It didn't help that Julia and I started to have frequent run-ins. Unlike normal high school, when you might see this person in the hall every now and then or across the room at a party, she and I would be together constantly over the next few years. And almost always the goal was literally to rank and compare us, to dissect our skill sets and hold them up to the light. In a competitive sport like ours that kind of comparison is not only inevitable, it's essential. Coaches and decision makers need to figure out who is better on the hill, and the only way to do that is through constant evaluation and assessment. And yet, for a teenager struggling with the natural uneasiness that comes with figuring out your mind and your body, that constant judgment takes a toll that only winning can overcome. Unfortunately, even winning doesn't always solve everything, as I learned the hard way.

When you're on a ski team, butting heads is inevitable. You're

with a group of ten to twelve girls you don't know, and from the moment you meet them, you're around each other all the time. You're traveling together. You're eating together. Most of the time, you're also rooming together. You're inherently going to like some and not get along with others. As you can imagine, it's not exactly a friendship-bracelets-and-hair-braiding situation.

The tricky thing about skiing is that it has all the competitiveness of an individual sport, but you're still thrown together with a team. There's team meeting, team breakfast, team dinner. You travel together in the team van, where you have to navigate who gets shotgun. You still have all these team dynamics, but at the same time, you're directly competing against each other. It gets even crazier when it's the World Championships, where only six out of twelve people will go on to the Olympics. As you can imagine, things can get pretty dicey.

In my experience, team dynamics are even harder to navigate when you're with a group of women. Women can be a complicated bunch. If guys have a conflict, often they'll talk to each other and address it head-on. They'll have a fight in the locker room, and then afterward be like, "Bro, we're good." Women aren't as up front. With women, there's more of a brewing animosity. Sometimes it gets resolved . . . and sometimes it doesn't.

In the beginning of my career, I got picked on more often than not. During my first ski camp with the U.S. Ski Team, I was fourteen, and I was living and training with people who were eighteen, nineteen, twenty. They made all these jokes and I didn't have any idea what they were talking about. Then they laughed at me because I didn't know. I just smiled and laughed in return, because I didn't know what else to do. Then I would go to the gas station and buy a pint of Häagen-Dazs to eat by myself for lunch.

When I first made it onto the team at age fourteen and for the next couple of years, I was the little runt and I had no say. I

was quiet, I tried not to buck the system, and I fell in line. Once you start racing, almost everything is based on your ranking. For junior members, things like who you're rooming with or what van you travel in are never up to you. The top four girls get their own rooms or at least get to decide who they room with. Otherwise, the coaches try to pair personalities together. Back when the team didn't have as much money, we almost always had to room with somebody.

Some people go to bed right at 8:00 P.M., and some stay up late.

Some snore. Some have night terrors.

If you turn the light on after dark, some people are going to yell at you.

If your roommate had a boyfriend visiting, as you can imagine, that was the worst.

You name it, I've experienced it.

When you go to Europe as a junior team member, you're sitting next to the toilet on the bus. There is no choice in the matter. If it wasn't a bus, we had these crappy vans that barely functioned in the snow. It was always the physical therapists who drove the vans, because they were the oldest people around. (No offense to all the PTs out there, but in my personal experience, I have not known one PT who can drive a stick, or even drive well, for that matter.) Because the vans were so shitty, we had to put chains on the tires. Picture it: seven high-school-age girls and one adult man trying to figure out how to get chains on the car in a mountain pass. Occasionally, someone knew what they were doing, like my teammate Stacey Cook, who'd be under the wheel killing it.

Basically, traveling with the U.S. Ski Team is like a family adventure, albeit with a weird, blended family. Unlike the Europeans, who could drive in with their technician from whatever hometown, have the race, and drive home, we were constantly

on the road. We each arrived in Europe with six to nine ski bags and two duffel bags, and we never got to go home until the season was over. For this same reason, European skiers got to see their families and celebrate holidays with them, while some of us Americans would go years without being home for Christmas—in my case fifteen years. I always thought it was much, much harder for Americans to be successful for that reason alone.

As much as butting heads is inevitable, if you get along, you can also become really close with people. We used to have so much fun. There were a lot of pranks on the road, and I did a couple of things that were probably not cool. For a while, Sarah Schleper and I were the troublemakers. I went with her to Mount Hood camps, where she was Erich's other beloved student. My first year on the ski team, she tortured me. She would randomly tell me to drop and give her twenty. We had pull-up competitions, which weren't much in the way of competition, because I could only do around four and she could do twenty. She loved to test me.

Now, though, everything on the team is different. Everyone is a little more uptight. These days, everyone is specialized, and they have their own coach and their own trainer by the time they're fourteen years old. There's not much training done as a team anymore; everyone does their own thing. In general, the way sports have evolved for kids takes some of the fun out of it, and skiing is definitely going in that direction.

As the sport has gotten more popular, it's also gotten more money infused into it. So, in some ways, things became much easier, which is incredible to see. No one travels together; everyone has their own car. Eventually, the team got sponsored by Audi, so we had a bunch of Audis, which was awesome. (Of course, we got Range Rovers right as I was leaving, which I was extremely jealous of.) The girls on the team today have no idea

what it was like for us, just as we had no idea what it was like for everyone who came before us.

Even with all the interpersonal stuff back then, I enjoyed traveling together, because it helped to mitigate being away from home for so long. During my early years, I adored the other girls on the team. Jonna Mendes, Caroline Lalive, Kirsten Clark—those girls were great to me. It felt like I had a second family during all those months on the road. But when they retired, I didn't find another friend group for years. From about age twenty to twenty-five, it would be fair to say I didn't have any friends on the ski team.

Looking back now, that was definitely my fault. Because of my competitive nature, I tended to see the other girls as rivals, which only further complicated any potential friendships. While I'm sure everyone recognized that rivalry even between friends was essential to such a charged atmosphere, it grew more complex for me since I wasn't that social to begin with. I often felt like I didn't belong, and at a certain point, trying didn't seem worth the effort. So instead, I decided I'd rather just win, figuring I could forge my own path to acceptance by winning. But because I didn't let anyone get close to me, when I started to see success, not everyone was happy.

You know how when you're a teenager, you don't know a lot, but you think you do? Well, I didn't grow out of a lot of these feelings until my mid-twenties. I walked around with a chip on my shoulder for a long time, because I felt like an outcast. Finally, one day, a teammate pulled me over and told me I was standoffish. "Wait. What?" I said. I couldn't have been more surprised. I didn't have the self-awareness to see how I came off. I was hypercompetitive, and also afraid to be vulnerable, so I put up this wall where I didn't invite people in. If you combine that with arrogance, well, you get somebody who nobody wants to talk to.

All along, I'd told myself a story that wasn't even true. Ironi-

cally, I'd always prided myself on being nice to people. I'm from Minnesota, where people are pathologically nice. ("Minnesota nice" is a stereotype for a reason.) I tried to treat people well, and for the most part, I think I did, but I wasn't warm or open or inviting.

In my mid-twenties, after my teammate's admission and a lot of reflection, I finally realized I needed to become a good teammate. I began to approach the other girls with open eyes and an open heart, which was both a worthwhile and necessary experience for me. Eventually, as I began to open up, I came to understand how important teammates are. I had always thought of skiing as an individual sport—and it is—but over time, I saw that we were part of a larger whole. As with any group, each member's well-being was connected to everyone else's. The more we helped each other out, the more it lifted the entire team. That was a long personal-growth journey for me, figuring that out. But the more I became a leader, the more success we had as a team—and the more fun we had, too.

From age twenty-six until I retired at thirty-four, those were good years, where I had amazing teammates and we all felt supported. Together, as a group, we built an extremely successful downhill team, which was pretty cool. Sometimes I wish I could take back the way I acted in those early years, because with a little more awareness, I think I could have had a much better time. As I've since discovered, whether you're winning or losing, everything is so much nicer when you have friends.

It's safe to say I made a lot of social missteps that I didn't understand until later in life. But in my defense, I never got to have those typical formative experiences, like dating or going to school. I was never exposed to much outside of skiing, so my social experiences were all limited to this extreme, highly specific bubble. The absence of school in particular proved challenging. When I moved down to Vail, I was officially too young for the ski

academy—I was the only middle schooler in the academy, where you weren't supposed to enroll until high school—so I did home-schooling for two years. Homeschooling basically consisted of my dad going to the college bookstore and buying me *The Great Gatsby* and some college textbooks. The ski academy teachers gave me a curriculum, and I did my best to follow it.

When I was old enough to start high school, I enrolled through the Vail Ski Academy. The way it worked is you went to regular high school for the first quarter, then to the academy to continue your curriculum throughout the ski season, and then finally you returned to regular high school for the last quarter. While you're at the academy, you go to school in the morning and ski in the afternoon.

It was difficult to manage, both socially and academically. You couldn't really make friends at regular high school, because you were gone for half the year. And it was hard to juggle both classes and skiing, especially with all the bouncing around. After two years of that, the administrators at Battle Mountain High School sat my mom and me down and told us I didn't meet the Colorado state requirements for attendance, even with the academy. I needed to accrue a certain number of school hours, but I wasn't able to meet them because I'd been racing the entire time. "Am I getting kicked out of school?" I asked. It seemed hard to believe. The whole reason we had gone through the academy was to avoid this situation. And yet, there we were.

Since the current plan clearly wasn't working, they said I would need to find another form of schooling. We heard there were some good online options, so I just picked one that I thought looked good: the University of Missouri Columbia High School. For the next two years, I took online classes, essentially following along with a syllabus. It took me many hours to make my way through it, because I had to do so much reading. Unless you're a schoolteacher, you don't realize how much work teachers

do behind the scenes—lesson planning, picking and choosing exactly what to cover and how to present it. Without someone to guide me, it was a lot to manage.

A few years later, in 2002, I decided to take the GED and just be done with it. I never told anyone about it—I just did it. To be honest, now I'm kind of embarrassed that I did it that way. All the other skiers I knew went through the academy, and everywhere I looked, I saw other athletes who had a better education than I did. But it was a weird juncture in my life. There was a lot going on that year, in terms of both skiing and my personal life, and it was difficult to factor everything in. Taking the GED seemed like the path of least resistance, a way to check something off and put that one part of my life behind me.

Through high school, ski team, and all of the new experiences on and off the slope, my focus remained on making the Olympic team in 2002, and I definitely put my education on the back burner. In service to my career as a skier, I just did what I had to do. But I was always disappointed that no one helped me. My parents tried, but there wasn't much they could do when I was always traveling. I wanted to finish high school, but I didn't know how to get it done. There was no program, no structured system. No one on the team ever asked about my schooling or offered any kind of support. The whole thing was difficult— it's hard for me to admit even now. Of course, I wish I'd had a real education, with real teachers, and a normal social life. But I wanted something else. As I have learned throughout my life, there were only two options, it was either skiing or . . . and I always chose skiing.

Off the hill, this was one of my lowest points, at least where confidence was concerned. I often felt like I was sinking, with no idea how to get back to solid ground. On the hill, however, skiing offered me a sense of security at a time when I couldn't find it anywhere else. Whenever I called my dad, no matter what else

was going on in our lives, skiing was always the topic. It was the stabilizer, the balm for my frustrations, and a subject on which he was calming and reassuring. He was always ready with a confidence boost whenever I needed it.

"You're better," my dad would say, if I fell into a spiral of comparison. "Remember, you've worked harder than anyone." One thing about my dad is that he's always so assured in his delivery. He believes what he says, so much so that you can't help but believe it, too. If he told me I was on the right path, I must be. If he told me I was skiing well, I accepted his words as truth.

No matter how messy or frustrating life felt, on the hill I felt invincible. In the early part of my career, the only thing that offered me any sense of approval, both socially and with my coaches, was the fact that I was fast, and I leaned on it to give me a sense of purpose and belonging. The more I focused on racing, the faster I skied and the better I felt. I suppose it's not surprising that from that point forward, it became my singular focus.

This is the biggest race you've encountered at this point," my dad said, his voice serious. "Everything is riding on this. If you win, it will have a huge impact on your career."

The race in question was the Trofeo Topolino di Sci Alpino, arguably the most important international race for junior racers. It's held in Italy every year, in partnership with Disney, and it brings together some of the best young racers from all over the world.

I felt a lot of pressure. I had been told over and over again that this was the most meaningful race I'd skied at that point. I went to Topolino twice—1998 and 1999, when I was thirteen and fourteen—and both times, my dad presented a strong case for how much it mattered. He went through all the past results and showed me how this person won Topolino and went on to be an Olympic champion . . . this person won Topolino and went

on to win the overall title three times. . . . It was pretty hard evidence that if you won this race, you would go on to be successful. So, I knew what I needed to do.

In 1998, when I first qualified for Topolino, the organizers of the race made an exception for me. I was thirteen, and at the time, they didn't let racers that young in. We made a fun family trip out of it—my grandpa even came along, which was the only time besides the Korean War that he left the country. That year, I managed a second-place finish.

In 1999, I made it in for the second year in a row, and this time, it felt like an even bigger challenge. All six members of the U.S. team at that time—three boys and three girls, including me and Julia—dreamed of making it to the Olympics one day, and we knew this was a chance to prove ourselves. Even more than the previous year, I felt a ton of pressure to win. My dad told me this was a "make or break" moment, and I took that to heart.

After the first run, I was in second place. As I stepped into the starting gate for my second run, my nerves were at an all-time high. We're talking the kind of nerves where I was actually shaking. By this point, though, I knew enough about myself to recognize that when I was nervous, I didn't ski well.

When I was a junior racer, everything seemed pretty easy. I just skied, and things went well. But as I got older and began to realize how important each race was, I started putting more and more pressure on myself. Learning to calm my nerves was a process of trial and error. At Buck Hill and Mount Hood, where the people with the best points would train with the first group, there was always a certain amount of pressure to keep up. I studied the pressure I felt in those situations—along with the pressure of having Erich and my dad watch me—and used it as a sort of template. I observed what I was thinking when I had a good run. How did I feel? What did I do differently? Then I would try to repeat it. I learned to analyze my own psychology,

figuring out what makes me tick. I saw that when I skied well, my mind was clear.

This realization was a turning point for me. I saw firsthand how important it is to harness your anxiety and to clear your mind. When you step into the gate, you want to be completely in the moment. Before my second run, I told myself over and over *I can do it*. I did my best to clear my mind and focus on my breathing. And then I just skied.

It worked. I won the race at Topolino that year, which made me the first U.S. female ever to do so. But I walked away from that race with more than a first-place finish. I was one step closer to a strategy I would use for the rest of my career.

Focusing on myself, on what I could control, was always a struggle for me as a young skier. So much of reducing anxiety in skiing was about accepting that I could only control how I skied. In the end, that was the only element that I could dictate entirely on my own. There had been times before then that I'd been so focused on what other people—most notably Julia—were doing that I failed to focus on me, on my race. Now I understood clearly that I couldn't will anyone else to go slower by obsessively comparing myself to them, but I could find the ways to make myself faster by skiing more calmly. It was a crucial realization, and ultimately, my rivalry with Julia was instrumental in helping me see it.

I would think back on this race a lot in the years that followed. It was a huge, international race, and I—not Julia, not anyone else—was the person who had won it. "If you can win this race, you'll be on a good path," my dad had said. If ever I started to feel doubt, I heard his words in my head while I grasped, white-knuckled, to the belief that I was going to come out on top.

CHAPTER SIX

don't know what to do," I said.

"Just ski," was the reply from my ski rep, Thor Verdonk.

When he'd spotted me at Mount Hood and worked out the deal for Rossignol to be my ski sponsor, Thor was one of the first people who saw something in me. He helped me see myself as a professional skier. Before a race, if you don't already have your own technician, your ski company rep is usually the one who helps you tune your skis and get into your bindings, so he was with me before a lot of my early races. As a result, Thor was also pretty good at calming me down, which I needed just then because I was standing at the starting gate for my first World Cup race, more nervous than I've ever been in my life.

My first World Cup race was huge for me because in international ski racing, the World Cup circuit is the biggest deal. A lot of people, especially in the U.S., think that skiers only compete at the Olympics and maybe the World Championships,

but the World Cup is really what most racers focus on. In many ways, the World Cup is what counts most.

My first race was in Park City, Utah, which was about as close as you could possibly come to a home court advantage. A typical World Cup event had hundreds of thousands of fans, and this time, that included my whole family—my parents, my siblings, both sets of grandparents. My family didn't normally come to my races, especially my mom's parents, Grandpa Herb and Grandma Mary. But everyone came out for this one.

Julia had already been racing World Cup for a full year at that point, so I felt pretty behind. I had a bad starting number and obviously no experience. But on the upside, it was a good hill for me—steep on the top, flat on the bottom, where I hoped my Buck Hill experience would help make up the difference.

At sixteen, I was the youngest skier in a field of about seventy racers. Since it was one of the bigger races for me at the time, I knew I had to impress people if I wanted to make the Olympics the following year. Up until that point, I'd have these little bursts of good results, sprinkled in among a bunch of DNFs, or races I didn't finish. I was always in the top twenty or thirty, chipping away at my ranking, trying my hardest to prove that I belonged.

It was a lot of pressure, and despite my best efforts to tune it all out, it was a level of anxiety unlike anything I'd felt previously. The past couple of years I'd spent gaining experience and improving, but more than anything else, I was learning. When you're skiing at that level at such a young age, so much of what you're doing is learning all the time. Learning how to deal with pain. Learning how to deal with anxiety. Learning how to win. You don't have the routines and self-talk to minimize anxiety and maintain mental strength, so you're constantly testing out new strategies. Seeing what works, what doesn't. Of course, often I didn't actually know that was what I was doing. I was just trying to improve.

But when you encounter something new—whether it's the hill, the conditions, or the moment—you don't have experience to fall back on to calm yourself. At that age, I was building the habits that would support me in the future. I had to discover them myself. And that was where I found myself that morning, talking with Thor, remembering my past, and getting ready to drop into my future.

The first time I got injured was at age twelve. I was at the Whistler Cup in 1997, one of the biggest international races for kids, in (you guessed it) Whistler, British Columbia. Tina Maze won every race that year as well as the overall title. I was second in slalom, and then in GS, I fell and hyperextended my knee. I wound up with a tibial plateau fracture on my left knee and was on crutches for a long time. My injury happened in February, and that following summer was when we officially moved to Vail. I remember hopping around on one leg in the apartment building, doing the best I could.

That was my first experience with rehab and having to pass a bunch of tests in order to get clearance to ski again. The guy who did my rehab was named J.A. He also trained the U.S. Ski Team for a number of years, so he didn't hold back.

"I used to make the girls run up the stadium steps ten times a day," he said.

"Okay, sir, just tell me what to do," I said. "You want me to do a single leg squat for three minutes? I can try!"

He was pretty aggressive, but I made it work—most important, he made me accountable. The upside was that he had me working so hard, I could eat pints of ice cream and still lose weight. (My metabolism has always responded pretty well to ice cream, though, which is a good thing, because I love it.)

But that first injury was the start of a mental approach I'd need plenty throughout my career: Whenever I was injured,

my internal drive shifted. I decided I could overcome anything, and I could do whatever I set my mind to. Skiing was the one thing I had that was mine, and no one could take it away from me. In those moments, it became about not giving up, fighting through it, and not letting anyone tell me what to do. Every time I got injured, the process was the same: I dug into myself and found a way to keep going.

One thing my dad always drove home was this idea of mental toughness. *Mental toughness, mental toughness.* It got to the point where I was like, "If you say 'mental toughness' one more time . . ." It didn't make much sense until I got injured, but from then on, the older I got, the more I understood what he meant and how I could use it to my advantage.

In essence, mental toughness for me became *shut up and do the work.* The weather is bad? So what? When I go on the mountain, my knee doesn't hurt. This is the line I want to take, this is what I want to do, and now I'm going to go do it. It's almost like *Rocky.* Whatever challenge you're up against, whether it's the media pressure, the course, the weather, the competition, your own body . . . you cannot let it get to you. *You* are in control. That's what mental toughness is to me. With practice, I learned to channel my thoughts in the right way, to stay focused, to be stronger than whatever was happening around me.

That would serve me well, particularly when it came to Julia.

After a few years of knowing each other, Julia and I tried to get closer. One time, she invited me to her house in Squaw Valley, which I took as a sign that she wanted to be my friend, and I was excited. From the moment I arrived, I was trying my best to fit in, which for me meant I was pretty quiet the whole time. Whenever I'm not comfortable, that's usually my default reaction—I just stop talking.

As part of our training, we decided to go for a long bike ride with her father. Pretty much as soon as we started riding, Julia and her dad tore off ahead of me, leaving me in the dust. I had never been to Squaw before, and I had no idea where they were going, or if they planned to come back. They didn't tell me what to do if we got separated. I just kept pedaling as hard as I could to keep up with them, until they disappeared on the horizon.

I wasn't scared, but I was worried. I didn't have a cell phone and I didn't know the area. I rode in frustration for a couple of miles, then got off the bike and sat by the side of the road. There was this big open vista, and I could see for miles in every direction, but I didn't see any cyclists. I figured Julia and her father would have to circle back this way at some point, and I was right, eventually they did. But it took a while. And while I was waiting, I started to feel pissed.

I thought this trip was about trying to be friends, and instead it felt like I was being put in my place. To be fair, we were young, and we were competitors, and that rivalry made friendship tricky. I understood that just as well as she did—it was a hard thing to navigate. But I still couldn't help but feel like I was being sized up.

When Julia finally rolled up to where I was sitting, she said, "Hey, what happened to you?" Like I was the one who had disappeared. Apparently, they stopped at a Starbucks in the next town, where they realized they had left me in their wake.

That was the tipping point for me. I'd spent so much time chasing her, literally and figuratively, and I didn't want to do it anymore. I realized I had a choice: to keep running after Julia, or to focus on myself. It was time to pursue my own goals. Ultimately, that trip to Squaw was a good experience, because it inspired me to usher in a new way of thinking. After that day, I started the hard work of learning how to be myself. I tried to let

go of my attempt to be "cool" and focused on what I was there to do—to ski fast and enjoy it.

"Just ski."

At the top of the hill, my first World Cup race waiting beneath me, the words still rang in my head minutes after he'd said them. And Thor was right, of course. The pressure, the anxiety, that was clutter that needed to be discarded. Skiing was all that mattered.

They were simple words of advice, but they did the trick.

I'd love to say that I followed his suggestion and made the podium with the echo of that simple message following me down the hill. But that was rarely how it went for me—there was never a finger-snap solution or a magical race where I suddenly became a different skier. I always had to work for it; success was always a process, steady and incremental. And my first World Cup was no different.

I skied horribly at the top—a little too conservatively—but my Buck Hill skills came into play in the flat, as I knew they would. Still, it wasn't quite enough to make up the time. I finished in thirty-first place, two-hundredths shy of qualifying.

So yeah, my first World Cup race wasn't this huge, spectacular thing. But it was what I needed it to be, a chance to learn, a chance to improve how I dealt with anxiety. I proved to everyone that I had skills and a certain amount of speed, which was important to show the coaches. More than anything, though, I proved it to myself. And it marked the start of the next phase. From that point forward, I knew how it felt to compete on the World Cup stage—to race in front of a crowd, to hold up my skis at the finish with all these TV cameras pointing at my face, to be a real, honest-to-goodness professional skier. That race marked the start of the next phase—I was on the ascent, and even if I was the only person who saw it, that was okay. My hill was the only one that mattered.

CHAPTER SEVEN

It wasn't necessarily the first thing I thought about when I woke up, but if it wasn't the second, it was definitely the third. And by the time I'd look at myself in the bathroom mirror, it would be staring back at me—the Olympics.

Just about everything in my life at that time was in service to this goal my dad and I had set: getting to the 2002 games. It was all consuming. Sometimes thinking about it would produce specific thoughts and feelings. Sometimes the word would just sort of hang in the air above me, a permanent thought bubble over my head.

And yet, the planning behind it had been so long term, the goal itself so large and looming, that as the games got closer it became hard to adjust to the shift in immediacy. Something that for years had been in the distant future was now staring me in the face, just a year away. I was racing well. Steadily improving enough that I was definitely in the conversation for the games, but actually skiing in them was far from assured.

The U.S. Ski Team had a whole complex in Park City, Utah, where its national office is located. The idea was that everyone on the team was required to live there for these summer training camps. It was a good way for the team officials to keep everything centralized and also to keep tabs on us—what we were up to, who was in shape, how we were performing. The downside was that although living there was necessary, we were expected to cover our own food and rent, and money was tight.

I first moved there in the summer of 2001, when I was sixteen years old. To be perfectly honest, when I arrived in Park City, I didn't really like it. I wasn't alone in feeling that way—I think the fact that it was mandatory for everyone to spend a minimum amount of time there turned a lot of people off. This was especially true for the older girls, many of whom had boyfriends and husbands back home and didn't want to spend their only time off in Park City.

On the positive side, I did like that there were so many people from the ski team there. It was a good chance to be social with my teammates and to get to know people outside of just competing with them. I can be very single-minded and I'm obviously very competitive, so in those early days on the team, I may not have given the exact impression that I wanted to be friends with my teammates. But ironically, that's all I wanted.

Living in Park City was also a good growing-up experience for me. After so much time on the road, I was used to being away from home, but traveling with the team is different than living alone. I'd never had my own apartment or condo before, never needed to manage my own time or complete the mundane tasks of adulthood. Emotionally, I still wasn't quite an adult—I had a ways to go before I felt that sense of responsibility and accountability—but it was my first real step in that direction.

In Park City, I was surrounded by racers. The whole town

revolved around skiing, so being there kept skiing at the top of my mind. With so many of my teammates there, it felt fully immersive. We trained together, we socialized together. You couldn't help but feel like a real, honest-to-goodness skier, especially when there wasn't the time or space to be anything else.

That kind of an environment, especially six months before the Olympics, tends to bring out the hypercompetitiveness in everyone. After years of talk and speculation, when you're that close to the actual games, people start having discussions about who's got it and who doesn't. Those discussions lead to decisions that can make or break careers.

A few months later, in the lead-up to the 2002 Olympics, I overhead my coaches talking about me. The team was staying in a hotel in Austria when late one night, I heard familiar voices echoing from out in the hallway. I pressed my ear against the hotel room door and heard my coaches discussing the girls who were in the running to make the Olympic team. My chest tightened as I heard them say a string of horrible things about me, culminating in, "Lindsey's not going to make it."

It was brutal. That would have been bad enough, until they got to the second part of the conversation.

"Let's focus our efforts on Julia."

I couldn't believe what I was hearing. Sure, I wasn't winning—I was barely getting on podiums—but no one on our team was winning, and Julia was skiing only slightly better than I was. I was new on the World Cup circuit, and I just needed a moment to find my footing. I knew that I had the talent. I trusted that. More than anything, I knew I had the drive, and that counts for a lot. I was confident in my plan, confident that if I kept working, I would get better—better than I had been, better than Julia, and good enough to win.

Obviously, my coaches didn't feel that way. They thought Julia was more naturally talented, a point they so clearly voiced.

But they failed to account for the larger question of how much success is a product of work ethic and how much is a product of talent. The fact is, they underestimated me on all levels, both when it came to my talent and skill, but also—and especially—how much I wanted it, and how hard I was willing to work in order to get there.

If I try to look at it from their perspective, I can understand how they might have seen it that way. I think they were just hedging their bets, as coaches do. It wasn't personal; they were simply going with who they thought would be a better competitor at that moment, the person they thought would give the team a stronger chance. I don't think there was any malice in it, and they didn't know that I could hear them. They didn't know how hurtful those words were, especially to someone who was sixteen years old.

Up until that moment, I'd been optimistic. I thought that I was making progress, and that the coaches recognized it, too. In the beginning of the season, at Lake Louise, I was in third place before I crashed six gates before the finish. I thought for sure I'd shown them I had speed, that it was only a matter of time before I would break in. But now, it seemed that didn't hold as much weight as I'd thought.

As I sat there in my hotel room, tears streaming down my face, I thought, *Fuck you guys. I'll show you.* My coaches' words ushered in a tough realization. The people whose job it was to believe in me didn't think I had what it took. Before that night, I trusted that my coaches had my back, that they would always do what was best for me. From that point on, I understood that they would do what was best for the team. *I* needed to be the one to look out for myself, and I needed to demonstrate that I deserved to be there.

Over the course of my career, I've found I do much better when people doubt me—the press, my coaches, my competi-

tors, my teammates. Whenever anyone questioned my ability, that became a part of my drive. That night in Austria was the first of many times where I took someone's lack of belief in me and turned it into extra motivation. I didn't want to live in Julia's shadow, and I was determined to prove them wrong.

It became an extension of my grandfather's approach—to make it work by outworking everyone else. I was organized and scheduled things. I woke up early—way before my races—to work out, while everyone else woke up later, right at the alarm. Before a race, some of the other athletes would go out at night, while I would stay in my hotel room and prepare. I always thought that one day my effort would pay off, that my hard work would catch up to me. Eventually, it did.

I've always been competitive, and I certainly wouldn't change that about myself. I see it as a positive thing. I think it's important to be competitive, whether you're an athlete or not. Leaning into your competitive nature helps push you to be the best you can be. Everyone has different motivations, different triggers that push them to work harder and be better. For me, it was often to prove myself—to the naysayers or the bullies or the media or whoever was disbelieving at that time—that I could be the best. Sometimes I was triggered by what people said, but I always welcomed it, because I turned it into fuel.

I can't pinpoint the starting point of when I began seeing someone's lack of faith as a source of motivation, because as far as I can remember, I've always been that way. I suspect it's something innate within me, part of the way I'm wired. I was always stubborn, even as a kid. If my parents told me not to climb a tree, you better believe I was going to climb the damn tree. I can definitely be contrarian that way. Want to motivate me? Tell me I can't do something.

While my competitive streak clearly started long before I heard the coaches doubt me in the hotel, in the aftermath

of that night, I began to channel the emotional sting of their words into hard work and results in a way that I never had before. I can't begin to tell you how empowering it felt—or how many times in the future I would fall back on this same mental muscle to push myself to be better in the face of external doubt. To take negativity from others and use it to make myself better became vital to the success that I'd have later on. Or put another way, if you don't want me to win, then you probably shouldn't push my buttons.

If somebody told me I couldn't do slalom, my mind immediately said, *Fuck you, I'm going to do slalom.* If someone said I was too skinny to succeed at downhill, *Fuck you, I'm going to do downhill.*

Eventually it got the point where I could dial it up, nearly on command. Later in my career, the Slovenian skier Tina Maze made a negative comment about me before a race. She had won the race before, and she said something to a reporter about how she didn't think I could do it. I skied purely to prove her wrong. At the finish, I said, "In your fucking face, Tina," which I fully admit I definitely should not have said. It wasn't very sportsmanlike. But, what can I say? I get very triggered when people talk shit about me.

At the same time, there is a massive double standard when it comes to competitiveness and aggression in male and female athletes, one that I felt I hit up against many times. I mean, look at John McEnroe. Everyone loved him. He was so vocally aggressive, and everyone thought it was entertaining, but if a woman does that—anything even close to that—it's deemed unacceptable. If John McEnroe had been a woman, she would have been kicked off the court. No question about it. To that end, I don't necessarily agree with what Serena Williams said, during the now-infamous U.S. Open final when she called the chair umpire a thief, but she's well within her rights. I don't think she

should be penalized for it when her male counterparts aren't. People acted as though nothing like this had ever happened before. Well, many men act that way, fairly regularly, but it doesn't stand out and they aren't criticized for it. You don't have to agree with it, but she's not breaking any rules.

I'm not saying it's a positive thing for an athlete to have an outburst; there's definitely a level of sportsmanship and conduct that needs to be upheld. And as Tina Maze can attest, I'm guilty of falling short sometimes, too. But it's not like being competitive is an unattractive trait. It's not like aggression isn't a natural thing for an athlete to feel. There is obviously a lot of pressure and emotion wrapped up in sports, and it's only natural to react to that from time to time. Especially when someone knocks you.

For me, when I found myself on the receiving end of a competitive outburst, it was more advantageous to hold my emotions in and use them as fuel. I believe you're tipping your hand to your competitor if you show your emotion, in any direction. But that's also easier to say when we're talking about ski racing, where you don't have that direct contact with your competition. In a sport like tennis, where you're face-to-face, and the chair umpire is making the calls, everything is right out there, emotions are high, and that can definitely get heated.

Still, for a woman, there is an undeniable expectation to hold your tongue. There were a lot of times when someone would say something about me, whether it was a competitor or the media, and I would want to rebut, but I chose not to. Usually, the consensus from my own team was not to reply, because "that's not a good look." Most of the time, I would still think, *Why not? They're challenging my character; shouldn't I defend myself?* But the reality is that, as a woman athlete, your opinion is only going to be taken seriously so many times before you're characterized as combative or bitchy or shrill. There is an unfair expectation placed on women—ironically, including female athletes who often made

it to where they are through a tremendous amount of toughness and grit—to be *pleasant*. So yeah. Unlike the men, you are expected to pick and choose when you speak up and when you don't.

These days, social media in particular can make that difficult. There is so much negativity on social media, and that can be hard to deal with. I get hate from strangers all the time—people telling me horrible things, like how they hope I jump off a cliff. Or the onslaught of people chiming in to offer that I'm washed up, that I'm fat, that I'm a slut. Some days it affects me more than others, but I try to keep it in perspective. I've accepted that I'm going to get body-shamed no matter what, but the competitive part of me struggles to ignore the voices who suggest that I'm irrelevant. It's different than when a competitor or the media criticizes you, but it's not invisible. It's the new wave of judgment. And it never stops. It's always out there, waiting to get inside your head. Sometimes it's a fine line between negativity and constructive criticism, so I think you have to take it all for what it is. Learn from it if you can, and if not, you need to move on. If you can find a way to let it fuel you, even better. Let it push you to rise to the occasion.

Throughout my career, I received criticism for the way I looked, sometimes from my own teammates. I always raced in makeup, something I started doing as a teenager and got more into over the years. In a world of race uniforms, my hair and makeup were the only parts of my look that were truly mine. I liked growing my hair long and braiding it, and experimenting with different beauty products, especially eye makeup. I felt more confident with it on, almost like putting on a costume or becoming an alter ego. But some skiers, particularly on the men's team, would comment on it.

"Why do you wear makeup every day?" they would ask.

"You trying to impress people or something?"

They accused me of wearing makeup to be more marketable, which couldn't have been further from the truth. I wore makeup for myself—because I liked it, because it felt like *me*. It was a form of expression, my personal way of being feminine, of looking and feeling good. Their accusations were sexist, and I told them as much. Everyone, athletes included, should wear whatever makes them feel good. I never set out to make a statement with it, but I do think that my racing in makeup helped changed the public's perspective on how an athlete can look. Just as there is no standard when it comes to our bodies, there is no one-size-fits-all approach to beauty and self-expression. We can present ourselves however we want.

I think it's also important to say, in no uncertain terms, that you can be competitive and be feminine. You can be strong and be feminine. You can be outspoken and be feminine. You can be aggressive and be feminine. These things are not mutually exclusive. Wanting to succeed, and being vocal about it, is not a negative. Including—and especially—if you are a woman.

Even in retirement, this part of me that feeds off doubt hasn't gone away. And I'll tell you something—that kind of personality doesn't play out well when you retire from sports, or really, in life in general. I'm still learning that you can't be competitive about everything, all the time. You can't build a life around proving everyone wrong. But in so many ways, that's who I am. I'm emotional and invested in everything I do.

And whereas negative words often provided me with fuel, positive words helped give me focus. Sometime before the 2002 Olympics, I started taping buzzwords onto my skis. In those days, I had a tech named Chief, and he would put tape on my skis to keep track of them, and say, "Which one? Number one? Number two?"

By then I'd realized the importance of honing my thoughts, so one day, I wrote "be aggressive" on the end of my ski, on top

of the tape he'd already put there. It became a habit. Over the next couple of years, I would make a number of these notes, with messages like "stay focused" and "move forward."

During this period, I felt so much pressure to perform—to make the team, to win a race, to qualify, to prove I had what it took. Every race felt like it was do or die, and the buzzwords helped me stay focused on the skiing instead of the results. Those sticky notes gave me a sense of stability in a place where there were so many variables. Eventually, I got to a place where I didn't need them anymore. But for a long time—including my first Olympics and my first World Cup podium—seeing those words on the end of my skis, combined with my mental prep, taught me to train my focus. With focus came consistency, the key factor that would help propel me to the next level.

I woke up in that hotel room in Austria with the coaches' words still burning in my ears. "Let's focus on Julia." Where I'd initially been hurt by their doubt, the more I ruminated on it, I was surprised to discover how much it deepened my drive and sharpened my focus. I felt like I was on deadline, thrust onto an urgent timeline to prove myself (and in doing so, to prove them wrong). While this feeling was brought on by many people over the years—teammates, competitors, journalists—it was especially true of my coaches. When they doubted me, it lit a fire under me that was unlike anything else.

Our next race was in Saalbach, an Austrian resort town near Salzburg, and despite my newly complicated emotions, I was really looking forward to it. I've always skied well in Austria. Maybe it was because I spoke German, which I'd started learning when I first traveled there at age nine, or because it was full of happy memories from trips throughout the years. Most likely, though, it's because Austrians love the sport so much that every race is suffused with this explosion of energy and excitement

that you can't help but absorb. Whatever the reason, Saalbach was a good place to get my confidence going before the Olympics, even though I still didn't know if I would actually make the team.

Of course, something else was at play for me that weekend. I was starting to understand how to make the coaches' doubt work in my favor, how to alchemize my feelings of frustration or insecurity into empowerment. As I turned the coaches' words over and over in my mind, it heightened my emotions, deepening my anger and causing my aggression to skyrocket. If you think about it, aggression is a pretty helpful thing to have in your back pocket when you're throwing yourself down a mountain. After all, your attitude is a big part of what determines if you're able to conquer it. And while anger and aggression may not be the most positive emotions, they paid off in terms of my performance.

As I stepped into the gate of the downhill race in Saalbach, I had plenty of anger to spare. My breathing grew deeper and stronger, summoning enough fury to give me an edge. Throughout my career, regardless of what was going on in the rest of my life, everyone always told me that when I set foot in the starting gate, I looked enraged, like I was "going to eat a child." I may not have actually seemed rabid (like the Austrian racer Hermann Meier, who famously foamed at the mouth), but from this day forward, it became my hallmark. The truth was, I probably would have learned to tap into my aggression one way or another, but it was more potent and easier to access when someone's lack of belief made it top of mind. It gave me that something extra I could employ on the course, in the critical moments when I needed it.

The terrain at Saalbach made sense to me. Even though it was the first time I'd been there, none of the other skiers had raced on this course for a while, which meant no one had a huge

advantage. At that point in my career, it helped level the playing field enough to make a difference. On the mountain, I channeled my aggression into a calculated risk—just touching the line where you almost lose control.

I finished twenty-fourth that day. For context, Picabo finished eighteenth and Julia came in forty-first. I may not have made it onto the podium, but a top-thirty result, and finishing ahead of Julia, was a good progression for me. I saw how I could translate my coaches' doubts into results, and I was ready to try it again. Six weeks later, I had another top-thirty finish, coming in twenty-third in the downhill at Åre, again pulling in ahead of Julia. These races felt significant to me, like the start of a new cycle. It would take more than this to prove myself to my coaches, and if their opinions had changed, they didn't make that known. But I could feel myself getting more consistent, and as I did, my confidence grew.

CHAPTER EIGHT

Standing next to Picabo Street, staring up at the mountain, I had no idea what she was looking at. We were inspecting the course in Zermatt, and I'd been following her around like a shadow in the months before the 2002 games, watching and learning from her. For the most part, I just hovered. When she was racing, you did *not* approach Picabo. She was super focused and very assertive about her position on the team. But when we were in training or in quiet moments like this, I would sometimes ask her questions.

"What are you looking at when you're inspecting the course?" I asked.

I knew what I was looking for, but not what *she* was looking for.

"I'm looking for the fall line," she said.

The fall line is the fastest way down the mountain, the path you'd take if gravity were the only factor. You want to use the fall line to gain speed, because if you're not using it, then you're

fighting against it. Some people are naturally gifted at finding the fall line, and others are not.

"But how do you do that?" I asked her.

"I can't tell you where it is," she told me. "You have to feel it. You have to see it for yourself."

I'll admit that when I first heard them, Picabo's words weren't very helpful. I was still learning how to trust my instinct, how to combine what I observed during inspection with what I intuitively felt on the hill. But as I put her advice into practice, the pieces began to fall into place.

Conceptually, the fall line is a simple idea, but in practice, it can prove elusive. Here's one way to visualize it: If you take a ball and you send it down the mountain, what's the route that it's going to take? What is the fastest way gravity will pull it down the hill? That's the fall line. If you can see that during inspection, then in theory, you can execute it on a run. But that is easier said than done. Every course is different—you can't always look at a track and say, "Oh, there's the fall line." Oftentimes, it also comes down to a natural feeling, almost like a sixth sense.

Being around Picabo during those months, observing how she handled the press and how she handled people, I absorbed so much from her, just as I had when I got her autograph all those years before. I saw the impact she had, and it made an impression on me.

But there were other more subtle yet equally lasting effects from this time with her. In the run-up to the 2002 Olympics, all the hype was on her, because she was making a comeback after a crash. Because she had been injured so many times, she was a shell of herself, but still there was a ton of scrutiny and speculation about how she would perform. The sense of expectation was overwhelming. As a teammate, but also as a fan, I could feel it all around her. Staring at the prospect of my first

trip to the Olympics, I couldn't imagine being in the spotlight like that, having to ski through that kind of pressure or that kind of pain. It was a feeling I could not yet relate to, although one day, I would.

Standing next to Picabo, just watching her go through her routine, was eye-opening. Because what I'd understand soon enough was that seeing the fall line is not something you can really learn how to do. There's no how-to manual to finding it; it isn't something everyone can see or intuit. In my experience, accessing it requires a combination of both your mental approach and your physical talent. Some people just go, without really knowing what they're doing. They don't know how to visualize; they don't remember the course when they inspect it. They just go, and hope that they make the right decisions on the way down.

I was still learning to find the fall line for myself, but I knew I was close, that I was on the path to finding the fastest way down the mountain. The more I thought about her words, and the more I applied them to my own experience, the more I saw that Picabo was exactly spot-on. Her words would remain with me throughout my career, confirming that I was on the right track, that what I was seeing, and feeling, was right.

Eight years after getting her autograph, I ended up on the 2002 U.S. Olympic Ski Team with Picabo Street.

I wish I could say that when I made it to my first Olympics, it was just like I had always imagined. I wish I could tell you I felt a tremendous sense of accomplishment at my biggest dream coming true, that I could stand back and appreciate how it felt to finally meet my goal. In some ways, that was the case. But, as it often is, the reality was more complicated—both better and worse than I imagined.

In Olympic ski racing, there are four spots for each team in

each race, where two spots are based purely on results and ranking and the other two are to be filled at the coaches' discretion. Some years, based on the team's performance, it's very clear who will be racing. Other years, any number of the spots are up for grabs. In this case, two spots were open for the combined, but we wouldn't know who would claim them until just before the race.

When I found out I made the 2002 Olympic team, we were in Cortina, which is always the last race before the Olympics. The announcement happened during our daily team meeting, and when the coach said my name, it felt ambiguous at best. A bunch of us, including me, had made it onto the team as provisional members, the ski equivalent of benchwarmers. I'd been anticipating the news all day, but now that it was out, it felt a little anticlimactic, because while I was one step closer, I didn't yet know if I would be racing. Once we were on site, the coaches would have us participate in the downhill training runs to see who was the fastest, and that determined who would race. I'd been on the fence up until this announcement, and I remained on the fence after it. If anything, it felt like one more invitation to prove myself. I knew I had about an 80 percent chance of racing in the combined, but I didn't want to get my hopes up, because they could swap us out at any time. So, my mindset heading into the games was one of hopeful excitement, mixed with a healthy dose of unease.

Walking in the opening ceremonies in Salt Lake City, I was focused on the course and the training runs, but I tried to enjoy every moment as much as I could. My body struggled to be present while my brain was in hypercompetitive mode. Still, it was an amazing experience. It sounds cheesy to say, but I felt such a sense of unity, with both the team and everyone in the stadium. Because it was right after 9/11, we all felt that we were coming together in this moment. It was amazing to experience that feeling

in our home country, and in Salt Lake, a place where I had spent so much time. I had goose bumps the entire time.

My whole family had come to Salt Lake. In fact, it was the first and last time my entire family—my grandparents, parents, aunts, uncles, and all four of my siblings—were together at one of my races. It was such a big deal, and I was happy they could make it there to share in the experience. It remains a fond memory for all of us.

In my training runs, I skied at a level that far exceeded anything I'd done up until this point. It was like all the resolve I'd built up in the races before this just kept growing and growing, and now a wave had finally pushed me over the top. It helped that I liked the course, which was technically challenging, with really big jumps. But more than anything, I leaned into the magnitude of the moment—I'd been working toward this for my entire life—and let that energy carry me. I typically performed well under pressure, and there had never been more. As a result, I surpassed everyone's expectations, including my own.

The day before the combined, we gathered for our team meeting where the announcement finally came—Julia and I would fill the discretionary spots and be the ones to race. This was it. I was no longer a provisional member of the U.S. Olympic Team, but a real one. I had finally earned my place. I suspect the coaches always knew that Julia and I would race, but since we hadn't raced at Salt Lake before, they wanted to wait until after our training runs to be sure. Sometimes different people are faster on certain hills, and that was the safest way to play it.

There it was—the dream I'd announced at nine years old had actually become my reality. I was thrilled, but I barely gave myself time to feel it. I immediately went into racing mode, my mindset less emotional and more focused. There was reason for excitement, sure, but not yet for celebration. "I've got this chance," I told myself, "and now I've gotta work." I needed to

take everything I'd learned about focus and consistency and put it into practice. After all, it's not a victory until you've done well in the race.

The next morning, I charged out of the gate and into my first Olympic race. It was surreal—the hill, the crowds, the Olympic rings keeping watch over it all. The experience rushed by in a blur of nervous anticipation and determined focus. Just as I had in my training runs, I raised the bar when it came to my skiing. I finished fourth in the downhill portion and eighth in the slalom. I skied so well that the coaches decided to let me race in the actual slalom race, something I could never have anticipated. I was thrilled. It was a real accomplishment, but it also meant I took the spot away from Caroline Lalive, my twenty-seven-year-old teammate who had far more experience and had very much expected to race.

In the end, I came in sixth overall in the combined, and I was the top American female finisher in the Salt Lake City games. This felt huge, to have proven myself in what seemed like such an indisputable way. On paper, my success was undeniable—I'd made a breakout performance on the biggest stage there was.

Going to the Olympics for the first time, at age seventeen, the truth is that no one expected me to do much of anything. The coaches had Julia and me race because they were giving us experience, not because they thought we would perform. We may have stood on the largest stage, but their eyes were not on us. I can't speak to exactly how they anticipated we'd do, but it certainly wasn't a top-ten finish—especially for me. Everyone's cards were on Julia, and I was an afterthought. It was the first time I demonstrated—in a big race, no less—that not only could I perform, but I could compete.

Behind the scenes, those Olympics led to another moment that was eye-opening for me. Since I was a kid, everyone always

told me I was tippy, that my body position on the hill leaned too far in. But because Erich always told me never to change, I never had. After the downhill portion of the combined, I was watching video with my coach, Alex Hoedlmoser, when he played a side-by-side of me and Renate Götschl, who I regard as one of the best downhillers of all time. As I watched us both racing down the mountain, what I saw was unmistakable: She skied like me. In several sections of the course, her form was identical to mine.

"See?" I cried, pointing at the screen. "She's doing the same thing! You've always told me I can't do that!" There was no arguing with concrete, visual proof.

"Sometimes, leaning can be better," Alex conceded. "The trick is that you need to stay in control of it and use it when it's needed." Hearing his words, and watching those videos, was very validating. That was one of the first moments in my career when I trusted that what I was doing was right.

This is it, I thought, letting out a huge sigh of relief.

Personally, I was ecstatic about my finish, which felt like a huge stepping-stone on the way to establishing myself as a real contender. I had proven, beyond a shadow of a doubt, that I had what it took, and surely my coaches would see me differently. I walked away from the Olympics hoping that it would move the needle. But in the weeks and months that followed, there wasn't a congratulatory word to be had. I waited to feel some sense of accomplishment or validation from them. It never came.

Ultimately, my results were completely overshadowed, because the games as a whole were seen as such a disaster. The U.S. Olympic Team fell far short of everyone's expectations—in the end, we showed our strength only in speed skating, figure skating, and snowboarding. In skiing, only Bode Miller took home medals, two silvers. It was widely regarded as our worst Olympic showing in decades. From a political standpoint, the

team struggled to admit that I had been the best performer. There were also other more senior girls who were expected to do better than they had—even Picabo, in what would be her final Olympic season, had only managed to finish sixteenth because of her injuries—so my results weren't really acknowledged. Instead, everyone acted as though my races had never happened.

There was one person who recognized my breakthrough for what it was—my dad. He kept telling me what a great performance it was, but not even his praise could help me feel better about what I'd accomplished. Though he'd been with me from the beginning, though he'd put me on this path, and though he never uttered a word of praise unless he meant it, I still couldn't accept his words. In part, that's because the only recognition I received came from my family and the people I was close to, and he was the center of that circle. As a result, the sense of accomplishment felt hollow.

To make matters worse, the World Juniors were scheduled for right after the Olympics, and after our performance, the team decided they were so important that we needed to leave Salt Lake immediately. I didn't even get to stay for the closing ceremony, something I really wish I could have experienced. If I had stayed in Salt Lake, I would have avoided a lot of problems, because when I went over to the World Juniors, I crashed, and that derailed everything. That would have been a great place for me to do well—a repeat success to prove to my coaches that I was worth recognition—but instead I crashed, literally. In a matter of days, I went from the highest point in my career so far, back to what felt like zero.

My first Olympics had come and gone, and in a lot of ways, it felt like nothing had changed. I had accomplished what I'd been working toward since I was nine, and I should have been on top of the world. Yet I felt restless, and more unsatisfied than ever. For as long as I could remember, every decision, every ef-

fort, had been for that moment, and now, it had barely moved the needle. My coaches didn't regard me any differently. My future remained uncertain.

As an athlete, you want to believe that the Olympics will change everything. That success on that biggest stage will translate into a different level of performance and respect once the cameras are off and the crowds have moved on. It's such an audacious goal in the first place that it feels almost impossible to imagine any other outcome. Of course, it rarely works that way, but you actually have to experience the Olympics before you can understand that in your bones. I know plenty of adult athletes who have left the games believing that a switch has been flipped on their careers, only to be disappointed by the reality that awaited them when the ceremony of it all died down. And you better believe that, as a seventeen-year-old, I'd gone into the games with a huge amount of anticipation of the transformation that awaited me on the other side. I thought that after the games my food would taste better, that the satisfaction of my accomplishment would greet me every morning and set the tone for each and every day. That the future would look instantly brighter. Instead, I woke up after the games and, for the first time in eight years, I needed a new goal.

For years, I always assumed the hardest part would be getting to the Olympics and competing on that level; instead, it was everything that followed.

THE FALL LINE

It didn't happen all at once, but little by little, doubt crept in.

After Salt Lake, I tried to return my mindset to where it had been before the games: to focus on the future and establish myself and my place on the team. Immediately, though, I came to see just how hard that would be. Not only did the coaches continue to overlook my performance at the games, they actually demoted me back to the Europa Cup, which is the level below the World Cup. I was furious. I had just shown everyone—in very certain terms—that I had the ability to be successful. Yet still, they didn't believe in me, and so, I started not to believe in myself.

In my darker moments, I could still hear the voices from outside my hotel room echoing in my head, reminding me why I'd never make it, telling me I wasn't good enough. But, whereas before that doubt had kindled my competitive spark, now it dampened it. I began to see myself through the lens of their criticisms. I became less happy-go-lucky around my coaches,

growing more reserved in their presence. I was careful never to show my emotions in front of them, reserving any reactions for when I was out of their sight and safe from their judgment. And gradually, my resolve and faith in myself began to weaken.

So much of skiing well is about confidence. In ski racing, there is actually no such thing as momentum. The power, the pace, the movement all come from you. You create your own speed, on the mountain and in life. When you're throwing yourself down the mountain at eighty miles per hour, you often can't see the ground in front of you, so you need to have the confidence that what you're doing is right. In a way, your confidence is actually what keeps you moving forward.

Perhaps that's true in every sport—after all, to take risks you have to have the confidence you can pull it off. But skiing specifically requires a level of self-reliance that makes complete confidence essential, because in skiing taking risks involves both the possibility of failure and danger. If you miss a buzzer-beater in a basketball game, you might be emotionally disappointed, but it almost certainly won't result in a career-ending injury. To attempt a big jump at a high speed, you have to believe that you can land it; if you don't believe it, you usually won't try it, because the cost of failure is too great. Similarly, you have to believe that you can lean into an edge just enough to give you that extra fraction of a second without losing control. You don't always need others to believe in you, but you have to believe in yourself.

My entire career up to this point, I'd always had that confidence, no matter what anyone else said. Now the frustration of being doubted began to influence how I thought about myself. Not only did it make it hard to ski well, it robbed skiing of the fun and made me question whether all the sacrifices I was making were worth it.

This was the only time in my professional career—either before or after—that I thought about quitting. I was in a pretty

big slump. I worried I was plateauing, my dad's dreaded "ski bum" speech always playing somewhere in the back of my mind. The truth was, I didn't want to quit—I wanted to pursue my goals as much as ever. But I felt backed into a corner, and I didn't know what steps I could take to escape it. The Olympics were supposed to be my proving ground. Instead, they were almost my undoing.

Still, I continued on, grasping to regain my focus. I decided that I owed it to myself to try one last-ditch effort to get out of this cycle. I would give myself one more year to get back on track, one more chance to improve, and if I couldn't, then I would quit.

Perhaps I might have dealt with this tough time on the hill better if there had been less going on off it. Much of my success up until that point had come during a time of incredible stability in my life; everything—my family, social life, school—was built around skiing. I was able to excel because I'd achieved the consistency, both emotional and physical, on and off skis, that was essential to performing on a high level. Unfortunately, all that was changing.

That summer of 2002, I was living out in Park City when my parents told me they'd started the process of getting a divorce. First, my mom called to tell me it was happening, and I remember thinking it was probably just a fight and they would bounce back from it. Then, a few weeks later, my dad called to say the same, which confirmed that it was real.

I was in the airport on my way to Mount Hood for the U.S. Ski Team Development Camp when I heard the news from my dad, and I sat in the terminal and cried. Before I boarded my flight, I went to the airport bookstore and bought a journal. I was overwhelmed with thoughts and emotions and I didn't know where to put them all, so in the ensuing weeks, I dumped them all onto its pages. Where the journal fell short, I dumped the rest of my feelings into my skiing.

"Just focus on your skiing right now," my dad had told me, right after he broke the news. "That's the best thing you can do."

Staring out the plane window, I struggled to process what I'd just been told. In hindsight, it wasn't a surprise, but it was still incredibly hard to hear. After the Olympics, my family had moved back to Minnesota, and it felt like this traveling circus said, "We're done here. Pack up and move out." I'd been away from home and living with the team for a while by this point, and though I wasn't involved in the day-to-day family happenings, it still felt like a big change, one that I'd played a huge role in. It was almost like the goal we had set up to accomplish was complete—I had made it to the Olympics, and now there wasn't any family goal or motivation left to keep us going. Not only that, but I felt like I had a hand in splitting up the family in the process.

The news felt alienating. I couldn't be with the rest of the family. I couldn't unpack what had happened with the other people who understood it. I was left trying to navigate these complicated feelings on my own. Socially, that was one of my quietest times, because I felt like there was no one else on the team I could confide in. I called my grandparents a lot, but beyond that, I retreated, learning to rely only on myself. My days consisted of skiing, working out, and journaling, my nights spent alone in my room, blasting Avril Lavigne on repeat and letting my feelings spill onto the pages. The only time I would change this routine was to go down the road to the Huckleberry Inn for a malted milkshake. Ice cream has always been comforting to me, especially in times of hardship.

Even before I'd heard about my parents, being out in Park City was hard. I was incredibly homesick. I hadn't been getting along with my dad, which meant I had also lost a person I could confide in. It was overwhelming, and I didn't know how to cope.

To top it all off, I found myself at the beginning of a serious

relationship—my first—and unsure of how to deal with reconciling my own emerging personal life with the deterioration of my parents' marriage.

I'd first met Thomas Vonn a year earlier at a ski team party the summer before the Olympics, when I was living in Salt Lake with the team. As we'd chatted at the party, I discovered that I already knew his roommates because I'd grown up skiing with them, so we also had people in common. But more than that, the thing that most stood out about him was that he seemed just as passionate about skiing as I was.

We'd texted some and hung out a couple of times that summer, but it was all very casual. At the Olympics, I'd reconnected with Thomas—as a member of the U.S. Ski Team, he was there at the opening ceremonies, and we both raced on the same mountain. I'd seen him a few times during the run-up to the games, but seeing him at the games got me thinking about him again. Following the games, we picked up where we'd left off. Soon after, we officially began dating, and as the year wore on, we spent more and more time together. Eventually, that summer of 2002, I moved into a condo in Park City, which I shared with two of my teammates. Thomas was in a condo just down the road with two of his teammates. We were within walking distance from one another, which made things all the more convenient.

Up until Thomas and I started dating, my relationship experience had been practically nonexistent. When I was ten, I held hands with a kid named Derek. And then when I was twelve, I held hands with another kid, Pat, who was my friend Claire's brother. We were just good friends, until one day when he called me "babe," and I was like, *Whoa, this is going too far.* So, I broke up with him. On Valentine's Day. I didn't even realize it was Valentine's Day, which was terrible. It just goes to show you how not good I was with guys.

When I was thirteen, I had my first kiss, in Italy, when I was skiing at Topolino. A boy from the Netherlands wrote me a note and asked me to go for a walk with him, and at the end of the walk, he kissed me. I had braces at the time, and it was definitely more of a peck. The whole thing wasn't much in the way of romance. After that, we were pen pals—actual pen pals, with handwritten letters—for a while before ultimately losing touch. (I saw him again one time, years later at a race, and was like, *Weird.*)

. . . And that's about it on the dating front. So yeah, I didn't have much experience. Before I met Thomas, I'd never even thought about dating, because I was always around people who were so much older than me. Factor into that the part where I didn't go to high school. I didn't go to the prom. I had no idea what I was getting into. It was like I skipped ten steps and went straight into adulthood.

After Thomas and I started dating, I began spending a lot of my time with him. My friends became annoyed that I fell into that early relationship trap where you spend all your free time with that person, but that was only one side of the story. They were right that I wasn't around as much, but the larger truth was, the reason for my absence was mostly psychological. With everything going on between my parents and skiing, I wasn't emotionally equipped to handle it all on my own.

Initially, I'd started what would become a yearslong pattern of using skiing as an escape. Skiing became the place I turned to avoid dealing with the difficulties in other parts of my life. It was both my greatest love and my most effective emotional crutch. But eventually even self-medicating on the slopes no longer provided the distraction that I needed. I could only run away for so long before I was overcome once more.

Looking back, it seems obvious that my parents' divorce took a huge toll on everything that year. My skiing, my personal life,

all of it was made more complicated by what was going on with my family. Even worse, though, was not knowing how to talk about it. I didn't talk to my family about it. I didn't talk to anyone. I felt stuck, like there was no way out and nothing would ever get better. I fell into a spiral of wondering, *What's the point? Why try?* I was in a dark hole, and I started to isolate.

At the time, I didn't have the emotional awareness or vocabulary to see these feelings for what they were: depression. Anyone who has experienced depression will know what I'm talking about. In a way, it's like you stop being yourself, and turn into a person you don't recognize. You feel hopeless, kind of like you're falling deeper and deeper into a black pit and you're powerless to stop it. You fight hard to get out of it, but no matter how much you try, you can't move. When you're depressed, there is no *why*. Everything feels pointless. *Why talk to anyone,* I'd think, *when no one wants to talk to me? Why bother? Why try?* It feels like there is no way up and no way out.

It reached a point where I stayed inside my bedroom all day. I didn't want to come out, I didn't want to socialize. It was almost like being trapped by some invisible force. My motivation plummeted, and I lost interest in everything—I wasn't even into working out. In my rational brain, I knew exercise was important, but for the first time ever, I placed my training on the back burner, because I didn't want to leave the house. Once that happened, I saw that there was a problem. Skiing had been the only rock in my life, and now even that was faltering. This was the first time in my life when I didn't put my career first, and that was a red flag.

Around the same time, one of my friends was going through a period of depression, which none of us knew about. He wound up talking to someone about it and going on medication, and a couple of months after the fact, he told me about his experience. In turn, I shared how I'd been feeling. In my eyes, it was more

of a conversation than a confession, because I didn't think my situation was the same as his.

"You should really look into it," he told me. "It helped me a lot."

When I finally went to the doctor, I still didn't give it that much weight. I sat in the waiting room, browsing through the assortment of out-of-date magazines and telling myself that I was there more to confirm there was nothing "wrong" with me than to seek a diagnosis. I didn't actually think I needed help; I half thought I was fine. Like a lot of people, I rationalized my symptoms as, "I'm just going through a hard time." I figured my mood was due to external factors and would right itself soon enough.

But as I told the doctor how I'd been feeling, I was met with a concerned expression.

"Your symptoms are very consistent with depression," he said. I blinked. This wasn't what I'd expected. Even once the words were out, I didn't fully believe him.

"Really?" I asked. "Are you sure?"

"Yes," he assured me. "And what's more, there is nothing 'wrong' with you. What you're experiencing is actually quite common."

Up until that point, I'd been under the impression that depression was always very serious and severe. I didn't yet understand that there are varying degrees of it, or that it was possible to be depressed and still high functioning.

"Depression affects many, many people, and it's nothing to be ashamed of," the doctor continued. I appreciated that he had put it in context, but unfortunately, hearing those words wasn't a relief; more than anything, I felt embarrassed. Despite what he had said, I worried that other people still might not understand it. Just because depression was common didn't mean that I wouldn't be judged. It all felt like a lot to navigate, so I thought it best to keep it to myself.

The doctor prescribed Zoloft, which helped me stay on a more even level, where I wasn't getting down on myself or isolating. He also recommended that I see a psychologist. However, that was not a step I was willing to take then. Consistent therapy would prove challenging with travel, since I was never in the same place for very long. Plus, that felt like an additional layer of embarrassment. As I write this, I've had so many injuries and surgeries that I've gotten used to being around doctors, but back then, I wasn't comfortable with anyone offering their opinion of me, especially if it involved them going beneath my hard outer shell.

Luckily, I noticed a huge difference from the medication alone. Once I began treatment, everything felt brighter. It got me back on track. I finally felt like I was accomplishing things, and that not everything was terrible. The cloud began to lift, and I started to feel a sense of purpose. I ventured outside my room again, and I didn't have as hard a time motivating myself. The wheels started turning and I started to pick up steam.

What I didn't understand then, and would only come to see through years of hard work on myself, is that maintaining your mental health is a constant challenge, a balancing act that can go off-kilter at the most unexpected moments. At the time, I was just relieved to feel more like myself again. While I understood my diagnosis, in theory, I didn't yet realize the extent to which it would always be with me, lingering in the background of moments both high and low. In some ways, my struggle was just starting. From then on, through my success and failures, my medals and injuries, my depression was never far away.

Any way you sliced it, that summer was hard. Even when I regained my footing and made my way back to the gym, my training, which usually gave me a sense of stability and focus, was all over the place.

I was determined to prove myself to the team and fight my way back onto the World Cup circuit. But my resolve alone wasn't enough to do it. In terms of my performance, I hit a plateau where I wasn't getting better on the slopes, and I needed to improve if I was going to get ahead. I wasn't competitive, and that was a problem. In ski racing, there are a lot of different variables that factor into your performance, but the one glaring hole for me was my fitness.

When I showed up at the gym for training, I was handed a sheet of paper with a list of exercises on it. I was expected to fill in my weight and follow the program on my own. I took one look at it and was like, "I don't even know what these exercises are." I noticed I was given the same weight training program as Kirsten Clark, who at the time was in her mid-twenties and had been on the World Cup for many years. As best as I could tell, they were just doling out the same one-size-fits-all routine, without tailoring it in any way to each specific athlete. As soon as we'd been given our program, they didn't help or monitor or guide us at all.

They also had everyone on creatine, a supplement that's supposed to help create muscle mass. I don't know how it came about; they weren't up front about what was happening. After your workout, the trainers would give you a shake. I was told it would help me build muscle faster, and that it was totally legal and tested and verified. Well, I ballooned up. I must've gained at least twenty pounds that summer. But unlike what they had promised, it was water weight, not muscle mass. I was retaining water to the point where other people would notice and comment on it. ("You look . . . different," my grandparents said, when I went to visit.) I didn't feel stronger at all, just bigger.

My bones are definitely from my father's side; I got the Kildow genes. We're big-boned people, we're not slight. It took me a long time—years—to get that puffiness out. The worst part was that the extra weight affected me negatively in my ski

performance. Ultimately, I think that's part of the reason why I started struggling in slalom and transitioned into downhill. When I was seventeen or eighteen, I started having more and more trouble finishing my slalom races, so I switched my emphasis to speed events, where I was having more and more success. I kept training and competing in slalom and giant slalom, but that was mostly to keep me well rounded.

But yeah, when it came to fitness, I was definitely on the wrong program. The whole thing was unfortunate, because we actually had a ton of talent on the team at that time. We had so many great racers, but we were understaffed. We had a lot of sponsors, and all these programs, but in my opinion, they weren't implemented correctly. It goes to show you that just because there is money in the system, it doesn't mean the system will be successful. The U.S. Ski Team had a lot of money in 2002. We also had the worst Olympics in a very long time.

Adding to this was that, in my late teens, I had a few coaches who, simply put, were harsh and blunt and just not nice. Some of the girls would cry, and there were a few times the coaches got fired after only two or three months. A lot of them were men's coaches who transitioned into women's coaching, and I don't think they understood women's psychology and how we needed to be coached. Perhaps it goes without saying, but coaching women is different than coaching men.

In a lot of ways, coaching is like being a psychologist. It's not just about the athlete's physical performance, but also about managing an athlete's emotions and getting them to focus during the times they're distracted. As with anything else, everyone has a different style, and there are some coaches who are better at it than others. Then there are some who come right out and say, "Wow, that fucking sucked." That style works for the maybe two people who enjoy harsh criticism, but the rest of us don't flourish in that environment.

In general, I don't think that women respond well to hyper-negative coaching. I'm not saying women can't take criticism—we absolutely can. But this was degrading criticism, the kind where someone tries to cut you down in order to build you up. Over the years, my skin thickened to it, and I was good at blocking that stuff out, so it wouldn't really get to me. But that didn't make it any better that it happened. I think women, in particular, need to be approached a certain way—a more nuanced way—where feedback is mixed with encouragement and positive reinforcement. It's not sexist; that's just how we operate as human beings.

That season, the coaches thought the condition of a lot of the athletes wasn't up to their standard, but they were definitely part of the problem. Training with the ski team, I started getting worse instead of getting better.

Part of this struggle was my own fault: At this point in my life, I wasn't very good at working hard at the gym. I worked plenty hard, but my effort was all on the hill. To be honest, I used to go so far as to avoid working out in the gym, because I hated it. But it was the one hole in my preparation that could potentially be the key. If I didn't get better, I was in danger of becoming one of those hangers-on, and that definitely wasn't me. (As my dad very succinctly put it, "Shit or get off the pot.") I was in decent shape—I'd done whatever the ski team had given me to do—but after I'd taken the creatine, things started to go off the rails. I was so diligent and so precise with everything else, and now it was time to take my fitness to that same level.

While I was in Park City grappling with whether or not I should quit, my dad came to me with an idea. He thought I should hire a trainer, someone to help light a fire in me when it came to my overall fitness. I hadn't done anything great in terms of dryland training, and I had never had a program that was specialized for me. I was willing to do anything to take my ski-

ing to the next level, so I agreed. My dad said he already had just the person in mind—he had even started making arrangements.

What I didn't yet grasp was that my dad hadn't hired any old trainer. No, the plan was for me to spend six weeks with Jacques Choynowski, a renowned fitness guru who had trained many world-class skiers, including Anja Pärson and Pernilla Wiberg. What's more, Jacques was based in Monaco, where I would be spending the summer.

I had no idea what six weeks of one-on-one training with Jacques must have cost, only that it was something we couldn't afford. But my dad got my sponsors at Rossignol to front the trainer's fees and travel costs against any future earnings. Rossignol was already familiar with Jacques, since many of their athletes had worked with him before, and they were happy to sign off on this plan. It sounded good to them, so it sounded good to me.

Monaco may sound glamorous—all cliffs and blue water and visions of Grace Kelly—but training with Jacques was anything but. I was there to get my ass kicked. From the moment I arrived, everything about the experience was drastically different than anything I'd ever done.

Jacques and his girlfriend lived in a tiny one-bedroom apartment, where I also stayed for the duration of my training. As the guest, I slept in the bedroom, while Jacques and his girlfriend slept on the couch. Jacques is an older Polish guy, with white hair, a white mustache, and a goatee. The best way I can describe him is . . . extremely intimidating. He was very brusque and old school, like a drill sergeant. There was barely a sliver of warmth or friendliness about him. It felt like boot camp.

A typical day started first thing in the morning, when even the sun was barely awake. Jacques's girlfriend made me breakfast, usually fruit and a couple of hard-boiled eggs. That was one positive: I ate very well there. The food in Monaco is insane,

especially the fruit, which is incredibly fresh and delicious. Another unexpected positive was that Jacques's girlfriend was also from the United States—if my memory serves me correctly, either Kansas or Nebraska. It was nice to have another American around. She wore this cat-eye eyeliner, where the line extends out a bit beyond the eyelid, which I admired. That's actually where I got the idea to do my eye makeup like that. One morning, over breakfast, she showed me how she applied it, and I've kept on doing that for the rest of my life.

After breakfast, I'd head to the gym. Monaco is so tiny that you can go everywhere on foot, so every morning, I would walk from the house to the gym (and some evenings if Jacques was still working, I would walk home as well). First was a track workout—sprints and jumps and whatever else he could think to throw at me. Next was core and agility work—medicine ball throws, drills, plyometrics. After that, I'd ride the stationary bike, unless he was feeling particularly evil. In that case, he would put me on this old bicycle of his and make me ride up and down the hills of Monaco, while he drove behind me, shouting orders from his car. To be clear, there are definitely worse places to be than Monaco, and the views were stunning, but it's kind of hard to appreciate them when you're sprinting up a steep incline.

Then we'd take a break for "lunch." Lunch was always a protein shake, after which Jacques would get right back to torturing me, this time with an intense lifting session.

"You don't need water!" he would bark, as I completed exercises as fast as I could, never with any breaks.

Normally, when you weight train, you do three to five sets of exercises, where you take two to three minutes to recover between each set. Jacques did not take two to three minutes. There was no break, and no recovery. It was nonstop work. Everything we did was more like circuit training, where I kept up a certain pace—always on the verge of puking and constantly out of

breath. That's how I felt the entire time I trained with Jacques: I was always catching my breath, and I never actually caught it.

It was not a happy experience, physically or emotionally.

"How long do you want me to run?" I'd ask.

"Until I tell you to stop," he'd reply.

I couldn't plan or anticipate anything. I'm the kind of person who likes to know exactly what I'm committing to—which exercises, how many sets, how long it will take—so I can pace myself, to a degree. Jacques's thing was that he never told me what we were doing. He would yell out the next move, and I would do it.

That was a hard thing to adapt to, mentally. But it also allowed me to be in the moment, which I needed to learn. You can't always predict what's going to happen—in the gym, in life, on the mountain—and you have to be able to react. Whatever he threw at me, I would react and then I would adapt, and that definitely kept me on my toes. It sharpened a skill set that I'd always been lacking.

Some of the things he said to me should never have been said. Upon meeting me, he straight-up told me I was fat. Throughout our time together, he repeatedly told me that I was out of shape, overweight, or else not committed enough to be a champion. This is part of what earned him the nickname "Jacques le Cock," which I spent the next six weeks muttering under my breath.

But it wasn't all negative. While Jacques was undoubtedly an asshole—and precisely the kind of coach who offered up that degrading brand of criticism that hardly anyone responds well to—in some ways, his hard-core approach to training was what I needed at that moment. It reinvigorated me mentally at a time when I needed to reaffirm to myself why I was doing this. His uncompromising approach hardened me in ways that proved necessary to become the competitor I wanted to be. It was almost like Navy SEAL training, where it's brutal but it'll make

you tough as hell. I emerged from that experience much tougher than before. It also answered the question of whether or not I would make it to the next level. After my training with Jacques, I knew that I would.

That experience changed me in a lot of ways. I learned to keep my head down and do what I was told. I learned how to push myself through physical pain. I learned what was tolerable and what was not. I learned how to bite my tongue and work hard, without making excuses. That last one—the part about working hard—was probably the biggest takeaway. Before my time with Jacques, I'd always thought that I knew what hard work was. What it meant to push myself and sacrifice. The truth was, I only knew about what hard work was on the hill. So much of the actual hard work is what happens everywhere else.

I always felt like I would do anything to be a better skier, but I never realized how important fitness was until I met Jacques. In order to work hard and see results, you have to make yourself feel uncomfortable. I was ready to step up my game, and fitness proved to be the missing piece that would help me progress. Doing what I'd been doing wasn't working. It was time to do something different.

Those six weeks were easily the most grueling of my entire career. At the end of our time together, he wanted to be my full-time trainer, which was absolutely not happening. But my time with him accomplished what we set out to do. He changed my definition of what "hard" meant—at the gym, and in life in general. From then on, Monaco, and all I'd experienced there, became my gauge.

saw the white of the snow on the other side of the finish line. Then I saw the clock.

1:18.22. It would prove good enough for fifth place, my highest finish in a World Cup race. The best part, though, was that I would be getting another shot to better it.

It was January 2004, and I was at the World Cup races in Cortina, Italy. I've always loved Cortina—it was probably my favorite place to race, along with Lake Louise—and it felt really comfortable there. The course was very suited to my skill set—it's high speed and I read it well. The fall line at Cortina was easy for me to find, almost like I had a direct connection with the hill. I knew where to go without thinking about it, knew what to do automatically. The way the hill in Cortina is situated, you can't really set it differently, so the course remained almost the same year after year. Once I'd visualized the course, I always knew what to expect, because I could see it in my head before I

got there. Now I was on the edge of using my ease there to cement my place on the World Cup stage.

I'd come back from my time in Monaco feeling physically strong, and on the hill, I began to see a difference right away. After my experience with Jacques, I'd started a routine of full-on weight lifting the night before my race. One of the other great things to come out of training with Jacques was that, from then on, I woke up early and worked out in the morning before I headed to the hill. I'd do sprints on the bike, stretch, do some core activation, some agility training, and just generally get my mind and body going. As you can imagine, that translated well to the rest of my career.

Race by race, I'd fought my way back onto the World Cup, and by the time the 2003–2004 World Cup season had begun, I was poised for a breakthrough. I was nineteen years old and by this point, my game had changed. My skiing had improved a lot, and there was no denying that my time with Jacques had been a resounding success. But despite being physically ready to step up to the next level, internally, I still hadn't regained my confidence. I was right on the precipice, but I hadn't arrived.

In terms of results, I still had plenty to prove. Up until this point, I'd had a few DNFs, a couple of DNQs, a few middle-of-the-pack finishes. It was enough to justify my participation, but it wasn't really doing anything to cement my future with the U.S. Ski Team. I wanted to firmly establish myself as a World Cup racer, so they could never demote me again. I knew I belonged on the top tier; it was just a matter of showing everyone else.

Because I found so much focus and drive whenever someone didn't believe in me, I continued to use that negativity to my advantage as much as possible. I was working hard to prove myself, and a big part of my motivation stemmed from wanting recognition, especially from those who doubted me. One little phrase of doubt would be enough to fuel me for a long time.

When I'd been demoted from the World Cup, I made it my aim to not just get back on it, but to win. Doubt by doubt, I'd kept others' words in the front of my mind as I fought my way up the ranks.

That week in Cortina, I was energized by my fifth-place performance on the downhill. Suddenly, I was filled with confidence, the confidence that had been elusive since the Olympics. And that confidence changed everything. Looking back, it took me until that point to feel like I belonged. I'd always felt in my gut that I had the talent and I was willing to work harder than everyone else, and I trusted the results would come. But until it actually happened, until the whole world knew it, too, I would slide into the trap of doubting myself.

And once that confidence had returned, I worked hard to make sure that it never failed me again. If there was one thing I learned from that difficult period after the Salt Lake games, it was the importance of not underestimating yourself. A lot of times I see people who are so smart and so talented and they just lack confidence in themselves. You have to dream big, but you also have to do yourself the favor of trusting your own abilities. No one can believe in you but you. It's a simple rule, but no matter what anyone else tells you—you're too this, you're too that, you're not built for this, you're not smart enough, you're not athletic enough—you have to listen to what only you know is true. That's what I've said all along, and I still do.

As if the fifth-place finish in Italy weren't good enough, I also knew I was about to get another shot at the same course. Because of an earlier cancellation on the tour, there were two super Gs and two downhills that week. That happens sometimes, where an event gets postponed due to weather conditions, and they'll piggyback that race onto another one. So, I had an extra chance to prove myself. It also meant that I could use one of my strengths: learning from the course and my run.

By the time I got to the second downhill race, I'd thought through that fifth-place run a thousand times. *If I just clean up a couple of turns, make some transitions quicker and smoother over the blind roll, ski a little more aggressively, I know I can be faster.* I felt ready. When I stepped into the starting gate that day, I knew I could push my way onto that podium. Because I had no doubt it was where I belonged.

In my previous races, I was trying to scrape by and get a top-ten or top-fourteen placement. But that day, I threw down a time of 1:16.51, which—for that moment—put me in the lead. I had never occupied the leaderboard in a World Cup race, and it was unlike anything I'd ever felt. I held my breath as the next twenty skiers took their runs, knowing with each one that I was inching ever closer to being counted in the top group. In one of my favorite photos from this race, you can actually see my little handwritten "be aggressive" sticky note on my ski as I look up at the course.

When Carole Montillet of France, skiing twenty-eighth, crossed the finish line with a time of 1:16.27, my heart sank, but just a little. I was a quarter second off her pace, and still hanging on in second place.

Next, Hilde Gerg of Germany was up. She was one of the all-time great downhill skiers, so I was torn between rooting for her, marveling at the way she attacked the course, and hoping she might have an off day. Hilde crossed the finish line with a time of 1:16.81, a hair behind mine, meaning I maintained my second-place spot.

The final top skier to go was Renate Götschl of Austria, who was ranked number one in the downhill at that time. Of everyone in the field, I was worried about her most of all. She also held the record for the most wins at Cortina, so she had the course in her favor. If she skied a clean race, I feared there was no way my time would hold up against hers. She posted a

time of 1:16.50—a single hundredth of a second ahead of me—bumping me into third place.

I hadn't won, but it hardly mattered—I was on the podium.

As the three of us posed for pictures and collected our medals, it felt like the start of something new. I had watched so many versions of this ceremony over the years, and finally I was in its midst. What's more, I felt like I had finally figured it out. I saw the path to winning, and I couldn't wait to repeat it.

Those races in Cortina were the culmination of everything I'd been working toward since the 2002 Olympics. I'd met my goal of establishing myself on the World Cup, and now I could firmly shift my sights to winning. Once I broke that barrier, it was like, game over. After you win, you want to win again and again. Everything snowballed from there.

This is how you do it, I realized, followed by another realization that was just as important: *I can do it.* After that race, I never looked back.

When you get to a certain level of skiing, everyone needs to have a little something extra. Everyone's so talented. Everyone's style is different. There are so many ways to be good. To make it in the World Cup, you have to possess some bit of talent—some special awareness, something innate within you. It might be your ability to see terrain, to find the line, to visualize the course so your body will know exactly what to do and when.

Throughout my career, I always watched people. I watched what they did, how they prepared. Who were my competitors? What were they doing? What were they talking about? What were their strengths? What made them good? Everyone has the thing they do best, their own personal strength. Some people are good at gliding. Picabo was really good at that—she could create speed out of nothing. She didn't give a fuck; she just pointed her tips downhill and went for it. (She wasn't as good

at turning, but again, everyone has their strengths.) Likewise, some skiers are very coachable; a coach will tell them to do something and they can go out on the course and execute it.

The more I'd watch, the more I'd pick up on things. I noticed a lot of girls didn't hold their tuck long enough to get the most out of it, because they were afraid to carry that much speed with them into the turn. So they'd come out of it. But if you stay in your tuck until the last possible moment, that's where you can find that extra hundredth of a second. My teammate Jonna Mendes had this incredible tuck that I always tried to emulate. My body is totally different than hers, but I was amazed by it. I watched Renate Götschl of Austria and saw she had the same inclination to tip toward the inside as I did. I would talk about lines with my friend the German skier Maria Riesch, especially if we were inspecting a course at the same time.

Often, though, when I watched another skier, I wasn't just studying her technique. If anything, I was studying mine. I would see how she executed her line, where she was looking to make up time. But I'd also imagine myself in that same scene, putting myself into her head, into her moment. What was she seeing? Then, I'd take whatever I learned from her approach and attach it to my own.

You have to get good at observing women, because they don't usually share things. Some girls liked to talk to me, and many didn't. I would ask some of them, "What do you think about this line?" and most of them wouldn't tell me the real answer. It was different when I trained with men, which I often found much more helpful, because they actually talked about what they were doing. I could say, "What are you working on? What skis are you on? What's your line? What are you thinking about here?" We would do jumps together, and I would just straight up ask them, "How do you do it?" and actually get a response. They were always excited to answer and to help me.

I liked training with the men. They didn't care if I gave them shit; they'd give me shit right back. I could swear. I could be sarcastic. I could be myself without judgment. That's not to say that I'm gnarly and manly. But there are two parts of being an athlete: You're a competitor, and you're also a person. When I was around the guys, I felt I was accepted as both.

Perhaps that's partially how Thomas ended up as my coach. We were still living together, still in a serious relationship. At first, he helped me out with small things. I had some trouble with my equipment, and I kept crashing. He said, "Send me your video, I'll take a look and see if I can spot anything." After he watched, he said my equipment was definitely off and he told me he could fix it. He adjusted my boots, and just like that, I started skiing better.

From there, he offered me advice from time to time. I sent him video; he gave me feedback. He might make some adjustments to my equipment here and there, but he wasn't that involved. All that changed in 2004, the year I turned twenty. He didn't make the U.S. Ski Team that year, but he obviously loved skiing and still wanted to be around it. He suggested that maybe he could help me, and everything he had done for me so far had been great. I'd started winning races and everything seemed to be heading in the right direction. We were already dating seriously, and he traveled with me anyway. So, he helped me. It was a series of steps that ultimately led to him becoming my coach.

And it was really nice having him in my corner. He was an incredibly knowledgeable skier who knew the sport inside and out, and I skied well under his guidance. It's always the case that men are faster than women—that's just the way it is—so I felt like I had an upper edge having a male skier by my side. Men ski a different line and have a more dynamic approach, and I felt I could use that to my advantage.

It also worked out that our strengths complemented each

other's. Thomas was a tech guy. He really focused on the equipment. He loved to analyze video and zero in on every minuscule technical detail. I trusted him to handle all the moving pieces so I could focus on my training. For him, it was less about fun or feelings or going fast or enjoying winning. Meanwhile, those were the parts I lived for.

It's amazing when you can learn firsthand from people who are willing to share the right information. I surrounded myself with people like that, because I wanted to absorb all I could. The Norwegian skiers Aksel Lund Svindal and Kjetil Jansrud were always especially willing to talk. Aksel loves skiing so much, and he adores anyone that loves it. Not only is he one of the greatest downhill skiers of all time, he's also an incredible teammate. He's willing to help however he can, because he wants everyone to be better. The moment you stop learning is the moment when someone's going to pass you. Kjetil also loves skiing and is a happy-go-lucky guy who always seemed to make training more fun. We would joke that I trained with them because I have Norwegian heritage. My known relatives have the surname "Nilsen," which Kjetil and Aksel enjoyed calling me on the hill, as a nickname of sorts.

It took me a long time to figure out precisely what my special skills were, but that first World Cup podium in Italy confirmed something I'd suspected all along: Skiing, for me at least, is mostly mental. When it came to my performance that 2003– 2004 season, a couple of things were in play. Certainly my fitness was far better than it ever had been, and that produced very tangible differences in my races. But even more important was that my mental preparation had improved drastically. I'd always been good at visualization, but that season it became a source of true strength. Even more surprising, though, was how these two abilities—my fitness and my mind—worked together in a way that I never could have anticipated. Because I was in

better shape physically, I got less tired and was able to use my mind more. So much of skiing is reactive, and when you're moving as fast as we do, you have to have super-fast reflexes so you can react in real time. I felt mentally sharper, and as a result, I was able to react much more quickly.

In the end, it really was a mental shift that permanently altered my skiing for the better. Strength and power can obviously help a lot, but you can tactically outthink people with your line and your approach. Someone like me, I overanalyze. I examine every piece of terrain, every bump. I memorize everything, because I feel that gives me a huge advantage. That's the first part. The next part is to translate it into my approach when I'm actually skiing.

I definitely believe I have a photographic memory, as far as visuals are concerned. I'm not that good at recalling past events. For example, a golfer might say, "I used a seven iron on the seventeenth hole, and I hit the ball one hundred fifty feet, ten feet from the pin." I can't do that. I can generally tell you what I did, but it's more that I remember what I *see*. I'm the kind of person who never needs directions. If I travel a certain way once, I'll never need a map again. I always know exactly where I'm going.

My dad said that comes from my grandfather. He called it a kinesthetic sense—having a photographic memory, combined with a strong sense of how your body relates to space and time. Growing up, I never thought I had anything special. I just knew I needed to memorize a course, so I did.

I'd visualize the gates until I could see them in my sleep. Whenever I stepped into the starting gate, I could see the entire course spilling out in front of me. I anticipated exactly what I'd have to do five, ten, twenty gates down the mountain, while remaining focused on the gate that was right in front of me. That was always my approach—to compartmentalize the task in front of me, to attack the course as a series of different components.

It helped me stay in the moment and made the impossible feel possible.

When I was at Ski Club Vail, we watched every event at Lake Louise. I think that's part of the reason why I was always so good at Lake Louise—the World Cup race there was the only one that was on television in the U.S., and we watched it over and over. After each race, we would all close our eyes, get in our tucks, and visualize the course. The coaches would time us while we did it. We watched so many replays that when I arrived at Lake Louise for the first time, I didn't even need to analyze the course that closely in person, because I already knew it so well. I felt like I had been there.

And that's what the goal of my preparation became after Cortina in 2004: Make every course feel like Lake Louise. Run it all in my head so many times that the actual skiing was never in question. If I could do it in my head, I could do it in the snow.

CHAPTER ELEVEN

The whole thing took an instant, barely enough time to make sense of what had just happened, other than the part where I was now in extreme pain.

Those moments after a crash are always disturbing, regardless of the outcome. It's nearly impossible to take a spill and not come out of it questioning whether this is it—not just for the race, but for your skiing career altogether. In a sport like this, it's so rare that we get to pick our exits; more often than not, they are forced upon us. Sometimes it comes at the end of a long career, sometimes people have to hang it up far too young. Stretched out in the snow in immense pain, it's impossible to know whether this is it for you, and it's equally impossible to keep that fear at bay. It floods in just behind the pain.

In skiing, danger is never far from us; even if we don't acknowledge the stakes, we all know them. We've seen it happen at races and on video. Sometimes there's a bad crash and you have to be the next person down the hill. Other times you've

already had your run, as you watch the helicopter come to airlift someone off the mountain. When things go bad in skiing, they can be catastrophic.

I'd crashed before, and I'd already had my fair share of injuries, but overall, I'd been pretty lucky. None of my crashes had been major, none of my injuries that serious. Now I was lying in the snow in Turin, Italy, trying to figure out which future awaited me. My time at the 2006 Olympics had barely begun, but now it was almost certainly over. More than that, though, I feared I might never ski again.

Once I got in my groove after Cortina in 2004, I never focused on the big picture or thought about overall titles. Whereas my goal as a young skier had been vivid and clear, in the form of reaching the 2002 games, now I was more focused on the consistency of performing week in and week out without dwelling too much on the big picture. In the moment, I just wanted to win as much as I could. Sure, I kept track of the World Cup standings, but it was always a one-foot-in-front-of-the-other sort of thing. I've never been one to go after things I didn't think I could realistically achieve.

You know those people who are compulsive one-uppers? Where whenever you do something or have something, they have to one-up you by doing or having something better? (Those people are really annoying.) Well, I'm like that, but instead of trying to one-up other people, I perpetually try to one-up myself. Throughout my entire career, especially during these years where I was really trying to prove myself, that was my mindset. After each success, I'd immediately look for how I could one-up myself, how I could take it one step further. As I did better and better, I kept increasing my aim, in a steady progression. I never knew what my next goal would be until I reached whatever I'd been working toward. It was only ever a question of *What's next,*

what's next, what's next? Constantly moving forward, letting the momentum I'd generated carry me.

The one exception to this approach was the pursuit of an Olympic gold medal. That was my big aim, the hopeful culmination of every effort I'd made. And when I arrived at the 2006 Winter Olympic Games in Turin, Italy, I felt ready to make those dreams a reality. Four years earlier, I made the Olympic team as a provisional member, still fighting to establish my spot. Now, it was a very different fight. My place on the team was unquestionable. This time, I wanted a medal.

This wasn't some pie-in-the-sky dream. Everything was lining up to make it a reality. In the months leading up to the games, I'd been crushing it in the downhill and slalom, and my recent results in super G and the combined were pretty damn good, too. I was scheduled to ski in all five disciplines at the games, and I had a real shot at making it onto the podium.

During my first training run, I skied exceptionally well, coming in second behind the Austrian skier Michaela Dorfmeister. On the second training run, I was leading halfway down the course, but right as I entered the second half, I ran into some trouble on a series of man-made rolls, which are undulations built into the terrain, using mounds of snow or sometimes dirt, to make a course more challenging. Rolls are smaller than jumps, and on their face they aren't anything special, but they still add another exciting element to the course. There were three in a row, and when I went over one of them, my ski got light. As I landed, my uphill ski hooked up and went in the wrong direction. The next thing I knew, I was being forced into the splits. Both my knees touched the ground—going eighty miles per hour—and the force of it flipped me over. All this happened just before a twenty-five-meter jump, which is a little over eighty feet. It wasn't the biggest jump by any means, which was fortunate, because as I continued moving

forward, I went off it facing backward. I hurtled through the air for a couple of seconds before landing flat on my back. I finally came to a full stop, my legs still in the splits, screaming the whole time.

Immediately, I thought my back and hips were broken. The pain was excruciating. It's not likely that you go off a jump backward, land on your back, and do not break something major. Someone on the mountain popped off my skis, which were still attached to my boots. They shot me up with morphine while I was still on the hill, then placed me on a stretcher and helicoptered me to a hospital in Turin. This was only the second time I'd been airlifted off a mountain, and I was terrified it might also be the last.

At first glance, everyone also thought I had broken my back. As I sat there crying in the hospital, awaiting the results of my MRI and CT scans, I fully believed that I would never ski again. I'd crashed before, but never like that. Like most skiers, up until that point, I felt pretty invincible. Despite the inherent risks, I never thought my career could end. Skiing had always been there, for as long as I could remember, and I never stopped to consider that it could be taken away. For the first time, I absorbed the magnitude of what could potentially happen.

That moment was a wake-up call for me. More than anything, it changed my perception of how much I needed my body. Up until that point, I had placed so much emphasis on my mind and the psychological aspects of the sport—mental toughness, focus, visualization—but now I saw that I couldn't make things happen with my mind alone. I also needed to make them happen physically. I realized how privileged I was to have my body, how lucky I was to be able to do what I do.

As I sat there, propped up in bed and sobbing, Picabo Street walked into the room. This wasn't completely out of left field; I knew she was at the Olympics, because she was commentat-

ing. In skiing, news travels fast, and because she was on site, she could actually get there faster than my coaches, who were still with the other girls doing their training runs. It was such a kind gesture, and I was so glad to see her. Since that day, I've been injured a lot of times, and I can tell you, it's not often that people will come visit you in the hospital. They're not the easiest places to be, especially for people who have had a lot of surgeries, which Picabo has. So, it was especially meaningful that she came. I cried the entire time she was there. It was *the most*.

Picabo wasn't alone; she was with her friend Micki Date, an energy healer who she often traveled with. Micki is also a practicing intuitive, and had been Picabo's adviser for a long, long time. Micki and I hadn't spoken much before this, but of course I knew exactly who she was.

As they stood by my bedside, I told them everything—about how well I skied on the first training run, about the crash, about my fears that I'd never be able to ski again. They did their best to distract me, cycling through a bunch of non-injury-related topics and trying to keep things light. Then Micki placed her hand on my face and told me not to worry.

"You will be fine. You will come back. You're going to ski, and you're going to win." She spoke with the utmost certainty and she told me she had a vision. "You will win three Olympic medals," she stated, as though it were fact. (And over the course of my career, I did, which is nuts.) I let her words sink in. I believe in these things, to an extent. But at that moment, I was just so grateful for her presence and her positivity. Whether she was right or wrong, she gave me hope, which was exactly what I needed.

My mom was also with me in the hospital, and she did her best to comfort me while we waited for the results. When the scans came back, it turned out I was okay. Improbably, nothing was broken. I just had some bad bruising on my back. As

soon as the doctors told me I was fine, I was ready to get out of the hospital. My brain immediately shifted gears from worrying about my injuries to focusing on the downhill, which was in just two days. Mind you, I was still in a ton of pain, and I hadn't so much as stood up since the crash. But as far as I was concerned, I needed to get out of there and back to the hill as soon as possible.

Even so, the doctors said they wanted to hold me overnight for observation, which I suppose wasn't a surprise. They meant business, and there was no arguing with them. The U.S. doctor even stayed overnight in the bed next to mine, to make sure that I was okay. My mom went back to her hotel for the night and said she'd be back to pick me up first thing in the morning.

After a fitful night of sleep, I woke up early, raring to go. I needed to get back to the Olympic village, get treatment, and prepare for the downhill race, which was now the following day. I waited and waited and waited, and after what felt like an eternity, my mom still hadn't arrived. I had been in the hospital for around twenty-four hours at this point, and that was enough.

I remained relatively patient until 11:00 A.M., which was definitely not first thing in the morning. There was no way she would wait that long. My mom didn't have a phone with her, so I had no way to contact her. Europe can be difficult and confusing, I figured. Not everyone speaks English, and maybe she was already here, but was having trouble getting upstairs. She must be in the lobby. That was the obvious answer.

I gotta get out of here, I thought. I grabbed my stuff, which was in a plastic bag, and made a run for the elevator. "Run" is a bit of an overstatement, because I could barely walk. I was still wearing my hospital gown at this point, which was open in the back. So, I'm hobbling down the hallway with my gown flapping in the breeze, booking it to the elevator. I made it there and pushed the button, letting out a sigh of relief. I really thought I

was home free. Just as the elevator doors opened, three nurses came running after me, screaming in Italian.

At this point, I was desperate for them to understand. I started speaking too loudly and too slowly, while making exaggerated gestures. "No! It's. Okay! My mom. Is. Downstairs!" They didn't speak any English, and I obviously didn't speak any Italian, so we just kept talking at each other. *"Non capisco! Non capisco!"* Despite my very best efforts, I was forced back to my room, where I waited for another hour.

At noon, my mom finally came up the stairs. The moment I saw her, I was like, "Where have you been? I need to get back!" It turns out, she was just trying to be thoughtful. She showed up late on purpose, because she knew I was recovering, and she thought I would want to sleep in. Of course, though I never said a word about it to anyone, that incident became the big news story that day—how Lindsey Vonn tried to escape the hospital.

I got myself back to the hill, and I raced the next day, although it was pushing the limits for sure. But I still believed I could do it. I had worked hard for this spot, and I was going to do everything in my power to honor it. Before you can ski, the team has a standard protocol where you need to do certain exercises before you can get back on snow. I did my best to grin and bear it.

"Does that hurt?" the coaches asked, as I made my way through a bunch of lateral bounds.

"No, no! Not at all!" I said, lying through my teeth. I was in so much pain. But I couldn't let them see it, otherwise I'd be out. All along my brain was like, *This is the Olympics.* I couldn't miss that. I had to get back up there. I thought it must be obvious how much I was struggling, but somehow, they cleared me to compete.

All I wanted was to get back in that starting gate, and I did. It was one of those perfect days on the hill, where the sun was

shining, and the sky was blue and clear. I didn't do that great—I managed an eighth-place finish—but I got back up and I tried.

When the games were finished, I wound up getting the U.S. Olympic Spirit Award, which is voted on by fans, the media, and other Olympians, and given to the athlete who best represents the Olympic spirit. It's an almost clichéd ending to this experience, but it also felt weirdly appropriate. Of course, I was going to fight my way back from an injury—any other Olympic athlete would have done the same. Still, I was grateful to be recognized for that. Especially when I contrasted this experience with the 2002 Olympics, it felt nice to be recognized. This time, the coaches saw my efforts. They were paying attention and they appreciated me.

I'm not going to lie, though, I was disappointed. I'd been skiing so well leading up to this point, and this wasn't anything like the big Olympic finish I'd imagined. Nothing had happened the way I'd hoped, but with my newfound gratitude, I felt more able to deal with the disappointment this time around. In a way, the 2006 Olympics were one of the best things that ever happened to me, because they put things in perspective. The games shone a spotlight on the sport I loved so much I couldn't be without it. I reminded myself how grateful I was that after being airlifted off the mountain just two days before, I was still here, getting to do what I loved.

It's hard to crash like that and not have it impact your confidence, but at the same time, I'd located something else inside myself—a deeper resolve, a reaffirmation of how precious our time is, and how much every opportunity matters. Those games gave me a new lease on life. They also provided me with a source of motivation I would draw on for the next four years. I crashed, but I wasn't devastated by it. No matter what happened, anything was better than not skiing. From here on out, I decided that if I was going to go down, I would go down try-

ing to win, every time. I would get back up and keep on trying. I didn't have unlimited chances, and it was up to me to make them count. This setback—painful, scary, and disappointing as it was—became foundational to who I was on and off skis. The real change in spirit was the part that no one else could see. Now I understood that everything can be taken away at any second, so you have to appreciate every day, every race. I would never again take skiing for granted. Perhaps most important, I never looked at my body the same way again.

CHAPTER TWELVE

For better or worse, every time I stood in the starting gate, I believed that I could win. Of course, you don't win every time, but you always have to believe—even when the course is scary as hell.

At the World Cup races in St. Anton, Austria, in December 2007, it was the first time that women had raced there. Since 2001, they had held the men's World Championships there, which meant we all would have to race on a men's track. It was a technically demanding course, with a ton of turns on top of shifting terrain, including a portion in the middle of the course that was too steep for groomers to go on. It was gnarly.

When a course was more demanding, it meant I had to study it more—more variables mean more preparation. With any course, you want to know everything you possibly can about it—exactly where you need to go and what it's going to take to win—and the more challenges there are, the more elements you need to keep track of. It also means you need to come up with

a good game plan to ensure you're ready to meet those challenges. Often, knowing where you can afford to make mistakes, where you can push the limits and where you can't, is the most important part. The stakes are higher on a harder course. You can't make a mistake in the wrong place, because you won't get another chance.

It's kind of like how in tennis, there are a couple of ways you can approach your game. The first is to just play your opponent and try to beat them. The second, more involved approach is to analyze your opponent's weaknesses, and attack those weaknesses to your advantage. Skiing is really similar, except the mountain is your opponent.

In either case, you have to prepare. And then, when the time comes, you have to take what you've gathered and execute it in real time. In that way, ski racing is like a physical game of chess. The research is always available, but ultimately, it's up to every athlete whether they do it or not.

Every time I approached a course I hadn't skied before, no matter how difficult, I studied what people had done in the past. There are always trends you can learn from, whether they're general mistakes or certain parts of a course that consistently cause trouble. What part of the terrain tripped up other skiers? Where can you afford to make an error, and where can you not?

For a course like St. Anton, I couldn't leave any stone unturned. The previous summer, well before the season, I'd actually hiked up the hill to get a grasp of how steep it was. I wanted to see the terrain and get a feel for it, which would help me visualize the course. It was just as tough as advertised. Still, I didn't let the difficulty throw me. If anything, I felt more excited for the challenge. Skiing with confidence will do that.

In the year after the Turin Olympics, I'd won two silver medals in the downhill and super G at the World Championships in Sweden. Then, on the training run for the slalom, I

hooked a tip—a common problem for me, when the tip of your inside ski goes on the wrong side of the gate, where it catches, causing you to straddle. I've had all sorts of injuries that way, but in this instance, I partially tore my ACL. In practical terms, it meant I had to stop skiing for the rest of the year, and since I had that unexpected downtime, I figured it was as good a time as any to plan a wedding.

We ended up marrying in September 2007 in Deer Valley, Utah. My family was there, and there was no shortage of tears, including from Grandpa Don. As the most stoic member of the family, he had never cried in front of me before, and I was touched that I could inspire that kind of emotion from him.

I started the 2007–2008 season on a high—newly married and on a tear. And now here I was at St. Anton, staring down this pretty insane run. It wasn't a popular course by any means, largely because it was so difficult. The entire course is steep, but the bottom section is what sets it apart. Skiers go over the "waterfall" and into "hell," a huge drop-off leading to an incredibly steep portion, into a compression—an abrupt change in the pitch where the course suddenly becomes flatter. While this is happening, the whole thing suddenly transitions from sun into shade. You pick up a ton of speed there, and it's hard to control the g-forces, especially since you can't see well in the darkness.

A lot of the other women crashed, and many others encountered so much trouble that they pulled off the course and didn't finish. Whenever racers crashed before me, I always asked the coaches if there was a problem on the course, because there were different reasons that a crash could happen. Was there something on the course that was causing them to crash? Or was it their fear? Because I came into every race with a predetermined game plan, it was rare that my approach changed, but I would amend it if something was wrong with the snow conditions, or if a jump carried farther than I anticipated. In this

case, however, the coaches said there wasn't any universal issue, they were all just making dumb mistakes.

Okay, I thought. *They're just as scared as I thought they were.* And I stayed the course.

Though that level of fear wasn't something I was personally fluent in, as my career progressed, I learned how to read it in others. Some racers were afraid of speed, others of jumps, while others were tentative, in general, because of the risk inherent in the course. Sometimes, when a racer has had injuries in the past, those things stay with them. Whatever it was, I could see it when they looked at the course. I could read it in their face, in their mannerisms, in the things they said.

Generally, the most common thing I observed in other racers was fear of taking risks. They might still ski well, but they'd be afraid to push it to the limit, to toe the line right up to where they might crash. They maybe even went *right* up to the limit, but they didn't touch it, which isn't going far enough. There are so many factors at play in every race, but if you can eliminate just that one—if you're willing to go just beyond the point where anyone else is—it gives you a leg up on the competition. And as I stared down the course, I was not afraid.

I ended up winning both my races that weekend—the downhill and the combined. That final section was pivotal for me—the stretch from "hell" to the finish line is where I won the race. In fact, I absolutely crushed the downhill, winning by a huge margin of nearly a second and a half.

After I won, I was at a press conference sitting next to Robert Trenkwalder, who ran the Athletes Special Projects program at Red Bull, whom I'd partnered with at age nineteen, and who would go on to become one of my longest-lasting and most significant sponsors. A reporter asked me, in German, how I won the race. "What's the key to your success?" he asked. "Everyone else is having a hard time."

I leaned over to Robert and said, "How do you say 'balls' in German?"

"What do you mean?" he asked.

I was like, "You know," and made a gesture in the general direction of his crotch.

He started to laugh. *"Eier,"* he said, which is literally translated as "eggs."

I turned back to the press and said, in German, "You have to have big balls." The whole room erupted in laughter.

"No, really," the reporter said.

"No, really," I replied. "That's my answer."

After that, it became a thing. People would ask me, *Where are your balls, Lindsey? How are your balls?* But honestly, that's what downhill is. Having balls. At its core, downhill is about who is willing to throw themselves down the mountain the fastest. I have my foot on the gas pedal until I'm crashing into the fence. And that is why I crash into the fence.

I'm never nervous about going too fast or trying to slow myself down. It's all or nothing for me. When the going gets difficult, or more challenging in any way, you can count on a lot of the girls to back off. Certainly not everyone, but at least a third of the field. If you want to be the best at a sport like skiing, then there's no room for fear. Races are won or lost by how far you're willing to push yourself, what you're willing to risk, where you see your limits. You have to put it all out there, push the edges of what's possible—just go for it. All out. If you're a true downhiller, you want to do high-speed jumps, big turns, big compressions. You want to do it all. There are very few people who you can call true downhillers. It's not exactly normal.

The truth is, for as long as I can remember, I have never felt afraid. Fear was never a factor for me. Even as a little kid, I can't remember a single time I was fearful. I think back on all the trips my mom and I took, from Minnesota to Colorado

and back, when there were plenty of times where we'd drive for hours through a blizzard. My mom would say, "We need to stop, I can't see the lines." And I would tell her, "It's fine. Keep driving. Go where I say to go." I didn't sense danger, and I wasn't afraid we might get into an accident. I just wanted to keep going. (I don't know why she listened to a fifteen-year-old. But I had an odd confidence about things, and I could often use it to my advantage.)

A psychologist friend has said to me, "I would love to do an MRI to see what's going on in your brain." She's convinced, and I have to say I agree with her, that there is something about the way I'm wired that prevents me from processing fear. If you were to take a look at my brain, I suspect it's something similar to Alex Honnold, the climber from *Free Solo*, whose amygdala (the part of your brain that registers fear) is nearly impossible to provoke. I feel the most at home when I'm going eighty miles per hour down the side of a mountain. I am perfectly calm and confident in those moments that other people would find terrifying.

I guess that would also explain the pure thrill I felt the first few times I went speeding down the mountain, or when I drove my grandparents' golf cart as fast as it would go. Or why I'm never afraid when I'm diving with sharks or rappelling down a cliff. When something comes with a warning of risk or danger, it never frightens me in the slightest. To me, there is only adrenaline, the thrill of being alive. That's the most exciting feeling there is.

That's not to say I don't experience anxiety—that's different. I have emotional fears. I am afraid of failure. I am afraid of not being good enough. I am afraid of abandonment, of people leaving or turning their backs on me. I am afraid that when some headline says I can't do something, that there may be a kernel

of truth buried in it. But my fears are never informed by the presence of danger. They are never tied to physical consequence. They are never about my personal safety.

My sister Karin always asks, "Why did you become what you are, and I became what I am, when we grew up in the exact same situation?" We have similar body types, we come from the same family, we had the same opportunities and access to skiing. But we grew up and became two different things entirely, and she's fascinated by how that happened. Well, the thing is, she can feel fear. To me, that's the difference.

While this had always been true, as I matured as a skier, as I grew into my muscles and my training, as I understood my body and what it was actually capable of, I was able to harness my lack of fear in ways that brought my skiing to an entirely different place. Sometimes it was like on the St. Anton track—I could just ski aggressively in places that others would not. Other times it meant feeling collected in moments or during conditions where fear was more of a distraction for others. Regardless of the situation, as my skiing improved, this absence of fear took on a new integral dimension in my performance.

Interestingly, though, it took many years for me to understand the role that having no fear played in my performance, to become conscious of what was going on—or perhaps more accurately *wasn't* going on—inside my head. While my lack of fear seems like a superpower, I never thought about it that way, mostly because for years I didn't even realize that what I experienced was different, until other people told me so. I mean, how could I recognize the absence of feelings I'd never experienced? Sometimes, on the mountain, I heard what the other girls would say—when they looked out at the exact same conditions and expressed entirely different things. For them, there was fear in the anticipation, and sometimes in the execution,

when weather was rough, or the conditions were particularly dangerous. I never looked out at the course ahead of me and saw danger. I only saw a challenge.

People, perhaps somewhat naturally, ask if I'm afraid of death, and the truth is, I don't ever think about it. Even in high-risk moments, it doesn't really occur to me, because you could die at any time. You could be in the wrong place at the wrong time. You could be walking down the street and get hit by a car. There are a million different things you could die from, but if you stop to think about that, then you aren't really living, you know? So instead, I never, ever think about consequences (which can be a problem, I suppose). That's one way to embrace what's in front of you without worrying what comes next.

My lack of fear is probably part of what pushed me to go where others wouldn't, including the times when I probably came back from an injury sooner than I should have. For a lot of people, there is this ingrained fear about testing their body, or doing something before they're "ready." But that's not something I worried about. It's not like I would blatantly go against what a doctor told me, but I never had that sense of trepidation that others had about coming back. I was never focused on the consequences, I was focused on what came next—the next race, the next goal, the next milestone. I wouldn't let anything derail me, because I didn't want to miss a minute. For me, the only risk I felt was the risk of regret. The only thing worth fearing was not taking the big chances. Wondering "what if?": That's the scariest thing of all.

Sometimes having balls can also mean having the courage to do things differently, to refuse to be boxed in by expectations. The better I skied, the more taking risks became second nature—as long as the risks I took could make me faster.

Later that year, in the summer of 2008, I was at Coronet

Peak in New Zealand, on some of the iciest conditions I had ever skied. I was training slalom next to Olympic gold medalist Ted Ligety, who had just won the combined in Turin. He was cruising through the slalom, skiing on this solid ice like it was nothing, while I was sliding all over the place.

"What are you using?" I gestured toward his skis. "I can't get a grip."

He gave me a confused look.

"Can I try them?" I asked.

"They're men's skis," he replied.

"No shit," I said. "But can I try them?"

He somewhat reluctantly agreed. Luckily, my boot fit in his binding, and then I was off. I tried a run on his skis, and it was the easiest slalom I'd ever had. They were so much faster. It clicked for me then, and that was it. I was sold.

For a female skier, skiing on men's skis is not something you naturally think to do. But it made a lot of sense to me. Men's skis aren't better, per se. It's not like any woman could hop on men's skis and that alone would make her better or faster. The main difference is they're longer and stiffer than women's skis. Choosing the right skis is kind of like choosing the right tires for your car. The heavier you are, the longer your skis should probably be. Men's skis take more power to turn, but they're also more stable.

Personally, I like stiffer skis, but plenty of people (both male and female) don't. When I trained with the French or Canadian or Norwegian men, I'd always ask them, "What's your stiffness?" and would find, even though they were male, they usually trained on softer skis. When it comes to equipment, everyone has their own little nuanced things that work for them. It's all about personal preference.

One thing men's skis have going for them is that because there are more men racing, companies put more research and

development into their equipment. When it comes to innovation in gear technology, it happens in waves. Certain manufacturers will figure something out that the others have yet to recognize. They'll dominate for a minute, until everyone else catches up. You also have to factor in that no two skis are alike. Each and every ski is made differently, and you never know what the factors could be. It could be one degree warmer in the factory that day, and that would make a difference. Out of one hundred skis, maybe five of them will be pretty fast. So, the more skis you make, the more fast skis you'll produce.

There are so many changes made to the equipment over the years, and that can have a lot to do with people's struggles. Sometimes a change suits you well, and sometimes it doesn't. In skiing, there are lots of variables you can change about your equipment to make it faster. You can change the boot, the ramp angle, the bindings, the ramp angle *in* the bindings, the construction, the core, the bases, the edges . . . truly, a million different things. Some people take whatever their technician gives them. Other people are super detailed and rework a lot of things. But it's a slippery slope—if you adjust too many things, you have no base to work from, so you can't change too many variables at one time.

Personally, I was able to create more power and ski faster on men's skis. They suited me well and I felt comfortable on them. But everyone thought I was insane. Before the season started, rumors started circulating that I was on them, and everyone was more or less laughing at me. There was a lot of "Who does she think she is, skiing on men's skis? She's never going to be able to make the turns."

When I made my debut on men's skis, I won the first three races in Lake Louise, and I won by large margins. After that, people were like, "Okay. Wow. Never mind." Some people thought it was wrong and should be made illegal. But the

truth is, I wasn't giving myself an advantage. If anything, using men's skis made it more difficult for me. I was just better at controlling them.

Before I started on men's skis, I had never really performed well in slalom. I'd had a few good moments and a bunch of top-ten finishes, but not since back in my Minnesota days would I have considered slalom to be my specialty. Once I started skiing on these longer skis, I found my form again, and I really stepped up my game.

At the 2008 World Cup races in Levi, Austria, I was due to start eighteenth in slalom. The way it works in slalom is that the top skiers start in positions one through seven, and the next group goes eighth through fifteenth. My eighteenth-place start meant I wasn't anything close to a serious contender. I may have had these new skis, but no one—including me—thought I would make a great showing, let alone push my way onto the podium.

Then, on my first run, I absolutely destroyed the course. It felt like I was flying, the same way it did when I first tried Ted's skis back in New Zealand. I finished with a time of 53.61, nearly a quarter second ahead of Nicole Hosp of Austria, who had led the field at 53.83. It was the fastest time by a decent margin, and I was in unfamiliar territory.

"What the hell was that?" asked my friend Maria Riesch after the first run. She had posted a 54.08, which put her in fourth place.

"I don't know, dude," I said. Honestly, I was as surprised as she was.

For a long time, several years actually, Maria and I finished one and two in downhill, so we were used to being competitive there. But typically, she was dominant in slalom while I excelled at super G. This was new territory for both of us.

I may not have known where that first run came from, but

once I had the lead, I was determined to keep it. I visualized the course leading up to my second run—where I needed to be, what I needed to do. There was a long flat at the top of the course that would play to my advantage, and the steep part was pretty steep. As I stepped into the gate, Maria was in second place with a time of 54.56, just .26 seconds behind *another* Maria, Maria Pietilä Holmner of Sweden, who was currently in the lead.

I absolutely crushed the top and banked a lot of time where I could on the flats. The goal in slalom is to go around the gate by the thinnest margin. On the steep part of the course, I made a huge mistake and almost crashed out. From that point on, I attacked the course like a bull seeing red. I started to redline the course in such a way that I was banging through the gates like they weren't even there. That's how you need to do it. No second-guessing, no hesitation. You just look for the straightest line possible, because that's the fastest line, and then you go for it—hard.

As I crossed the finish line, I didn't see my time straightaway, but I did see the Swedish Maria, sitting in the top spot in the leader box. Then my time flashed on the leaderboard, and we both knew I had won. She was very gracious about it, as she stepped forward to offer me a hug. The other Maria, *my* Maria, was right behind her.

That year, on my men's skis, I got to wear the red bib for most of the season. The red bib in skiing is like the yellow bib in cycling—it signifies that you're the best in the world at this one event. Whoever is leading the standings get it, and to get the red bib in slalom was a big deal for me.

After that showing, most women made an attempt with men's skis, but when they tried to turn with them, found they couldn't. Then, of course, all the ski companies tried to make

an in-between version—not quite women's and not quite men's. Though I continued to use men's skis in downhill and super G for the rest of my career, my reign in slalom ended the following year, when FIS changed the regulations on the radius of the skis, which altered how the ski turns. Once that happened, men's skis didn't really work for me in slalom and GS anymore, but our time together was certainly fun while it lasted. It was an interesting time, that season. A pivotal moment for me and skiing alike.

The thing is, when I made the decision to use men's skis, I wasn't trying to make a statement about gender. Honestly, that hadn't even occurred to me. I just found something that worked for me, a way to be better and faster. It was more of a technical decision than anything else. I'd always done whatever it took for me to be the best, even when it meant doing things differently. As my career progressed, breaking down different gender barriers was often an unintended but very welcome consequence.

Just as with men's skis, I never approached any part of my career through the lens of gender. Now, in retrospect, everyone talks about gender, but it wasn't something that I ever thought about when I was younger. I didn't grow up thinking girls couldn't do things, and I never really saw a distinction between what men could do and what women could do. I saw Pete Sampras and Andre Agassi and Steffi Graf and I made no distinction between them.

As I was coming up in the skiing world, my dad always said, "This is the perfect time to be a woman in sports." Before my time, women didn't get as much airtime in sports, but after the force created by Mia Hamm, who collaborated with an impressive roster of major brands, appeared in dozens of commercials, and even had her own video game, it was a different story. But beyond the marketing angle, my dad never pointed out gender.

He said, "Be the best you can be," and that's it. I'm glad for that, because that's the way I always saw things. I just wanted to be successful, period.

Because I was so singularly focused on simply being the best, I approached everything I did with a broad stroke—even if that meant taking risks. I always thought, *If I do the right things and say the right things and work hard on the hill and in the gym, that's all it'll take.* Of course, as the years went on, I realized it was far from that simple. But early on in my career, back when a more risk-averse mentality could have really held me back, I never thought about barriers or norms of any kind. I never stopped to consider any other factors beyond my abilities. Instead, I did whatever I needed to, all in service of being fast—without limitations.

CHAPTER THIRTEEN

It doesn't matter how much success you have, it's easy to feel like an underdog when people are constantly making you aware of your shortcomings. I guess that's why I arrived at the World Championships in Val d'Isère in February 2009 still feeling like I had something to prove.

So far in the 2008–2009 season, I'd been kicking ass—just a couple of weeks before, I'd won the slalom and super G in Garmisch, marking my seventeenth and eighteenth World Cup wins. Yet despite making the podium at the previous World Championships, taking two silver medals in Åre, Sweden, in 2007, I had never won gold at the World Championships. And of course, I had never won gold (or any medal, for that matter) at the Olympics. The press loved to remind me of both these disappointments, and leading up to the 2009 championship races the chorus went something like, "Hey! You've never won gold! You've never won gold! You've never won gold!" Frankly, I was tired of hearing it, so this time, my plan was to win.

I had my work cut out for me. The track that year was very difficult, and on a completely different slope than we normally skied. All spring long, the French team had been training there, which meant they had a huge advantage. With only two days on the hill, there was no way I could ever know the course as well, but I took my time with my inspection, trying to get every last detail committed to memory. In those days leading up to the race, I kept visualizing the course, keeping my mind focused on what I needed to do.

There was also the issue of the weather, which changed quite a lot. In the super G, it started off clear, with a perfectly blue sky and sunshine. The first five or seven racers had a beautiful, storybook day. Then, suddenly, a storm rolled in. The light got flat and dark, the snow started falling, and before you knew it, it was a whiteout. That often happens in skiing, where from the beginning to the end, it's like you're skiing two different races on two different days. Still, this was easily one of the most dramatic swings I've ever seen. As the top girls started their runs, I could see that it was a struggle. Racers were coming down full seconds behind the girls who had taken the early runs.

Everyone was nervous. I could see it in their eyes, in their body language. The first girls to go didn't ski aggressively, didn't attack the hill. They were passive, hesitant, afraid—the kiss of death in downhill. The second you give yourself over to the course, you're done. If you're not attacking the course, the course is attacking you.

I watched the girls ahead of me for anything I might be able to use. Now, it's one thing to know where the gates are, but there's no way to know the snow until you're on the course. There could be a hole, or a rut. The condition of the snow changes as more people ski the course. You can watch whoever races before you, but that will only tell you so much. It will tell you where someone got rattled, but it won't necessarily tell you why.

I watched Maria Riesch take her run, knowing her performance would be a good gauge, and she came down two or three seconds behind. She slid into fifteenth place, and at that point, I knew I was in trouble. If Maria's run was any indication, there was almost no chance of my getting a medal, never mind the gold.

It was clear it would not come easily, but the thing is, I love a challenge. I thrive on a challenge. I think I ski best when there is no other option except to ski 110 percent. I like knowing when there's a title on the line and the person I'm fighting against is right in front of me. I want to know what her time is, and exactly what I have to do to win the title. I like backing myself into a corner and fighting my way out. In that way, I actually enjoy being the underdog, because I like being scrappy.

I slipped into the starting gate, ready to give it everything I had. The worse the odds, the more I'm willing to rise to the occasion. And here, the odds were definitely against me. I knew I had no choice but to outski everyone to have any shot of getting in there. So, that's what I did. I let my instinct lead me down the hill, pushing as hard as I could. My legs acted like shock absorbers, prepared for any bump or roll. When the light is flat and visibility is poor, your ability to execute comes down to a combination of what you glean from your inspection—how well you know where you're going—and having a feel for the snow. Since you can't see the ground, it's better to use your preexisting knowledge of a course to predict what's coming, instead of relying on your eyesight. Meanwhile, your body has to be prepared for just about anything. When you're going for broke, you still need to be smart about it. So, I summoned everything I had—strength and power and agility. I needed them all to work together, and luckily, they did.

I finished with a time of 1:20.73, which was three-tenths faster than the leader, Marie Marchand-Arvier of France, who,

in addition to having the home-hill advantage, had started back when the sun was still shining. I waited for the rest of the field to come down the course, doing my best to look—and feel—like I was confident and not too anxious. One by one, the other girls tried to chase me. But no one could throw down a faster time.

The gold was mine. I finally had my World Championship win. This also made me the first American woman to win the world super G, a title I was all too happy to hold. But I couldn't fully celebrate, because now that I'd won, I needed to do it again. (I mean, what else would you expect from a compulsive one-upper?)

The next race was the downhill, but as it turned out, the conditions had gotten so bad, they delayed it for another couple of days until the weather improved. Over those next two days, the pressure to win just kept building, which presented its own sort of challenge. I was all amped up and ready to race, and I needed to keep the momentum going without burning out.

Normally, at the start, I was quiet and focused, concentrating on my breathing and what I needed to do in order to win. I became so unapproachable in the moments leading up to a race that everyone knew better than to talk to me. But before the downhill, my nervous energy was so high that I didn't know how to handle it. So, I reverted back to the way I used to behave at my very first races. As a kid, before I developed a system to deal with the pressure, I was known to joke and dance and even start snowball fights—anything to distract myself and take my mind off my nerves. In the moments before the race, I tried to goof around with Nicholas, my technician at the time, a serious type who wasn't very jokey, but it still helped.

My only play was to ski aggressively, staying as sharp as I could. When you're on your toes, you can react to anything the course throws at you. You can self-correct, make an adjustment. If I ever made a mistake in a course, I would think, *Just find the*

fall line. The fall line is almost always an instinctual thing. You can't always see where it is, especially when visibility is poor, so you have to feel it with your body. When you're executing, meeting the fall line is a natural sense. You know it when you're there. It's like seeing red. I would drop the hammer down and make up for lost time. Some people have an innate ability to use the fall line, and some people don't. That's something Bode Miller was really good at. He's such a gifted athlete; he could change tack in an instant. He could make these impressive comebacks that not many people could make, like finishing a race on one ski.

The pressure I felt to win the downhill was immense, not only to win a second World Championship gold, but because I knew the Olympics in Vancouver were just around the corner. This was my precursor. If I was going to perform there, on the biggest stage of all, I would have to find a way to overcome my nerves and balance my adrenaline. Adrenaline can be a good thing, if you can control it. The trick is to harness it, keeping it at the right level, while staying loose and ready to race.

In this instance, it was less about instinct and more about stepping on the gas—going as hard as I could go, through the entire course—or I knew I wouldn't even be close. Practically, that meant pushing it to the limit at every moment, going right up to the point where I almost lost control.

I posted a time of 1:30.31, which put me a half second ahead of the leader, Lara Gut of Switzerland. Now, I could finally celebrate. I had two gold medals at the World Championships, and there were still two races to come. It felt like I had finally stepped out from the shadows and into the light. The Vancouver Olympics were just around the corner, and I was ready. And now, everyone else knew it, too.

After the race, there was a press photo op, organized by Rossignol. It was in one of the ski lodges at the bottom of the

mountain, and they set it up to look like a party, to celebrate my win. The idea was that I would stand on a stage in front of a crowd of people, while one of the reps congratulated me, and everyone would take a bunch of photos. It was a good chance for the brand to get extra exposure while formally acknowledging what was a pretty big moment in my career.

As part of the photo op, someone handed me a bottle of champagne and told me I should open it, and then shake it up and spray the crowd the way they do in movies. Now, I had never opened a champagne bottle before, in my entire life. (It's not like I'd never *had* champagne, I'd just never been asked to open it.) I tried really hard to get it open, but I couldn't. The rep who was on stage with me tried to save me, but he couldn't get it open, either. It was a comedy of errors. At this point, the cork actually snapped as we tried to force it, so the situation was looking pretty hopeless. That's when someone from Rossignol yelled out, "Take a ski and slice the top off!" Almost like a bar trick.

The rep did as he was told, and it totally worked, but I guess it shattered the neck of the bottle more than it was supposed to. He handed it to me, champagne overflowing down its sides, so I didn't notice how jaggedly the glass had broken. I put my thumb over the opening, gave it a good shake, and started to spray the crowd.

There I was, spraying everyone, trying to get the photo, when all of a sudden, the crowd went silent and I saw the blood pouring down my arm. I'm not talking about a trickle; this was a serious amount of blood. I would have looked right at home on the set of a horror movie. The party was over. Everyone stopped cheering and looked at me in terror.

I ran outside to my physical therapist, thinking, *Oh fuck*. He tried to assess how bad the damage was. "Can you move your thumb?" he asked. I tried to move it and I couldn't.

We headed back to the hotel so the team doctor could check it out. He took one look and informed me that I had sliced clear through my tendon. A tendon, which attaches your muscle to your bone, is kind of like a spring or a bungee cord, in that it stretches and recoils. In this case, it recoiled all the way down into my hand. "You need to get it repaired right away," the doctor told me, "otherwise it will shrivel up and they'll need to cut far down your hand in order to get it back out."

I had a race in two days, so Red Bull got me a private plane to fly from France to Austria. (That part, at least, was pretty cool.) Once we got to the hospital, the hand surgeon wouldn't touch it, because he didn't want to be responsible. So instead, I asked a knee surgeon, Dr. Fink, who agreed to fix it. He tied the tendon in a ton of knots, which is why, to this day, my right thumb looks funny and doesn't straighten all the way. In a way, it's like a souvenir from my first World Championship golds.

My thumbs-up may look like I put my hand through a wood chipper, but it's in good company. On that same right hand, my fourth finger is super fucked up, and it's not even from skiing. When I was eleven, we were getting in the minivan at one of Erich's training camps at Mount Hood, and someone shut the sliding door on my hand. I had to get stitches, and it's permanently gnarled. For a long time, my nickname was "fingers." My right pinky doesn't straighten from this one time when I crashed in the Vancouver Olympic GS race and broke it. Of course, I had to race in the slalom the next day, so I had them make a soft cast in the shape of a hand gripping a pole, and it healed that way. All of which is to say, with two World Championship races still to go, this thumb injury obviously wasn't going to stop me.

The next day was slalom. As a skier, the nice thing about injuring your hand or arm is that you don't really need them. Sure, you need them to push from the starting gate, but in essence, you ski with your legs, so it's possible to manage. I wasn't

supposed to use my thumb at all, but it's kind of hard to hold a ski pole without it. So, we duct-taped my pole to my hand.

I was almost in the starting gate when I realized I still had my jacket on. Ordinarily this wouldn't have been a big deal, except for the part where my hand was already taped to my pole. We frantically tried to free my hand and get my jacket off, not disturbing my thumb too much, and then immediately scrambled to retape it. Meanwhile, I couldn't buckle my boots, my shin guards weren't tight enough . . . it was so chaotic. The whole situation was really less than ideal.

After the first run, I wound up in second place. On the second run, I got a bit off balance—I leaned in and my skis got out in front of me—and I tried to put my hand down but couldn't stay on my feet and crashed. Maria Riesch wound up winning. Later on, looking at the tape, I noticed that I probably wouldn't have leaned that way if my hand hadn't been taped to my pole. Were it not for the whole thumb incident, I would have had a good shot at making it onto the podium again, but I can't rewrite history.

Still, the relief at winning those medals was tremendous—I'd proven myself at exactly the right moment. Soon, I would need to step onto the biggest stage of them all, and having never won an Olympic medal before, I knew the pressure that was about to come. But now I also knew what gold felt like. I had the conviction, and now I also had the validation.

More than that, though, I looked back and saw the climb that had gotten me to this point. From my current perch higher up the mountain, I'd think back to those times after the 2002 games when I'd had so much doubt in myself that I'd almost ended my career before it had even gotten started. I never forgot what that doubt felt like, and even as I continued to ascend, I'd hold those old feelings up to the light—not to bring myself down, but to remind myself of the journey and how far back it

went. Seeing how far I'd traveled was a form of empowerment and pride—my own version, I guess, of what it must have felt like for Grandpa Don to drive around the streets of his town and see all the sidewalks he'd poured concrete for. Hard work got me here—now I needed hard work to sustain it.

Part of what happens when you stop being an underdog is that you start being a target. Everyone is coming for you. Sometimes this leads to healthy competition, sometimes it leads to resentment—the challenge is to use whichever it is to make you stronger.

By the winter of 2010, with the Olympics only a month away, I had become a favorite. Between the gold medals at the World Championships and back-to-back World Cup overall titles for the 2008 and 2009 seasons, people knew what I was capable of. I also started the season on a tear, winning every downhill race I entered and most super Gs. Then, in January 2010, the head of the Austrian Ski Administration said the reason I won so much was because I was bigger and thus heavier than the other girls and this gave me an advantage. Now, granted, he said it in German, and a lot of words don't translate directly to English, but pretty much everyone was on the same page that the way he said it implied that I was big. I did not take kindly to that comment.

The weekend after he said it, I was scheduled to compete in three World Cup races in Haus, Austria. Other people's negative comments were always enough to fuel me, but this one felt sufficient to catapult me to the next level. I was so pissed off that I decided I was going to win them all.

The opening race of the weekend was a downhill, and I put up a time of 1:38.84, which landed me in first place, 0.35 ahead of Anja Pärson of Sweden. Win number one went off without a hitch.

The next day was a second downhill, and there was a long weather delay. I tried not to notice, tried my best to stay focused and in the right frame of mind, but it was tough. The fog at the top of the mountain was insane and wasn't showing any signs of letting up, so finally, they decided to shorten the course. The adjusted start, in the middle of the course, was set up on one of the flats, which meant I couldn't rely on gravity so much as I pushed out of the gate. On a shortened downhill course like this, you couldn't afford any mistakes, because there wasn't room to make up for lost time.

Near the start, there was a bit of a mishap where I got my pole stuck in my legs, possibly because my wrist was broken from the races in Lienz after Christmas, but I'm not one to make excuses. As it was happening, I thought I was screwed, but luckily it only cost me about a tenth of a second, and I was able to find the right turns to tuck through and pick up whatever time I'd lost. Somehow, I posted 1:09.12, this time just 0.14 ahead of Nadja Kamer of Switzerland, which was enough to put me in the lead. Win number two wasn't quite as seamless as the first, but that only made it sweeter.

The weather cleared on time for the third race, a super G, on Sunday. I drew bib 19, so thankfully, I got to see a number of girls go off ahead of me. Martina Schild of Switzerland posted a 1:27.54, wearing bib number 2, and her time held for the longest while. Her lead went on for so long, which confirmed the course was slowing down as it was getting softer, until Anja Pärson shaved .32 off Martina's time, and Nadia Fanchini of Italy matched it, so I knew a win was still possible.

As I stepped into the gate, I thought, *This is mine.* I knew that I wanted to silence the Austrian coach, but mainly, I knew that winning three times in one weekend would be insane.

Super G is always a challenge. You only get one inspection, you have to be perfect with your line, and it can take a lot out

of you. But I stayed focused and I found a way to get it done. I put up a 1:26.69, more than a half second ahead of Anja's time. I was thrilled.

I had never swept three events in one weekend, at any level. But now, I had won all three. As I stepped onto the podium that third and final time, I thought of the head of the Austrian Ski Administration. He hadn't meant to, but his comment had given me enough fuel to crush all three of my races.

"Three races!" the reporters all said. "How did you do it?"

"Maybe it's just because I'm big," I replied.

After the fact, he apologized, but in truth he wasn't the first European ski director who wasn't a fan of me, and he certainly wasn't the last. One year, at the World Championships in Garmisch, I skied down the training run in my jacket and pants, with my bib on over my jacket. The director of the German Ski Federation saw it and called me a monkey circus. I had sustained a concussion earlier that week, and when I went down the training run, it was largely a test, to see if I could actually race. So what if I wore my jacket and pants? Was it the smartest thing in the world, in that situation? Maybe not, but I still won a bronze medal, so I don't really regret it.

The truth is, none of those guys particularly liked me, because I did things my own way. It was just one of many times over the course of my career where I felt misunderstood, simply because I was different. As an athlete you're in the public eye, and people are always trying to figure out how to categorize you. There have been so many different kinds of male athletes over the years, in part because there have just been so many male athletes, period. But as a female athlete people don't always know what to do when you don't fit their expectations. They were confused when I spoke my mind and did whatever I thought was best for me. They especially didn't appreciate how I didn't conform in a sport that's entirely male-dominated.

It's true—besides the athletes, and sometimes the physical therapists, there aren't *any* women in skiing, a problem that continues to this day even though I've been out of the sport for a few years now. For the last two seasons of my career, there was finally a woman, Coach Karin Harjo, on the U.S. Ski Team. She also had the distinction of being the first woman ever to set a World Cup slalom course, in 2016. She's really cool, and a good coach, so to me her presence seemed totally natural, but I'm not sure if that was the case for everyone.

Obviously, I'd love to see more women involved in skiing, across the board. Having more women present, especially in positions of power, would no doubt help usher out annoyances like administrators discrediting someone's success by chalking it up to their size. But on the subject of ski coaches, I don't think the rarity of female coaches is a matter of discrimination as much as it is simply a matter of job choice. For starters, it's not a luxurious job. Any way you slice it, coaching ski racing is very difficult. You're outside in the cold for hours at a time. You have to carry around the gates and drills and set up fencing. On a race day, the coaches need to sit there filming the entire race, for three or four hours. Sometimes they have to climb up trees to get a better view of the course. It's such a physically demanding job that it can take a real toll on your body. I can't think of one coach I know who doesn't have a neck problem or a back problem or some other physical ailment they're dealing with on an everyday basis.

That's the price you pay to stay involved in the sport, because once you retire from competitive skiing, there's no real avenue besides coaching to stay involved, but hardly any women racers elect to go into it. On the one hand, I encountered maybe five female coaches throughout my entire life—but on the other, I also never encountered a single woman who wanted to become

a coach and couldn't. It's simply not a road that a lot of people are cut out for.

On top of all that, ski coaches get paid very little money. It's not like being an NFL coach, who gets paid millions. After everything their job entails, the average ski coach makes somewhere between twenty-five and fifty thousand dollars. So yeah, people who want to be ski coaches *really* want to be ski coaches. It's a passion job, definitely not something to do for glory or a big paycheck.

Ultimately, with men playing such a prominent role across all levels of ski racing, I got used to sometimes feeling dismissed and even not-so-subtly ridiculed by some of those who ran the sport. Over time, I learned to ignore their various offhanded comments, their slights and dings, but just because I dulled my senses to them didn't mean their words had no effect. Much as I always had, I used their words as fuel, yet it's impossible for such critiques not to sink in on a deeper, more personal level, even if only subconsciously. This was part of their goal, after all: to get in my head, to make me doubt my instincts about who I was as a person and as a skier.

Honestly, though, ignoring these words entirely, pretending they weren't being said, should never be anyone's goal—it certainly wasn't mine. I wanted to hear them, to acknowledge them, because it was by acknowledging them that I could show how little power they had over me. For every race director or opposing coach who tried to take me down a notch, I could turn around and demonstrate that I was the only one who had control over my success—whether it was on a single run in Austria or a stage as big as the Olympics.

CHAPTER FOURTEEN

It's funny, but even now, all these years later, I can still remember the recipe. The timing, the dance of the different ingredients. I did it so frequently that I was practically doing it in my sleep. Of course, it wasn't enough. I guess I shouldn't have been surprised—no amount of banana bread baking was going to get rid of the anxiety I felt at the 2010 Olympics.

I was staying at a condo that my sponsor Red Bull had arranged for me. The setup was perfect, few distractions, largely isolated from all the craziness so that I could avoid the press. I was close to my physical therapist, my trainer Martin, and Robert Trenkwalder, who headed up my Red Bull Athlete Special Projects program. From the condo, I could ski straight down to the gondola, to avoid any unnecessary attention. But inside the condo, I needed something to distract me, and there weren't a lot of options, so I baked bread. I had so much anxiety to work through that I must've baked twenty loaves of banana bread, pan after pan after pan. All the coaches gained, like, ten pounds thanks to me.

Over the years, ever since that race when Thor had told me to "just ski," I'd gotten better at dealing with nerves. I understood how to focus my energy to calm myself while also keeping sharp when it came time to compete. But it's one thing to feel nervous the morning of a race; this was something else altogether. All consuming. Never ending. From inside and out, it was a pressure that even now, all these years later, is difficult to describe because it was simultaneously so welcome and such a burden.

The months leading up to the Vancouver Olympics had been more intense than any I'd ever experienced. In December, only two months out from the games, I had crashed during a run in Lienz, Austria, catching my edge, launching into the air and landing on my wrist. I went to the doctor and got an MRI, and after he determined that my wrist was broken—a fact I planned to keep under wraps—the doctor went straight to the media and told everybody. I didn't want word getting out, because I didn't need any more drama, and I certainly didn't want my competitors to have any kind of psychological edge.

If that weren't enough, a couple of weeks out from the games, I was back in Austria for our final training block when I crashed during slalom training, resulting in a major contusion on my shin. In my long list of injuries, this wasn't the most serious, but I was in a lot of pain. I could barely get my boot on at a moment when I was expected to be at the top of my game.

It wasn't easy, but I did my best to stay focused and in the right frame of mind. After both of my previous Olympics hadn't panned out the way I'd hoped, everything was riding on Vancouver. I was still chasing the dream I'd had when I was nine years old—not just to make it to the Olympics, but to be an Olympic champion. Everything I had done, all the choices, all the sacri-

fices, all the years of work, were leading to this moment. This time, more than any other, I needed everything to line up.

At the same time, the outside pressure was mounting. That February, I appeared on the cover of *Sports Illustrated*'s Olympic preview issue, next to the headline "America's Best Woman Skier Ever." It was extremely flattering, but they didn't actually tell me I got the cover until the week before the games, when I was sitting at home in Park City trying to figure out how I was going to ski with my shin in that state, which was the worst possible timing. "You probably have it, but we can't guarantee it," they said, which made me think for sure some other sport would come and knock me off. *The Olympic preview issue?* I thought. *I definitely won't make the cover of that.* But I was wrong. They put me on the cover—an incredible honor, even if it did amp up the expectations—and that changed a lot of things.

And then, there was the *Sports Illustrated* swimsuit issue, which ran at the same time.

The first time I was in the swimsuit issue was also the first time I was ever photographed in a bikini. It was really nerve-racking. I didn't know what I was doing, I didn't know how to pose. I was an athlete, not a model. But I thought it was empowering that they were including Olympians in a swimsuit edition—it was the first time they had done it—and I was honored to be included. I also love M. J. Day, the editor of the swimsuit issue. She's really forward thinking and always made me feel more confident about myself. Contrary to what a lot of people assume, the magazine is mostly run by women, not a bunch of chauvinistic men. The team is honestly awesome.

My family was definitely not pleased. But I don't know, sometimes you just need to say fuck it, and do what feels right for you. I felt I was in good company. Plus, I think it's good to have diversity in a feature like that, which is something they've been even more committed to in the years since. I found it absurd

that the long-held standard at the time was that "supermodel thin" was the thing to aspire to, when 99 percent of women don't look that way. When the magazine hit stands, it felt really liberating. And in later years, I went on to do the swimsuit issue two more times.

Anyway, it was a *lot*, but still it felt like the perfect lead-up to the Olympics. I had won almost every race coming into the games, and because people were paying attention, Americans actually saw my accomplishments. Everything was converging, so I could either embrace it or fight it—and as scary as the former felt, the latter felt irresponsible. After all, this was exactly what my dad had taught me back when I was ten—all the separate pieces were lining up, all I had to do was seize the moment. I was poised for the kind of Olympic showing I had always dreamed of. Now, all I had to do was win.

When I arrived in Vancouver, the press was insane. There were so many reporters and so many flashbulbs. I had never seen anything like it. At the previous Olympics, I was still a young skier, so nobody paid me any mind. This time, there was so much media. It was truly staggering. Usually, you have a team press conference, but I was told I would need to stay after the group press conference so I could answer my own questions separately. I had never had my own press conference before, and I insisted that I didn't need one.

"No, Lindsey, you don't understand the number of people that are here asking questions about you," they said. "It wouldn't be fair to your teammates." When I walked into the room, I was like, "Ohhhhhhh-kay. Now I see what you're talking about." I have never been—and may never again be—flashed by so many camera bulbs at the same time. It was intense. As instructed, I stayed there after the end of the team's conference, so the reporters could switch their questions over to me.

At any time, being confronted with a roomful of reporters

asking about your performance can be overwhelming, and this was no exception. But one of the hardest parts about it was that I didn't know what to say, because at this point, I didn't even know if I was going to race. After my shin injury, I still hadn't put a ski boot on in nearly two weeks. The media was pinning me to be the next Michael Phelps, and meanwhile I didn't even know if I could ski, let alone win. It was so much pressure, and the fact that I couldn't control it only made it worse. I sat there thinking, *Everybody just chill out.*

After that, I sequestered myself. Typically, you spend pretty much your whole time at the Olympics with the rest of the team, but the media was so intense that I ended up on my own at the condo most of the time.

Laying low was even easier because the media wasn't the only thing creating a sense of pressure. I had tried everything I could to help my shin heal, but it wasn't responding to therapy. While everyone else was out training, where I wished I could be, I still couldn't get my boot on. I felt like I was losing ground at a time when I needed it the most.

Then I was given a gift from the weather gods. It rained hard . . . for five days straight. It was brutal. As a result, a lot of the training got canceled. This bought me three or four extra days to recover, which was great for my shin injury, but bad for my mind. Before the crash, I'd allowed myself to entertain the idea of winning a medal, maybe two if things went well, and hopefully one of them gold. But I needed to keep my expectations in check and focus on what was right in front of me. I couldn't allow myself to get caught up in the hype.

During those extra recovery days, I met with Olympic doctors who gave me a lidocaine cream. It helped numb my shin just enough that I could shimmy my boot on. Martin, my trainer, also got creative with ways to help me prepare. I always did a lot of slackline training, where you balance on a suspended cable,

almost like a tightrope. Instead of just one line, we would set up two, so it was kind of like skiing. On the days when everything was postponed, Martin hooked up two slacklines to the ends of two cars parked outside the condo. That was probably one of the best things we could have done, because I was outside visualizing the course while I was balanced on the slacklines. It was really effective—you get that same leg burn; you get the same sense of proprioception.

I was surrounded by people who'd been with me for a long time, with one crucial addition. The first time I'd spoken to Heinz Hämmerle, who would later become my beloved ski technician, was in the summer of 2009. I had just switched to Head skis, and we went on our first training camp to New Zealand. I had met Heinz before, but only briefly on tour. He's Austrian, and I love speaking German whenever I can, so I tried it with him. I said (in German), "I'd love to meet with you tomorrow, so we can go over some things." He replied in English. From that point forward, I was like, *I guess that's it. I guess we're speaking English.*

Heinz is such a character—insane in the best way. He's super skinny and super jacked at the same time, and he's got these huge, strong hands. He's kind of like Popeye. I always say that instead of spinach, smoking gives him his power. Which I hate saying, because don't get me wrong, I do not encourage smoking. And the one time I made him eat a salad, he got incredibly sick.

When I picture Heinz, he's skiing downhill with two of my skis on his shoulder, no goggles, just his glasses, his bald head exposed, and a cigarette hanging out of his mouth. We all used to say his smoke got into the wax, and that's what made my skis so fast.

Heinz is really old school. He's been tuning equipment for longer than I've been alive. He doesn't wear a mask; he waxes

skis with highly toxic wax right in front of his face. "You know, you could always wear a face mask," I'd say, to which he'd reply, "Nope, it's the way it is."

He always has something to say, but it's short and sweet. His response to every question is always, "*Ja,* for sure."

"What's the plan, Heinz? You leaving at nine o'clock?"

"*Ja,* for sure."

And his cheer is always, "*Gemma,* baby!" which means "Let's go!"

It's a pretty big deal to find a tech who puts as much into their job as you do. He spends countless hours in tiny, unheated garages, tuning and waxing. He'll go to sleep at midnight and wake up at 3:00 A.M. to get the wax just right before a race.

He's invested.

In the starting gate, he screams just as loud as anyone. "*Gemma,* baby! Show them how it's done!" Whenever something happens, Heinz is there, and he's the most emo. He cried when I won, because he wanted it as much as I did. When I came back from all my injuries, he sobbed as badly as I did. He's like family to me.

Even with Heinz, I was always involved with my equipment. I let him do his thing in terms of how he prepared the skis and which wax he used. But we made decisions together in terms of which skis I would use for race day. During training, I kept a journal, where I wrote down each ski number, what it felt like, and the conditions, so I could look back and remember. Let's say you take seven different runs using seven different skis—the next day you won't remember what each ski felt like. I don't care who you are, it's impossible to keep track of it unless you write it down. So, I'd keep track of everything, and then I'd refer to my notes and say, for this terrain and this snow condition, this ski would work well.

As I've said, no two skis are alike. And I'm *very* sensitive.

I can always feel a difference in the base bevel, which is the angle of the ski in relation to the base. If the base bevel was .2 degrees off, I could tell. Heinz would always try to test me. He would change the bevel on the skis ever so slightly, and I would be like, "This isn't right. This doesn't feel right. I don't like it."

He'd get exasperated. "I want it to work because it's fast!" he'd say.

One time, I broke a ski, and he tried to put a left ski from one pair with a right ski from another. I could immediately tell the difference. He played dumb, putting his hands up in a sign of surrender, and saying in his thick Austrian accent, "I did not do anything."

"You put two different skis together, didn't you?" I said.

"It's impossible!" he shouted. "You cannot tell the difference!"

But I could.

"Are you *sure* you cannot ski in them?" he asked. Again, he's a character.

It's a good thing I was sensitive, even if it was sometimes a challenge. My sensitivity meant I would change the equipment to match the way I skied, instead of skiing to match the equipment. A lot of people do it the opposite way, but that's not how it should be.

Heinz and I had a mutual respect, which is part of what made our relationship work so well. He listened to my feedback, and I relied on him for the rest. A lot of technicians see it as a job, and they do their job—no more, no less. But tuning skis is a passion for him. Every day, he was pursuing his lifelong passion, as was I. What's more, we had the same focus: winning. I knew he made the absolute best decisions to make me as fast as he could.

When I found skis that were fast, I would tell him so, and he'd reply, "*Ja?* They're really fast? Show me how fast they are!"

Once we figured out which skis I liked, I trusted Heinz to make them fast, using his bag of tricks. The wax we used for the 2010 Olympics was something Heinz had from like twenty years before. He pulled it out of his secret stash for the occasion. There's a reason he's the most successful technician ever. He's got more Olympic and World Championship wins under his belt than anyone else. No one can even compare. It's why I call him Magic Heinzi. He does his magic stuff, and there you go.

If you ever want a little bit of magic, it's at the Olympics.

The entire time leading up to the race, I cut myself off from the media. I didn't march into the stadium with the rest of the athletes. I didn't even watch the opening ceremony. I wouldn't turn on the TV, because I didn't want to see any Olympic coverage. Facebook was just blowing up at that time, and I stayed away from that, too, thinking the likelihood of my feed being positive was not very high. I think my technique of being secluded helped block out some of the noise.

In the weeks leading up to the games, I'd visualized my performance at the 2009 World Championships, which I saw as my practice run for the way I hoped to perform at the Olympics. In Val d'Isère, I'd been able to manage my emotions and expectations, despite the conditions and the pressure to perform. I'd found my sweet spot in terms of my approach, and it had resulted in two gold medals. Now, I just needed to do it again.

But getting hurt had changed everything. Suddenly, my only concern was the most basic thing imaginable: whether I could race or not. I no longer cared about outside pressure, from the media or my coaches or anyone else. I didn't care what anybody expected from me. Frankly, I didn't even need to manage my own emotions, because I didn't have the space to feel them. It's like I went into a tunnel where the only thing that mattered

was getting my leg to a place where I could race. That was all I worried about, because that was all that mattered.

My family typically kept their distance in the lead-up to a race, because I needed my space to get into the right frame of mind. But this was an unprecedented circumstance, in quite a few ways, so the night before the downhill, Karin and Reed came over to hang out and take my mind off racing. My brother wanted to cut his hair, and he came up with the idea to shave a huge "LV" into the side of his head. So, that's what we did the night before the race. I went to get the clippers, wearing my socks, and I slipped and fell down the stairs. For a minute, I sat there at the bottom of the stairs, saying, "Oh my God, oh my God, oh my God."

Karin rushed over calling, "Are you okay?"

My ankle was a little stiff, but thankfully I was all right. I was so glad that spill didn't go in another direction, because it could've been really bad. So yeah, my pre-Olympics routine before the Vancouver Olympics consisted of baking banana bread, shaving my brother's head, and falling down the stairs.

Early in the morning before every race, while doing my prerace workout, I always listened to a specific playlist, which I would put together for the occasion. It was usually a collection of rap songs with lyrics that made me feel powerful and confident, like I was ready to take on the world. In all my years of racing, there is really only one time when a specific song stands out as striking a chord with me, and that was in Vancouver. The song was "Imma Do It" by Fabolous, and the lyrics of the chorus really struck me.

I don't know what Imma do, but Imma do it,
I don't know what Imma do, but Imma do it . . .

It's about putting it all on the line and just getting the job done. I normally didn't listen to music in the time frame lead-

ing up to a race. I'd listen first thing in the morning while I was working out, or sometimes at inspection, but never that close to the actual race. But the day of the downhill, as I was in the lodge before heading to the start, I kept on listening. It put me in the right frame of mind—like no one could stop me.

In the end, I think my shin injury sort of worked to my advantage. Because I had no idea if I would even be racing, perhaps, counterintuitively, that uncertainty made the situation strangely ideal by allowing me to become an underdog in my own head, if nowhere else. You can only afford to be nervous when you're prepared, and in this case, I was anything but. Because of the rain delay, we were left with only one day on the hill, and since the men had to do their race at the same time, we didn't even have a full downhill training run. The first training run was the first three-quarters of the track, from the start until the last jump, and the second run was that final portion, from three-quarters of the way down to the finish. We had no choice but to make it work with what we were given. To this day, I've never experienced anything like it.

On top of all that, there was still the fact that I hadn't skied in two weeks and I could barely put on my ski boot. With the odds not in my favor, my whole mental calculus changed; the chances of my winning were not high. So, I thought, my only course of action was to throw caution to the wind and give it everything. My plan, which I'll admit wasn't much of a plan, was to put it all on the line, with no expectations. My plan was to just ski.

When I arrived at the start of the downhill, I knew that Julia Mancuso was in the lead. Not only was she in the lead, but she was ahead by almost a full second. She'd put up an incredible run. I would need to ski pretty much perfectly in order to beat her.

Instantly, I was flooded with memories. Overhearing my

coaches talk about me outside that hotel room, standing in Julia's shadow, all those times I felt put down or underestimated or undervalued. Skiers like to say they're competing against themselves or against the course or against the clock, and all of those things are true. But for me, I had also spent much of my career competing against Julia. And now, here we were, head-to-head once again, on the biggest stage of all—and honestly, I wouldn't have wanted it any other way.

I just skied. I gave it my all. It was probably one of the best runs of my career.

When I crossed the finish line, I looked up and saw my name in green. If your name is in green, it means you're winning. I already knew that if I beat Julia, then in all likelihood, I would probably win the gold.

I had done it. I was an Olympic gold medalist.

I fell to the ground in a wave of overwhelming joy and relief. That emotion was like nothing I have ever felt, before or since. It was just so pure. I was like a kid again, so free, so exhilarated, so incredibly happy.

Everyone knows most athletes love what happens on the field, and that's true. But it's so much bigger than that. The love is in the sum total of everything we do. It's in the training and the mental preparation. It's in the anticipation before the race. It's in the excitement and challenge of the race itself. The race itself is a couple of minutes, tops. But everything leading up to that point—setting a goal and doing everything you possibly can to meet it—is what we live for. And in those instances where everything finally lines up, and then culminates in a moment like this—well, it's indescribable. It's like every step that led you there only stands to magnify the experience. My win was the end result of every choice and every effort I'd made since I was nine years old. It was the desired outcome of every sacrifice my family had ever made for me. It

was everything. To this day, that is the most satisfying feeling I have ever known.

I managed to hold it together, until the first question from NBC was, "What does this mean to you?" And then I just lost it. I felt so many emotions. It was like, all my childhood dreams and all the work I'd put in for my entire life was all being exposed to the entire world in one moment. I had a hard time controlling the tears.

The medal ceremony was insane. To stand up there on the podium, in front of the whole world, with the national anthem playing, and know it's because of you, there are really no words to describe it. I never really sang the national anthem. I told myself not to, because I'd get nervous and thought I might sing it wrong. You're so emotional on the podium that it's easy to mess it up, and people can get really mad at you, which wasn't something I wanted to risk. I did my best to stay composed and take it all in. It was difficult, but I think I did a decent job of not crying.

I tried to find my family in the crowd, but I couldn't spot them—Reed, with the "LV" shaved into his head, and Karin, who, true to form, was crying happy tears. My brother Dylan couldn't make it to Vancouver that year, and my sister Laura couldn't leave school during the semester. That was upsetting, both to them and to me. My family had given up so much for this moment, Laura and Dylan included, and I wanted them all to share it with me. I was an Olympic champion. I had always believed it would come to pass, and my family in supporting me had also believed it. Now the whole world believed it, too.

After winning the downhill, I couldn't really celebrate, because I had a race the next day. It was hard, but I couldn't let myself get too carried away. I still needed to focus on the combined.

When I won the gold, again the press started with the Michael Phelps thing, which was a lot of pressure and also kind of

absurd. It wasn't a fair comparison because, for one thing, Michael Phelps is superhuman, but also, skiing isn't the same as swimming. Michael Phelps could win the one-hundred-meter butterfly, the two-hundred-meter butterfly, the two-hundred-meter freestyle, the two-hundred-meter freestyle relay. He could dominate in the same event for different distances. In skiing, we have separate events. None of them are repeats, and none of them are the same. I mean, I wish we had a twenty-second downhill, a forty-second downhill, a sixty-second downhill. . . . That would be great, and I think I would have more medals if that were the case. But unfortunately, that isn't the way it works.

When I woke up on the morning of the combined, I could barely get up. It was easily the most physically and emotionally exhausted I'd ever felt. Winning the downhill and the emotions that came with it had taken everything out of me—there was nothing left. Despite the exhaustion, I rallied and still skied pretty well. In the combined, I was second in the downhill portion and then I hooked a tip—a common problem of mine—in the slalom. But I managed to win a bronze medal in the super G a few days later.

Then I slept. I slept so much.

Even all these years later, that Olympic experience still feels surreal. I had spent my entire life dreaming of that moment, and then it all went by so quickly—a cliché, of course, but so true. The moment was so big, it's like I will forever be in its middle, still trying to figure out what it all meant. What it still means. And what I keep coming back to is that it signaled the end of something for me, and at the same time it marked a new beginning. It was the end of my family's story, as it related to my career, and the start of mine.

Up until that moment, I've since realized, I was skiing for them . . . for us. I was carrying the torch for my grandpa Don, who started this skiing family. I was skiing for my brothers and

sisters, who had to give up so much because of me when my family moved to Colorado. I was skiing for my mother, who'd made such a terrible, tremendous sacrifice just giving birth to me, who'd driven from Minnesota to Colorado, eighteen hours each way, so I could ski, and who'd spent the next twenty-five years surrendering whatever she had left for the good of my career, for the good of us kids, for the good of our family. I was skiing for my father, whose nine-year-old daughter came to him with a dream and who, without hesitation, said, "If this is what you want, Lindsey, I will help you make it happen." My father, who was crazy enough to not only believe in me but to make that dream his priority.

When I crossed that finish line, no matter where we all were, I think we collectively let out a deep, deep sigh of relief knowing that our fight had been worth it. My family had spent every dime, every hope, and had jumped every hurdle to get me on that podium. In the process, they had become my "why"; wanting to prove myself, wanting to win, all came because I needed to validate their shared sacrifice. With the gold medal, I had done just that. I had justified their faith.

I had plenty of skiing left in me—I knew that, without a doubt, the summit was still above me. But I also knew that things would never be the same. From here on out, win or lose, I was no longer skiing for my family—I was skiing for me. They would support me, of course, and be present every step of the way. But everything my future held would be on my shoulders, alone—the weight was now mine to carry, for good or bad.

RISE

CHAPTER FIFTEEN

Immediately after the Olympics, I flew from Vancouver to Los Angeles to appear on *The Tonight Show with Jay Leno*. As I walked through my terminal at LAX, holding my boots, a group of people started cheering. I looked around, wondering what was happening. Then more people joined in.

"Who's here?" I asked. "Is it someone famous?"

"It's you," said Thomas.

The concept was so bizarre that it took a minute to register. Everyone suddenly knew who I was, and everyone knew I had won. That didn't ever happen. As an athlete, it was only one race. Yes, it was the Olympics, but by then, I had won forty races, including World Championships, and hardly anyone in the U.S. had ever cared. Up until that point, no one even knew that I was a ski racer! Every time I won, it was like I was winning for the first time. Then I won one race at the right time, and now, everyone knew my name. It was like the curtain had opened and there I was, standing in the spotlight with the

audience saying, "Oh my God, who is this new person?" But for me, it felt like, "Hi, I'm Lindsey and I've been here a long time. I've been working hard forever."

As I made my way through the airport, everyone—the entire terminal—clapped and cheered. The crowd started chanting, "U-S-A! U-S-A!"

In that moment, I realized that everything had changed.

At no point in my career, either when I was an underdog or after I won Olympic gold, did I ever question my purpose. And when I finally found success, I never struggled with impostor syndrome or worried I was somewhere that I wasn't meant to be. I always knew I'd earned my place because I remembered every painful moment that created it.

Still, when you get thrust into sudden celebrity for doing something that you've been doing your whole life, it's jarring. It's hard for it not to affect you in some way, even if you can't actually perceive or fully understand it in the moment. Just because I'd earned the attention through my achievements didn't mean I was immediately comfortable with it, yet I also recognized that everything happening was entirely my choice. The gold medal was what I'd been working toward for years, but in a way so was this new visibility, going all the way back to when I'd met Picabo. All at once, that possibility of transcending the sport—the idea that my dad had laid out for me all those years earlier when he hung those posters of Mia Hamm and Steffi Graf on my wall—appeared in view.

That stretch following the Vancouver games was the first time I started to step outside the bubble of ski racing—both professionally and personally. As I developed a business outside of skiing, I began to feel successful in a way that I hadn't before. As I've said, in skiing, pretty much all our money comes from endorsements and contracts. The government gives you money if you win the Olympics, and you also get a sum from

the International Ski Federation for winning a World Cup, but it's not a huge amount. It's like 30,000 Swiss francs for a World Cup win, but once you do the currency conversion and subtract taxes, you're down to maybe $15,000. As I write this, an Olympic gold medalist gets $37,500, but for many years before that it was $25,000—and again, this is all before taxes. So yeah, we really only make money if we get endorsement deals.

And in skiing, it's really, really hard to get to that level. You have to be at least top five in a discipline to be offered a good sponsorship deal—outside of your ski contract, your pole contract, your helmet contract. I was honored to join the limited company of other athletes to make it to that level. It was a very select group, including Hermann Maier, one of the first skiers to have a long-term, lucrative sponsorship deal, with Raiffeisen Bank. His yellow helmet with the bank's logo became his signature. He's still backed by them to this day, but that kind of relationship is rare.

For most Olympic athletes, the endorsement deals tend to intensify right before the games, because that's the window where you're on TV on a global scale. Before the Olympics, things were already good. And they only continued to pick up afterward. No matter how many World Cup wins I had, nothing was as big as winning the Olympics. It was a huge step for marketability, and a lot of brands wanted to take part in that. I was careful about who I decided to work with, but all of the interest was vindicating, like I'd broken through a barrier that had long separated our sport from the rest of American sports culture.

For me, it all went back to why Picabo was such a huge inspiration, because she was the first person to get "Nike" on her helmet. Everyone was like, "Holy shit, she's broken into the mainstream." Back then, that was a level that no skier had ever attained. I took what she did and expanded on it. Getting a sponsorship with Under Armour, and not just getting free product, but actually getting paid? That's rare, and I'm proud of it.

When people in the U.S. started to watch my skiing, it made me feel like all the risks I was taking were worth it. While it may not seem like it in the moment, when you race, you're risking your physical health, even your life. I've seen people die, lose limbs, or suffer a concussion after which they're never the same. Things like that happen all the time. If you stop and consider it for a while, it's enough to make you wonder how much your athletic career is worth. But now, I was seeing that I finally had a voice and the ability to make an impact.

For the most part, people were happy for me. I had already earned the respect of the ski community from my time on the World Cup, but now I started seeing validation from the larger public, including those who didn't know anything about skiing. It felt like I'd checked the last box I needed to solidify myself as a successful professional athlete. But unfortunately, as my career progressed, not everyone had a positive reaction.

One of the difficult lessons that came along with my sponsorships was that even when you've earned something, some people find it hard to digest. When I appeared on the cover of *Sports Illustrated*, some people said I was only receiving that level of attention because I was pretty. Really? By that point I had already won dozens of World Cups, World Championships, and soon after, the Olympics. This assertion was so asinine that I wasn't hurt by it, because obviously anyone who thought that way hadn't been paying attention. But I still found it irritating, because it was another way of dismissing years of hard work.

A lot of things contribute to an athlete's marketability—age, demographics, achievements, even how memorable their name is. Are they well spoken? Are they authentic? And yes, looks certainly play a role. Marketability can be a double-edged sword. I mean, did the way I look hurt me? No. For anyone in the public eye, do looks sometimes make them more marketable?

Where it all started, Buck Hill, Minnesota. Learning to ski with my favorite "Lindsey" hat.

Skiing in our family began with my grandpa Don and my grandma Shirley. They were my most devoted fans, traveling here to Vail to watch me compete in the Junior Olympics.

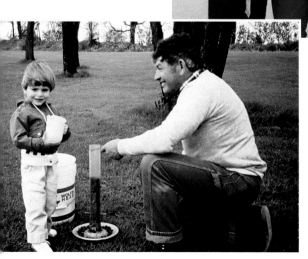

Milton, Wisconsin, at Grandma and Grandpa's house, filling the bird feeder with Grandpa. Grandma loved to watch the birds in the morning.

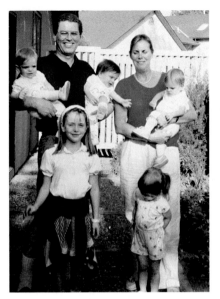

Our first home in Minnesota.

Family trip to Steamboat. As the first grandchild, I got all the love from the whole family. *(Below front row, from left to right: Uncle Leo Hummel, Dad, me; second row, from left to right: Uncle Jeff, Aunt Debbie, Grandma, Grandpa.)*

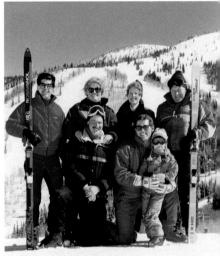

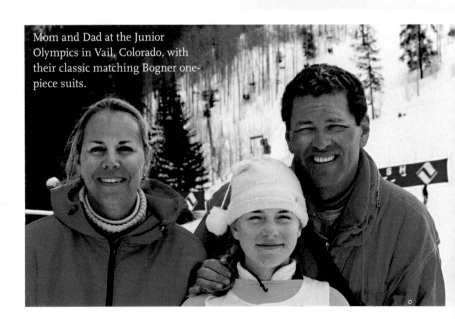

Mom and Dad at the Junior Olympics in Vail, Colorado, with their classic matching Bogner one-piece suits.

Hilary Lund and me training at Buck Hill.

Mount Hood, Oregon. I went here for Erich Sailer's ski camps from age seven until I made the U.S. Ski Team when I was fourteen.

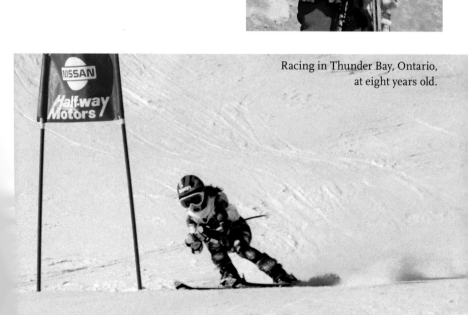

Racing in Thunder Bay, Ontario, at eight years old.

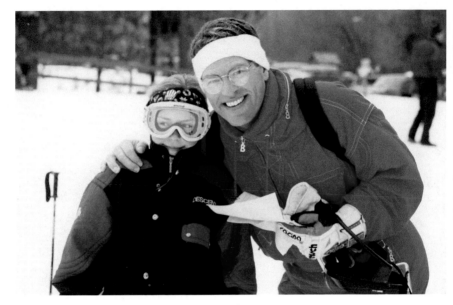

With Dad at Welch Village, Minnesota. One of
our weekends traveling to races in Minnesota.

Laura and me in Vail.

With Mom in Vail at the Junior
Olympics.

One of our classic Christmas pictures at the top of Lionshead in Vail.

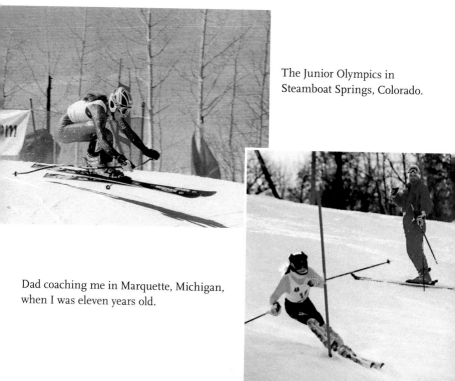

The Junior Olympics in Steamboat Springs, Colorado.

Dad coaching me in Marquette, Michigan, when I was eleven years old.

Right after I made the U.S. Ski Team, my dad took this picture. I was fifteen.

With Grandpa Don in Austria, training for the Trofeo Topolino race that was being held in Italy. This was the only time he left the country after the Korean War. Again, classic Bogner one-piece.

The only big race my entire family was able to attend, the Olympics in Salt Lake City in 2002.

My first World Cup win—the downhill at Lake Louise, Canada.

Mom, Karin, and Laura at the Salt Lake City Olympics in 2002.

Salt Lake City Olympics, 2002.

Post-crash in Lienz, Austria, December 2009. This one gave me a bone bruise two months before the Olympics in Vancouver.

Wade Bishop, me, and Jeff Fergus in Garmisch, Germany, 2013.

Training with the U.S. Men's Ski Team in Portillo, Chile, summer 2016.

Second ACL surgery, January 2014 at the Andrews Institute.

Walking in the opening ceremonies with my teammates. *(Back row, from left to right, Alice McKennis-Duran, Alice Merryweather, Megan McJames, Breezy Johnson; front row, from left to right, Laurenne Ross, Resi Stiegler, and me.)*

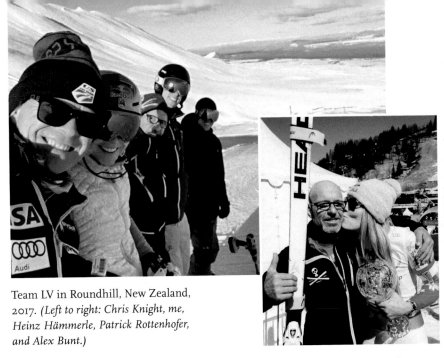

Team LV in Roundhill, New Zealand, 2017. *(Left to right: Chris Knight, me, Heinz Hämmerle, Patrick Rottenhofer, and Alex Bunt.)*

Heinz Hämmerle and me after I won the downhill and super G title in Méribel, France, 2015.

Cortina, Italy, 2017, when I broke the World Cup record for wins by a female skier with sixty-three.

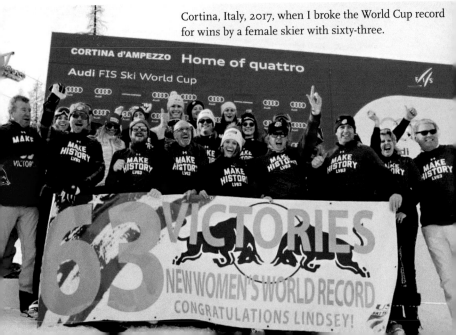

Training in Chile, summer of 2018.

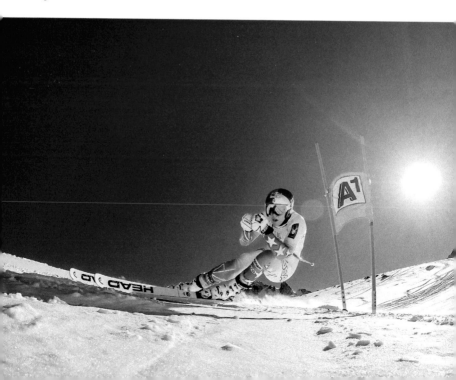

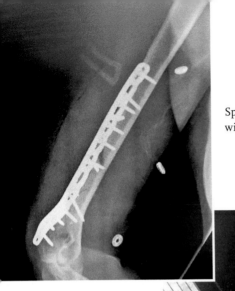

Spiral fracture of my humerus,
with a plate and thirteen screws.

Recovering in Vail,
Colorado, with my dogs
Leo, Bear, and Lucy.

Training at the U.S. Ski Team Center of Excellence in Park City, Utah.

Project Rock shoot, 2018 (Under Amour).

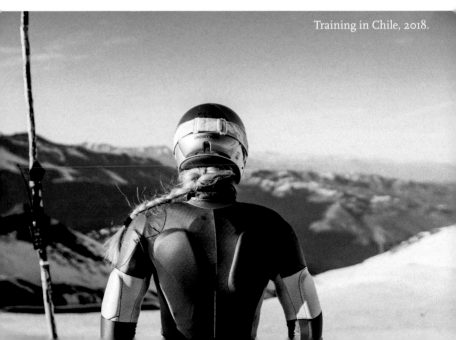

Training in Chile, 2018.

With Lindsay Winninger in Cortina, Italy, when I broke the win record, 2017.

Laura and me in Cortina, Italy, 2013.

Grandma and Grandpa in Milton, Wisconsin.

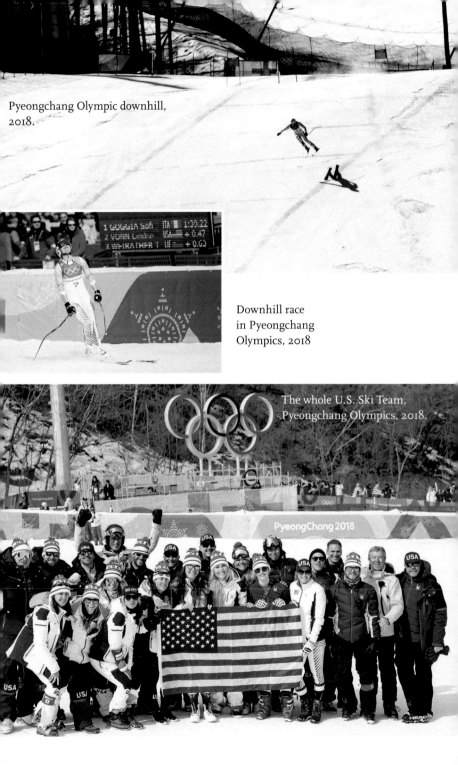

Pyeongchang Olympic downhill, 2018.

Downhill race in Pyeongchang Olympics, 2018

The whole U.S. Ski Team, Pyeongchang Olympics, 2018.

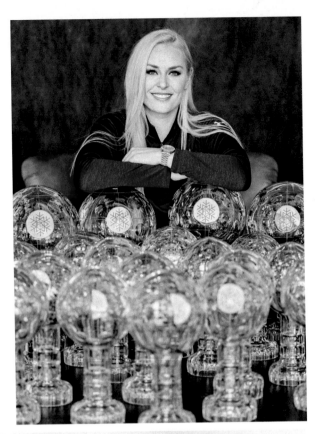

With my World Cup Globes after retirement, 2019.

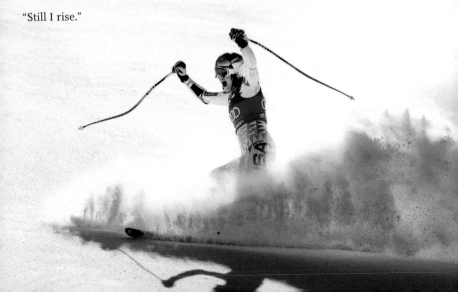

"Still I rise."

Yes, that's part of our society. But even if all those other factors played a role, I was there because of my accomplishments. Full stop.

I do think the same rules of marketability apply to everyone—there are certainly male athletes who receive a lot more attention due to their appearance. But there is still a double standard. With men, there is less of a chance that their achievements will be underwritten because of how they look. No one ran around saying Rafael Nadal wouldn't have gotten such-and-such a deal if he hadn't been good looking. For men, the respect is implicit.

The ski world was largely supportive of my success, but on the back end of my career, I'd sometimes hear other athletes asking, "Why does she have this?" They'd point to things like my Red Bull sponsorship, which I was so fortunate to land at age nineteen, and say that I was only capable of achieving what I had because I had sponsors behind me. But I had gotten the sponsorship after years of hard work—including the sponsor-led training, where I worked my ass off, in Europe, for the better part of each summer. Yes, they were correct that my sponsorships were positive forces in my career, but they forgot everything I'd needed to do in order to get there.

While I tried not to let their words get to me, my success did prove to be isolating in other ways. As my career took off in these new directions, I suddenly needed to do way more than just skiing. I had more interviews, more meetings, more obligations on top of the ones I'd already had. There was no time to meet for a meal or a coffee or to do anything social with my teammates. How could I make time for friends when I barely had the time to take care of myself? I was grateful—after all, this was what I had always wanted—but it did come at a cost. I knew that everything came with a shelf life, and I wanted to maximize it while I could. It was a trade-off. Once again, it

boiled down to choosing between my career and . . . everything else. The choice was easy to make.

All this fame had another, more personal impact on me, one that, for many, was imperceptible, but for those who knew me was quite powerful.

For much of my life, I'd felt like I had two selves—who I was on the hill, and who I was the rest of the time. Ever since I was young, there had been something of a disconnect between the confidence I embodied while skiing and the person I became when my boots came off.

On the hill, my belief in myself was absolute. The quarterback Russell Wilson says that in order to succeed, you need to have a 100 percent conviction in whatever it is you believe. He maintains that if you think, with your whole being, that you are the best at what you do, and if you always lead with confidence and positivity, then you will succeed. I always did exactly that. I don't know why, but aside from that brief time following the 2002 Olympics, I never had doubts. Even when I struggled, even when I crashed, I would think, *This is meant to happen. It's going to lead me, somehow, to the path of success.* I always felt I was exactly where I was meant to be. My only job was to keep going.

That unwavering confidence on the hill was actually one of the more paradoxical things about me, because across every other area of my life, my confidence remained just as low as it had been since that first camp at Mount Hood, back when I had a perm and braces and it felt like speed was all I had. Whenever I was in the starting gate, I had total faith in myself. Everywhere else in life, however, I continued to struggle with confidence— and often still do to this day, although I've made tremendous strides even as I'm writing this book.

It's very lopsided; my friends always joke that I'm the most

confident unconfident person they know. I can be confident in a setting where I'm playing the character of Lindsey Vonn. When I'm on the hill, or at a press conference, it's like I'm not really me, I'm dressing up as someone else, my powerful alter ego. When I'm at home, I'm not that person. I stick to myself, I'm quiet, I'm more reserved. When I was younger and I had to go to events, I used to rely on my sister Karin, who was a social butterfly. If she wasn't around, I would keep her in mind whenever I was in social settings, to try to fake it. (I'm much better now than I used to be, but I should be: I'm thirty-six years old.) I may be aggressive on the mountain, but in my personal life I tend to be a pushover. I don't like confrontation. So, instead of speaking my mind and creating conflict, my default is that I don't advocate for myself nearly as much as I should.

When I share this with people, they always say some version of, "But Lindsey, you *seem* so confident." Believe me, I know. I've made it so that others only see one part of me—and it takes work, a lot of work. There are many dimensions to who you are as a person, and just because I happen to have a very forward-facing persona that I can turn on when I need to doesn't mean that's the entirety of who I am.

I think it all boils down to the fact that, like many people, I feel the most confident when I'm in a familiar environment, especially when I'm doing something I'm good at. But since I hadn't been exposed to much outside the ski world, there were an awful lot of places that felt unfamiliar, an awful lot of things that sparked my insecurities. Sometimes, when I was crushing it on the mountain, it was enough to carry over into other parts of my life, but most of the time, it wasn't. Any time I ventured outside the ski bubble, my head filled with questions. Did I look right? Did I say the right thing? Could everyone tell I was uncomfortable?

This issue has been with me my whole life—but my gold

medal marked a big change in how I approached it. Before the 2010 Olympics, I remember feeling that in my life off-snow, I had zero confidence in myself. I was full of doubts. I never felt cool. I was insecure. From all the way back to Erich's camp at Mount Hood, if there was a group of girls, ten times out of ten, I was the one in the back. The Olympics ushered in a sort of sea change for me, because only then did I started to realize that maybe I hadn't given myself enough credit. The outside world saw something in me—someone who was worth looking up to—and I began to gain more confidence. For the first time in my career, I began to feel more poised, not just as a skier, but as a person.

I've since come to understand that confidence exists on a spectrum. If you've struggled with it at any point, then you know there is no single epiphany or moment that forever changes how you see yourself. Instead, confidence tends to ebb and flow constantly. There are times when you are able to locate a deep well of self-reliance to navigate a tough situation. Like-wise, you have moments when your inner voice is harsh, critical, demoralizing—the opposite of helpful. One of the most impor-tant steps to developing confidence is figuring out who you are, and that takes a while. It requires a lot of internal searching, a lot of questions, a lot of trial and error.

Struggling with confidence is a problem that's never "solved"—you have to work at it your whole life. But there are turning points, moments like what I went through after the gold medal, where your confidence changes in a more lasting way. And that's what this time did for me. It wasn't that I never struggled with my sense of self-worth, or doubted myself off the hill again. Far from it. But what did happen was that, overall, I began to feel more assured of myself, and slowly, I began to see myself as the person I wanted to be all the time, not just when I was skiing.

Of course, for all my newfound inner confidence, I developed some additional insecurities to go with it. After the gold medal, I started getting invited to these glitzy Hollywood settings. I'd gone to big events before, like the ESPYs, where I had historically been one of the smaller fish. I was always able to blend into the crowd of other athletes, content to hang in the background and take in the scenery. But now, everything changed. When I attended my first movie premiere, the red carpet was eye-opening.

"Lindsey!" the paparazzi called. "Lindsey, over here!" I was always comfortable in front of the camera—I could call upon my alter ego for that, similar to how I could summon my confidence on the hill—but now, for the first time, I felt out of my element. As I looked around at the actresses and assorted celebrities around me, the physical differences were plain to see. I was taller, heavier, more muscular. You know that old song from Sesame Street, "One of these things is not like the others"? That's how I felt. If these differences were so obvious to me, I worried they must be to everyone else, too. In many ways, I'd come so far, and yet in the glare of the flashbulbs, I felt exposed. It's like I was right back in the hot tub at Erich's ski camp, stuffing my bra with tissue, wanting so badly to fit in but instead coming up short.

When the cameras turned off and the lights died down, the feelings only worsened. I went down a rabbit hole of anxiety, fueled by the beast of comparison. Because I had so many media obligations in the aftermath of winning the gold, I didn't have as much time to work out, and I naturally began to get thinner. It wasn't intended, but in this new context, I wondered if maybe it was preferable.

After I won the Olympics, my image of what was expected of me—how I was supposed to look or how I was supposed to act—started to change. For my entire life up until this point, I

was always so focused on being successful, it didn't leave much room for anything else. I never thought about my appearance. My physical body had always been a tool, one that did whatever I needed it to in order to compete at the highest level. Who cared what it looked like as long as it could perform? But now I was being compared to people who were fifty or seventy-five pounds lighter than me. Naturally, I grew a lot more self-conscious.

In the skiing world, I never really felt like I fit in, so I'd never thought much about wanting to fit in anywhere else, either. I was always on the road, focused on my sport, and when it came to my personal life, I had the same three friends I'd had since I was seven, and no one else. So, the concept of my image, and whether or not I fit into the mainstream, never registered to me until after I was already in the spotlight. And there, suddenly magnified by all the attention, it felt glaring. I *really* didn't fit in.

What followed was a bit of an identity crisis as I tried to navigate this new landscape of fame. When I stepped onto the red carpet, the first realization was *Wait a minute, I don't look like everyone else.* The second part of that epiphany was grappling with the change in self-perception. Where I had once seen my body as capable and powerful, it had suddenly become a source of insecurity. Was it possible I wasn't who I thought I was? If I was going to be a part of this world, I felt like I needed to be thinner. I lost a bunch of weight due to my lessened training, and thought, maybe I should stay this way. For a couple of months, my focus shifted, and I started to lose sight of what was important when it came to my own career.

Our society is incredibly focused on the superficial, and it's undeniable that there is a double standard when it comes to the expectations of how a woman's body should look. On top of that, being a woman in sports is different than being a woman under any other spotlight. Your body is held to a multitude of different

standards, where your appearance is judged as harshly as your performance. For many years, including much of my career, the perception was that women aren't "supposed" to be muscular, that somehow having muscles made you inherently too masculine, as though the body that made you successful in your sport also made you unattractive. According to whom? If your body is part of what makes you great, why would that be seen as anything less than inspiring?

While we're at it, what's wrong with being strong? What image are you sending to kids if you're saying that about someone in the media? That's where our rampant epidemic of body dysmorphia comes from. Society has pretty much accepted the double standard when it comes to women and body image. But there is also a really troubling double standard when it comes to women and strength. Men are "supposed" to be strong. They are celebrated for looking strong, for acting strong, for being strong. And when women are visibly, physically strong, that's a problem? I disagree. I have no doubt that if a male athlete were to go through the same experience I did, where he was suddenly surrounded by celebrities with different body types, the story would be quite different. Not only would the pressure to conform not be the same, but he would find a way to frame it as a positive—to the tune of "Wow, I'm so much more ripped than everyone else."

I see now that there isn't a human alive who hasn't struggled with this to some degree, but at that time, I didn't yet have the strength to define what was best—both for me and for my career. At the end of the day, I was the only person who needed to live with myself, and I was the only person who needed to define her. Now, I realize that every person (and every body) has a purpose. When you're fully immersed in your purpose, it can help you see more objectively, rather than through the judgmental lens of our society. But it would be a while before I arrived at

that place. In the meantime, I succumbed to the pressure, and I took my eye off the prize.

The 2010–2011 season got off to a slow start, and I wasn't in my groove. I'd grown complacent, distracted by my new image and all that came along with it, and it took me a moment to regain my footing. Meanwhile, Maria Riesch was on top of her game that year. She had a big lead in every race, and I was trailing her, just chipping away. In March, I arrived at the 2011 World Cup finals, in Lenzerheide, Switzerland, ready to close the gap. I had won the World Cup overall title the three previous years, and I hoped to make this my fourth.

The first race was the super G, and a big opportunity for me. At the time, I was doing really well in super G, so I was looking forward to it. The conditions in Lenzerheide can be iffy, and this year was proving to be no different. Half the time, the weather gets in the way, and even when it doesn't, it's an issue. The morning of the race, we got word that it was canceled. I was disappointed, but not devastated. I would still have another chance.

The next day was slalom. We woke up to discover the conditions hadn't improved. It had snowed so much the night before that there was no surface. They had three hundred people—a mixture of soldiers and race officials—out on the hill, trying to make it work. They were packing in the snow with their boots, hosing the whole trail with a firehose and then salting it afterward to suck up the excess moisture. For most World Cups, they call in the Swiss army to help out, but this was next level. In my entire career, I've never seen anything like it. It was so much collective effort to try to get this race off.

The truth is, we never should have been skiing in those conditions, but I guess after canceling the super G they felt like they didn't have a choice. After all that, I managed a thirteenth-

place finish. I hadn't been doing that well at slalom, so all things considered, I saw this as a success. Then Maria pulled ahead of me—almost a full second ahead—finishing in fourth place.

That put her three points ahead.

I was happy for Maria, but I was also looking forward to the giant slalom the following day. When it came to GS, I was on a hot streak. Maria hadn't been doing well at GS, so this was my chance to make up the difference. It was my one last chance to compete for my fourth consecutive overall title, and to end this season on a high note.

To put this in perspective, three FIS points is essentially nothing. It's the difference between me finishing one spot higher in any one of that year's thirty-three World Cup races. Or Maria finishing one spot lower. The difference was basically nothing, but at the same time it was everything, because when it came to my results for the season, this race was my last shot.

The morning of the race, I woke up extra early, feeling ready for one final showdown. I always thrived in these all-or-nothing, make-or-break situations, and I was excited. Then, at 6:00 A.M., we got word that the race was canceled. I was floored.

After all the effort they had put in the day before, this time they didn't even try. My head coach, Alex Hoedlmoser, was on the phone with me when I first heard the news in my trailer, and his reaction was the same as mine. We looked out the window, only to discover it hadn't snowed that much. It wasn't even foggy. He thought the conditions were fine and that we could have raced. The call didn't make any sense to us.

Races often get canceled, but the way that one happened was really unfair. I'm sure others could say the same about other events and other results, but that still didn't make it any less crushing. All that morning, I hovered somewhere between pissed and devastated. Of course, I didn't agree with the decision. I almost refused to accept it. I'd woken up ready to lay it

all on the line and give it everything I had, only to have my one last shot get canceled. For a good long while, I sat in my RV and cried.

I'd had a slow start to the season, following my complacence after Vancouver. In an emotional sense, once I was on that winning high, I kept going with it, riding the wave as long as I could. But when it came to my training, my heart wasn't in it, because once I had won the gold medal, I'd gotten what I'd set out to do. I wasn't as hungry, and it showed in my results. Maria, on the other hand, had been on a tear all season long. If only I had given it my all throughout the season, this one race wouldn't have made all the difference. But it did.

I lost the World Cup overall title by three points.

I was devastated by the cancellation, but I was mainly disappointed in myself. That was a wake-up call of a different kind. I thought back over the course of the year and everything I'd been focused on. *What am I doing?* I thought. *I'm wasting my career because I'm self-conscious about the way I look?* The realization was crushing. My preoccupation with my appearance had real, measurable consequences to my performance. It was the first time, in all my years of training, that I'd been conscious of my size instead of laser focused on my goals. And where had it gotten me? What good had it done? I promised myself I would never again let superficial distractions get in the way of my success.

Though it was a tough pill to swallow, that experience taught me that one of the best ways I can support myself is by putting on my blinders to outside pressures and focusing on what's best for me—for my health, for my body, for my goals. Skiing was more important to me than anything, especially my appearance or what other people thought of it. I needed to get back on track. It might have been the end of the season, but it definitely wasn't the end. Next year, I pledged, would be different.

CHAPTER SIXTEEN

There's nothing quite like a home crowd. Everything feels better when you're competing at home—the atmosphere is warmer, wilder, louder, livelier. Everything feels heightened. Even the same scenery you've seen a thousand times looks different, in a good way. At home, you're always a favorite, whether you're coming in on top or not. That kind of enthusiasm feels amazing, but it's also its own kind of pressure, because you don't want to disappoint your hometown fans.

It was the first week of December 2011. Due to a lack of snow, the women's super G originally scheduled for Val d'Isère was moved to the famous Birds of Prey course, where the men's race had just been held the previous week. The run was situated in Beaver Creek, in Vail, which was about as close to my home as I could get. The sudden change of scenery was a welcome surprise. I had just slept in my own bed for the first time in weeks, and it felt amazing.

Ever since I was a course slipper at the World Champi-

onships in 1999, grooming the snow with my skis in between competitors' runs, I'd wanted to race this course. It had everything—steeps, side hills, hard turns. It's fast and technical and always coming at you. But one of the most exciting parts about Birds of Prey was that at the time, women had never raced it before.

Normally, when you race on a home hill, you have an advantage, because you've trained on it before. You know the course, you know the terrain, and that gives you a significant leg up on the competition. But in this case, the U.S. women's team had never trained there, either, so we were all on the same playing field. I felt like an underdog on my own turf.

A couple of days before the race, we all tried to ski it, and it was so icy from the men that we couldn't even make it down. While that wasn't the most encouraging experience, I tried not to let it affect me. I had never won a speed race on home soil, and I wanted to change that.

The day of the race, I woke up tense, with my stomach in knots. I did my best to stay loose, doing some agility drills to keep my muscles firing. As it got closer to race time, I went about my routine—deep breathing, visualization, trying to get in the zone. I still felt nervous as I went out of the gate, but I tried to pull it together. I'd won my last three races in a row, and I wanted to keep the momentum going. It was a perfect storm—the perfect time and place to step up and excel.

In keeping with the theme, all the jumps on the course are named after birds of prey: Peregrine, Screech Owl, Goshawk, Harrier, Red Tail. For the women's race, they amended the course, so we didn't go off the Bald Eagle—the biggest jump the men do. But the run was still extremely challenging. For one thing, it's deceptively steep. By just observing it, the drop doesn't look that dramatic, but in the execution, it keeps pulling

you down, making it a high-speed course. By any measure, the hill was intense, and I would need to match it.

Despite my best efforts, I was a little cautious at the top and through the middle. I ran the line a little low and barely made a couple of the gates. But I knew that if I attacked the course on the bottom, skiing aggressively through the fall line, I could make up the time, so that's what I did. I carried my speed all the way through the finish to come in 0.37 ahead of Switzerland's Fabienne Suter.

The crowd went wild—screaming kids and people of all ages, a sea of homemade signs and American flags. I pumped my fists and blew them a kiss, grateful for their energy. It felt incredible to win at home, especially under the circumstances. Since the race had been moved on such short notice, my immediate family wasn't there. But the hometown fans embraced me as their own. I knew that quarterback Tim Tebow's brother Robby was among the spectators, so before I stepped onto the podium, I knelt on the ground, saying "Go Broncos," emulating Tim's famous move. I'd thought it was a funny, celebratory thing to do, but the press turned it into something else, spinning it into a story that I must be dating Tim. It was the first of many such fictions, a preview of my new reality.

Before I left the stadium that day, I signed as many autographs as I could. There were a ton of kids in the crowd that day, which made me happy, since they were always among my favorite fans to talk to. A lot of them said they had skipped school to be there, so I posed for photos and signed as many helmets and jackets as it would take for them not to get in trouble for it.

The day may have started off tense, but I ended it feeling on top of the world. It was my forty-sixth World Cup victory—my fourth in a row and my fifth out of the six so far that season—but it was easily one of my most special. It felt like winning the

World Championships. I had done it, and what's more, I had done it on my own.

As it turned out, the following year *would* be different, in more ways than one. In the public eye, it seemed like I had it all. Behind the scenes, though, my marriage was ending.

When your work and your personal lives are intertwined the way ours were, everything feels magnified and all-consuming. Our emotions as a couple shouldn't have hinged solely on whether I won or lost. But that's how it came to feel, and over time, we grew apart. I felt like I was a skier and he was my coach. That was all we had. Eventually, after four years of marriage, I reached a point where I needed more freedom both on the hill and off. I wanted to determine my own line, both literally and figuratively, and I'd finally found the confidence within myself to do just that.

Once I pulled the trigger, I didn't have any hesitation about moving forward. It was hard to contain the news, because Thomas had been my coach, and people expected to see him by my side. Soon after we separated, I headed to a race in Aspen, where my sisters and Reed came to join me. That was the first time Thomas wasn't there, and people noticed. When the media asked why, I told them his dad was sick and that Thomas was in Florida helping him, which was true, but of course wasn't the whole story. It was clear I needed to get out in front of this before the rumors started to circulate. A week later, I contacted a trusted reporter at the *Denver Post*. We spoke, I gave him a statement with a few details, and he ultimately broke the story.

And then, I had to start over.

When I got divorced, the *Chicago Tribune* ran a piece by Philip Hersh with the title, "Can Lindsey Succeed Without a Man by Her Side?" The article said that first my dad led the way, then my ex-husband. Could I do it without someone directing me and tell-

ing me what to do? Could I still be fast without a man to guide me? There had always been plenty of articles citing my dad's or Thomas's role in helping me succeed. All of them took away my agency, and all of them filled me with rage. But this took it to a new level. This was the first time someone had said something to this extreme. I couldn't believe that the *Chicago Tribune* would print that headline, let alone any of the words that followed. Why was this even remotely a topic? If the tables were turned, no one would ever pose such questions about a man.

A lot of times, stories are framed a certain way to be sensational, to sell copies or drive clicks. But in this case, that wasn't even the worst part. I talked to this journalist, and I honestly believe that's what he thought. I couldn't believe there was anyone out there who didn't think I could be as good—or better—without a man by my side. From the moment I saw that headline, I was irate. It was an affront not only to me but to all successful women whose accomplishments are diminished by this kind of overt sexism.

When I talk about how negative comments served to fuel me, that might be the one that topped all the others. It was infuriating, but I didn't take it to heart. I didn't dwell. Those words lit a fire in me to prove him—and anyone who thought this way—wrong. I never forgot that headline, and I never will. For pure motivation, it was probably one of the best things that's ever happened to me, though to this day, just thinking about it leaves a bad taste in my mouth.

The week following the announcement of our separation, I won all three World Cup races at Lake Louise—two downhills and one super G. The following week, I went to Beaver Creek and skied the Birds of Prey, which felt like winning the World Championships.

As I always had, I turned to skiing to get me through this emotional time. The year following my divorce was the best of

my career in terms of points and victories. I won four titles. I won twelve races. Somewhere in the middle of that season, it felt like everything clicked for me. My confidence, my equipment, my conditioning, my relationships with my coaches and my teammates. Everything just worked. Having my strongest season right after my divorce was the best thing that could have happened to me. I made it clear to everyone that yes, I could succeed without a man by my side. But even more important, I proved that I didn't need someone else to set my value for me. I decided it for myself.

Over the course of that year, I became much stronger. The ski season let me take all my emotions and channel them into skiing, but when I stopped at the end of the season, it hit me pretty hard. Not in a tragic way, but in a realization of where my life was at that point. This was my new chapter. This was my chance to start fresh. Moving on after my divorce felt a little like building a house from scratch. I had demolished the old structure and now I had to rebuild it on my own. On the one hand, it meant I got to design everything exactly the way I wanted. But it also meant that, in the interim, I didn't have a home. It was pretty intense, and those initial steps were the hardest.

For the first time, I had to establish my own routines. Skiing was the easy part; everything else was hard. I took a long look around me to figure out what I needed versus what I wanted. Then I built a team of people who could support me and help with the things I didn't know how to manage. I'd had the same two agents, Mark Ervin and Sue Dorf, since I was seventeen, and they stuck by me and helped me find good people who I could trust. Up until that point, I had been completely sheltered, distanced from how the world worked. Suddenly, I was thrown into figuring out my finances, handling the media along with my publicist, and finally being involved with managing my contracts and partnerships. There was so much going on, and I

had to figure it out quickly. I wasn't sure if I could do it, but I hunkered down and developed a system. The thrill of being able to build this new house motivated me in a different way.

That summer, I moved to L.A., where I lived in a house with my childhood friend Ali. It was so nice to have more freedom. I went to dinners, I got dressed up, I went to events. My day-to-day life looked nothing like it had just a few weeks before, and I loved it. Our house had a pool, and everyone would come over for barbecues. We went to the Kentucky Derby with a big group of girls. My friends rallied around me and tried to support me as much as they could, and it really helped. A lot of people reached out and wanted to spend time with me. Two of my roommates from back in Park City reached out to see how I was doing, and to offer their friendship. "We wish you would have talked to us more!" they said. "You spent all your time at Thomas's place, and we didn't think you wanted to hang out with us." It was a revelation. Over the coming weeks, I heard a similar refrain from nearly the entire U.S. Ski Team. I'd spent my marriage segregated from the rest of the team, and in the process had missed out on so many experiences, like rooming with teammates, that could have fostered better connections. All along, I'd thought that no one wanted to spend time with me, but that wasn't the reality. From that point forward, things were different. I talked to everyone and ate my meals with the team. On the tour, where I used to exclusively hang out with Maria Riesch, I now socialized with everybody.

That summer, Red Bull put together a party for me to celebrate my sixteen titles. It was a sweet-sixteen-themed party, because growing up, I never got a chance to have—or even attend—one. I remember those months so fondly. They were easily some of the happiest times of my adult life.

Still, I knew I had to keep up my training. I never lost sight of my goal, which was always to win races. The previous season

had taught me that when you're in a good place, it means you need to work even harder, so that entire 2011–2012 season, I worked my ass off in the gym. On most days, I worked out three times a day—cardio in the morning, a track session with weight lifting in the afternoon, and more cardio in the evening. From a fitness perspective, I was on fire. While I was in L.A., I spent a ton of time at the Red Bull training center, where I got to work out with a bunch of pro athletes, including NBA and NFL players, like Aaron Rodgers and Clay Matthews. I was opened up to a whole new world of people who were kind and driven and strong. We'd do circuit training together, which was awesome. I was like, *Who else in the skiing world is training with NFL guys? Probably no one.*

All of the success on the hill after my divorce, though, couldn't mask the reality that emotionally, that year took its toll. When it came to talking through things, I confided in my sisters and my best friends, and learned a lot about myself and my marriage in the process. But it was tough mental work to keep my internal chaos from becoming public.

It takes a lot to be successful in sports, and much of it happens behind the scenes. There are so many aspects of our jobs that happen out of sight. People see the glamorous parts of being an athlete, but they don't see the hard work. That's true during the best of times in your career. But during the worst of times? Well, not surprisingly, that disconnect is even greater. People don't understand how difficult it is to go through life-changing events in the public eye—they don't see the time alone in strange hotel rooms, the loneliness. But I felt it all.

When you're a professional athlete, there's a pressure to be on all the time—for the cameras, in interviews, with fans. With the media, you're not just representing yourself, you're representing your sport (and in most cases, also your country). There are so many levels of an interview, so many things that come

into play. You don't want to be controversial; you don't want to be polarizing; you don't want to be negative. You want to steer things in the right direction. The trick is to figure out what you're going to say before you say it. At first, that part of the job was nerve-racking, but I've gotten better at it over time, through repetition. That's one aspect I've always liked—I love being in front of people. I think it goes back to all those choreographed dances I did as a kid. I always wanted to be entertaining in some way. I always perform better when there's a crowd.

But then the crowd would melt away, the race would be over, and the day would come to an end. That rush of adrenaline would come to an abrupt, and unwelcome, stop.

There were a lot of times when I came back to my room, still on a high from racing, and was confronted with deafening silence. I remember once in particular, while I was going through my divorce. It was a great weekend; I had just won back-to-back races in St. Moritz and was feeling strong. Immediately after the races, I went to meet my dad, who was helping me with my divorce, back at his hotel. There was no celebration. There was no time for reflection. We looked at some papers, I packed up my stuff, and then I climbed in my car with a bunch of Red Bulls and drove the five or six hours to Austria all by myself.

I arrived at my apartment in Austria around midnight—I don't think I even had dinner, maybe just a protein shake—and I went right to sleep. I remember waking up at five or six the next morning to a knock on the door from Doping Control, and thinking, *What the fuck? So this is it now?* The distance between my reality and public perception couldn't have been greater. To the outside world, everything looked incredible. I'd just had these back-to-back wins, and you'd probably expect I would be off somewhere celebrating. But nothing could have been further from the truth. Instead, I was alone—navigating a divorce alone, driving alone, sleeping alone, facing everything alone. I

felt isolated and exhausted. In the public eye, my life probably seemed pretty exciting, but behind the scenes, so much of my career was spent passing long periods of time in empty rooms, wondering what came next.

There were a lot of other times like that one—really shitty endings to punctuate what would otherwise be wonderful weekends. I think that happens a lot in ski racing. The enjoyment is in the racing, but not so much after the fact. There's the inspection, the waiting, watching other girls' runs, mentally preparing. There's a whole four-or-five-hour buildup to a two-minute race, and that's the peak of the excitement. But then it's done. Whether you win or lose, it's over. And then there is nothing.

By myself, I discovered just how much life on the road can take isolation to a new level. The driving is exhausting, with narrow, winding mountain roads and bad weather. After a lonely drive, I'd arrive at the hotel to stare down an even lonelier night. Being on a tour is regimented and repetitive. Your schedule, training, meals are all mapped out for you. The location changes, the food might be different, but your life feels the same—draining yet monotonous, every day.

Inside that quiet room in Austria, my future looked different than I'd imagined. When I first got married, I thought I'd have kids at thirty and raise a family in Norway. But now I saw it unfolding in entirely new directions. Thomas and I were together for a long time, and all along, I'd been changing. When we got divorced, I realized I was no longer the same person at age twenty-six that I was when I married him at twenty-two. My life was taking on a new shape, one that felt entirely different than the one it had held for so long. It was a big change, and a hard transition, but I felt ready to chart my new reality.

While I was going through the process of my divorce, I read a lot of self-help books and noticed a lot of them said the same thing: We *choose* to be happy. You are responsible for making

the decisions that will ultimately lead to your own fulfillment, whether it means staying or breaking up or getting divorced or making other changes. You have to ask yourself the hard question: *Am I happy?* And be truthful about the answer. A lot of us underestimate what we're capable of. If you find the person you want to be with forever, I think that's amazing. But if you don't, trust that you're strong enough to follow your own path.

The happiness thing goes both ways, too. You can't make someone else happy and you can't fix other people. You can't go into a relationship thinking you can be the thing that makes them happier or healthier or better. If you try to do that, you're going to end up with a lot of weird shit.

One of the biggest lessons I learned from my divorce was that I needed to find happiness in who I am. For a long time, skiing hid most of my issues, because it was a way to channel my emotions. I think that's why some of the best seasons of my career happened when everything around me was falling apart. But eventually, I needed to figure my shit out, because if you're an adult, and you want to be in a meaningful relationship, that's what you need to do. Busyness can only mask your issues for so long. Eventually, you will have to face them.

In a way, my depression actually improved during this time. I was on my own, and sometimes that was a struggle, but I felt supported in a different way. For the first time in my adult life, I was exploring different facets of myself as a person, outside of skiing. I was also learning how to take better care of myself emotionally, to seek balance in other areas of my life. In the off-season, I spent time working out or socializing with friends, simple actions that had big emotional payoffs, because they provided the mental resets that could help get me out of a slump.

When I won the Olympics, it had been the first step in finding confidence outside of skiing—not because of the gold medal itself, but because it opened the door just enough to give me

a taste of the wider world. Where my identity had previously hinged entirely on skiing, I came to see I had other things to offer. People respected me, and they cared what I had to say. After my divorce, that door blew wide open. I was making new friends, forming new connections, and entertaining new possibilities. Though I still had plenty of questions as to what came next, I felt ready to discover what was on the other side.

Following the divorce, my family was disappointed that I didn't want to change my name back to Kildow, but by that point, Lindsey Vonn was who I was. I had built up this alter ego, like my version of a company name. When I ski, I'm very aggressive. I'm determined and fierce. When I race, I am Lindsey Vonn. It has nothing to do with Thomas—or with anyone else. It's what I'd built, and I got to take that with me.

But regardless of the name, my family was back in my life in a big way. I talked to my dad a lot during that time. In the years leading up to my divorce, he and I weren't speaking, and it was difficult for me not to have him there, the way it had always been. There were so many experiences I wanted to share with him that I couldn't, which was hard for me, as I'm sure it was equally hard for him. After having such a strain on our relationship, it was nice to get back to a place where he and I could share things with each other and have day-to-day conversations. As we reconnected, he told me things I never knew—lessons from his own marriage and other things he'd learned—that really opened my eyes and helped me. I think sometimes parents don't think their kids can understand certain dynamics, and it takes shared life experiences to be able to open up and talk about them. That was an important moment of healing for my dad and me.

Indeed, of all the changes that stemmed from my divorce,

perhaps the most welcome was how it changed my relationships with my family, particularly my siblings. In the years following the divorce, my siblings stepped in to fill some of the gaps, which really eased my loneliness. Laura came on the road with me for two seasons, and her presence was exactly what I needed. Since I wasn't good at being alone, she kept me company. She made me breakfast in our tiny travel kitchens—eggs with bell peppers and onions became our go-to dish—and sometimes dinner. She helped with my media. She also became my personal entertainment squad, willing to be the butt of all jokes in exchange for a laugh. In the stretch of time immediately after the divorce, Laura would ride the chairlift with me, quoting *Dumb and Dumber* ("Hey, you want to hear the most annoying sound in the world? EEEEEEHHH!") or various Chris Farley movies ("Fat guy in a little coat . . . fat guy in a little coat"), to lighten the mood. When I was injured, she was there, filling up the Hyperice with ice. During recovery, she brought me ginger ale and crackers, my go-to post-surgery meal, and fired up endless episodes of *Law & Order* and *Homeland*. She packed my bags and helped with my crutches. I don't know what I would have done without her.

Compared to the rest of my family, Laura's pretty indifferent about skiing. Sometimes, though, she would ski with me, including this one time she tried to pass me, in Cortina. She caught her edge and face-planted into the side of the hill. "Don't try to pass me," I said, jokingly. "Bad things will happen." But she's always down for anything. She's really even-keeled—she doesn't get too high and she doesn't get too low.

During the 2012–2013 season, Red Bull had this sick modern RV bus, with a full kitchen and a shower. The deal was that the Formula One team used it in the summer, and I got to use it in the winter. It had a sofa and a TV and was big enough that

I could do my training there. It also had two beds, so Laura and I stayed in the bus together. She slept in a double bed above the driver's seat, and I slept in the back of the bus.

Laura is tidy, my mom always called her a "neatnik." Growing up, she was the one who cleaned the house, and she brought that same energy to the RV. I had my little bedroom area, which was a pit, but she kept the rest of the bus neat. It can be difficult maintaining the little things—it's not like you're going to stop and do your dishes right before you go out to race World Cup, you know? Thankfully, she was really good about that stuff.

One night, the two of us were in Garmisch, and it was really cold. I'm talking minus thirty-five degrees Celsius. In the middle of the night—the night before the downhill race—I woke up *freezing*. It was so cold outside that the power had gone out. I got up, put all my clothes on—socks, long underwear, sweatshirt, hat. I brought Laura some extra clothes to layer. At this point, it's two in the morning.

We tried to restart the system but couldn't figure it out. We had space heaters going, but they were so small, they didn't really do anything. Still, thank God we had them, or it could have gotten really bad. Laura and I snuggled up, shaking and trembling as we held each other tight, freezing our asses off. It was well below freezing in that bus. It was so cold we could see our breath.

The next day, I won my fiftieth World Cup race.

CHAPTER SEVENTEEN

T his is going to ruin your career."

I can still hear those words ringing in my ears, perhaps because they were said by multiple people as 2012 came to a close. In hindsight, with all that's happened in the world since then, it's hard to imagine my career actually being ruined by what I was about to do—share the story of my depression with the world. I mean, today, celebrities and athletes go public with their depression all the time. Michael Phelps, the most decorated American Olympian of all time, is now a spokesperson for an app promoting talk therapy and helped produce a 2020 documentary about Olympic athletes' struggles with mental health problems. As things that ruin athletes' careers go, talking about depression should barely register in the top fifty.

But back in 2012, athletes didn't talk about their mental health often, if at all. Even when journalists were having emotional, on-the-record conversations with athletes about their feelings, depression wasn't a topic that many volunteered to

discuss. Wins, losses, disappointments, regrets, injuries—of course all those things were fair game. But crippling depression or debilitating anxiety? Not so much. It's a testament to how far we've come in such a short time that the stigma of mental health problems in athletes, and in general, isn't nearly what it was back in 2012. Rightfully, we've decided as a culture that no one—whether you're famous or not—should be forced to suffer the effects of depression or anxiety in silence.

In 2012, though, to be an athlete with mental health problems meant largely suffering in silence. For someone whose livelihood depended on sponsors, having clinical depression wasn't just considered unusual, it was dangerous. Dangerous to your future, to your finances, to your fans. Dangerous because no one really understood what it meant for your career or what impact it might have on your performance.

For years, I walked around like I had something to hide, something that I needed to be embarrassed about, but then I decided to test just how dangerous sharing it would be. Some people thought it would be the end of me, that it would damage the image I'd created as a strong, resilient athlete; personally, though, I wasn't so sure. I mean, when I really considered it, having to battle depression alongside all the other everyday challenges of professional skiing had made me stronger mentally and physically. Not only did I have to work to be the best on the hill, I had to do it with my brain chemistry actively plotting against me. Actually, living with depression proved my resilience as much as or more than anything else I'd done to that point.

Despite my concern about what going public would mean, the only thing I knew for certain was that I didn't want to keep running from it. After all, it wasn't as though by talking about my depression I was doing something unprecedented; plenty of people before me had talked about their experience with this

issue. But talking about it was unprecedented *for me*. To let people, strangers, in on something that was so personal, so secret, that I'd hidden it for years from some of the people closest to me—well, it's not an exaggeration to say that whatever I'd done before, I'd never done anything this terrifying.

The truth is, for years, I'd never really told anyone about my experience with depression. Since my diagnosis, I'd found ways to manage it and figured out just as many ways to avoid talking about it. Of course, it surfaced sometimes, but I was always able to dismiss it or work around it. Still, those ten years were a long time to keep that darkness to myself, and after my divorce, I started to share it more—first with those close to me, and eventually with everyone else.

And when I finally opened the door, it felt really good. For so long, I'd been ashamed, but when I started to confide in people, I found that a lot of them, including my own family members, shared similar experiences.

"Lindsey, why didn't you tell me?" my mom asked.

"I was young at the time," I explained. "You were going through the divorce, and I didn't want to worry you or make you feel bad."

My mom understood, though she acknowledged, as any parent would, how sorry she was that she couldn't have been there for me. She confided that she, too, had experienced depression, something I'd suspected—despite the fact that she never complained, I knew she had her own struggles. It felt good to have that conversation, and I was glad we could now be fully open with each other.

The more I talked about it, the more I realized that with my divorce fully behind me, I wanted to get this off my shoulders publicly. As part of my fresh start, putting everything out in the open felt important to me. I was emerging from this time of huge personal transformation and introspection, and one of

the things I remember feeling was that I didn't want to hide my depression anymore. A few years earlier, I couldn't have imagined wanting to reveal this to an audience, but I wasn't the same person now. I took risks every day on the hill without thinking twice about them; now, I'd finally gained the confidence in myself to take a big one off it.

After talking through the options, my team and I felt like the best way to share my story was to do a print interview. I had a good relationship with an editor at *People*, so that's where it landed. They decided to put me on the cover, which was a big deal. Sure, I'd been on magazine covers before, but that always felt different. This time it was about a vulnerable, personal thing. Despite my concerns about how it would sit with my fans and my sponsors, I kept reminding myself that hundreds of millions of people all over the world experience depression, across every field and industry. Athletes are not immune to its trappings—most are just conditioned not to discuss or expose weakness. By talking about it, I wanted to help open up a conversation and give others the confidence to talk about their stories, as well. It's not a sign of weakness, and it's nothing to be ashamed of, so why not lead by example?

When the word was out, I think it came as a surprise to a lot of people, including those who knew me well. I had barely even spoken to my family about it at that point, let alone anyone else. Then, suddenly, there I was, on the cover of a magazine, openly talking about my mental health. But I was glad I did it. It was a big step, and I felt relieved that I took it. One unexpected consequence was that opening up about my depression definitely helped me with my depression—even more than any of the therapy or medication—because it meant that from then on I could be honest with everyone, including myself, about what I was going through. Simply saying the words out loud meant I could finally accept them.

A lot of people related to my story, and the reaction was largely positive. The basketball player Kevin Love (who is now a good friend) texted me to say he was proud of me. "Everyone should be talking about this," he said. A prominent news anchor approached me at an event and thanked me for sharing my story, confiding that he had been through a similar thing. "People think because I'm on TV everything must be great," he told me, "but sometimes it's not." The outpouring of support and solidarity—from so many people, from all different walks of life—was huge. The more stories I heard, the more it started to seem like everyone had experienced their own version. So why had no one said anything about it before?

Still, some people were critical. There were those who said, "You have everything, how can you be depressed?" People tried to rationalize it away, pointing out all the positives in my life as though taking stock of the external world is enough to correct an imbalance. Depression doesn't make logical sense. It's a chemical imbalance that doesn't discriminate. You can have every perceived success and every material thing in the universe and still be miserable. I can recognize that things are good and still feel down—much of my life is spent holding those two contradictory emotions in my head simultaneously, not because it's rational, but because it's who I am.

Because so much of the skiing press coverage is in Europe, I did notice a distinct difference in the way it was covered there as opposed to in the United States, because in Europe, there was, and still is, a larger stigma around depression. After I came forward, and for the rest of my career, in most European interviews, the reporter would ask, "How are you? Are you *still* taking *medication*?" Depression isn't like a headache, where you can take Advil until you feel better. Or they would say some version of, "How is your depression doing? Is it better? Is it healed?" Like I had a cold or a broken bone.

But in other interviews, and often behind the scenes, a lot of journalists and broadcasters both over there and back home told me about their own struggles with depression. I've also had lots of off-camera conversations with other athletes, media personalities, and fans. Depression affects so many people, and I think the most important thing is to be open and help clear the stigma around it. Some people still think I shouldn't have spoken out about it because it's such a personal thing, but given how much more open athletes are with their lives, there are fewer of those voices today. At the end of the day, it's my story, and it was definitely the right decision for me.

Once it was out in the open, I felt like I was able to put down a heavy load I hadn't fully realized I was carrying. Before, holding on to this secret made me feel like there was something wrong with me. But once I opened the door, it changed the way *I* saw my depression, too. It felt like I was in good company, that other people understood, and there was no longer anything to hide. Over the years, I've been able to confide in those close to me more and more. Learning to share this about myself was a crucial first step in helping me understand that being open about your personal struggles actually benefits everyone, because it creates the space for people to support each other. That's one thing I'll say for anyone currently in the midst of depression—you have to let your friends or family or people who care about you help you through it. Don't try to go it alone. Depression is such an isolating feeling, and staying physically isolated makes it even worse. Even if you think that no one understands, reach out and talk to somebody, whether it's a loved one or a therapist. You need to have support. I'd needed it for years and hadn't been able to get it because I was too ashamed.

Of course, what I didn't realize then, what I couldn't have known, was that I would soon need that support in a way that I never had before. I took a risk in sharing my story, but the tim-

ing was incredibly lucky. As I'd soon find out, the bigger, and more costly, risk would have been to stay silent.

For a professional athlete, there are a handful of moments that just change your career—full stop. You have no way of knowing it ahead of time, but then it happens and there is a near instantaneous awareness that everything will be different. Winning a gold medal will do that. So will your first truly horrific injury. In my case, I was just lucky that they came in that order—and that, by the time I had that injury in 2013, Lindsay Winninger was on my team.

Lindsay, my longtime physical therapist, and I first became friends in 2012. We were at a training camp in Chile, where you're pretty isolated from the rest of the world—there's a hotel at the bottom of the ski resort, and that's about it. Since we were hours from anything else, aside from skiing, there wasn't much to do. One evening, after we wrapped up training for the day, someone asked me, "What are you going to do tonight, Lindsey?" And I replied, "I'm going to watch *Law & Order*, like I do every night."

Lindsay was there, and she turned to me and said, "Oh my God, can I watch it with you?"

It was an instant thing. If you like *Law & Order*, you're my kind of people. (Come to think of it, my best friend Vanessa and I were set up on a friend date, and part of the reason why we instantly clicked was because she looks like this character on *Law & Order*. So yeah, if there's a connection to *Law & Order*, we're most likely going to be friends.)

From that point on, almost every night, Lindsay and I watched episodes of *Law & Order* together. At the time, she was the physical therapist for the whole team—she didn't yet work for me—but we developed a really close friendship. She's from Iowa, another Midwesterner. You can always trust a Midwest-

erner. We call each other "buddy," which is her thing. She's always done it, and now it's hard for me not to do it, too.

Before Lindsay, I had only worked with male physical therapists. I had good relationships with all of them, but there was definitely something different about working with a woman. I could share more with her, because I knew she understood where I was coming from, and it was comforting to have someone on the road with me who was also a friend. Lindsay is smart. She just got it. She knew there are always going to be people saying shit about you, and she saw from a distance how that affected me emotionally. It was good to have a friend who had my back and provided support and positive reinforcement.

Another thing about Lindsay is that she's just as competitive as I am. If someone presents a challenge, like when people said I couldn't come back from an injury, she's going to do her job better than anyone else, just to prove them wrong. That's how she's wired. Personally, I think she's one of the smartest PTs in the world. She has an incredibly vast knowledge base—not just about anatomy and recovery, but about sports. You'd be hardpressed to find anyone better. And I would need the best on my side, because what was coming wasn't pretty.

In February 2013, I was in Schladming, Austria, for the World Championships. Schladming started out like an average race day—perhaps a bit more pressure than usual because it was a World Championship, but I felt good. Though I'd underperformed in a few races in the 2013 season to that point because of a stomach problem, I felt confident about how I was skiing. I'd had my third career hat trick in Lake Louise at the beginning of the season, and along with a win in downhill in Cortina, I was just coming from another GS win in Maribor. Despite taking time off, I was still leading in the downhill standings and I intended to keep it that way.

The first race was a super G, but there were a ton of weather

delays. It was foggy and warm, and the snow just wasn't holding up. When I inspected the course, I could barely see one gate ahead of me. It had snowed so much two days before that they wouldn't allow anyone on the hill before the race. I didn't get a chance to free-ski on the hill, our coaches didn't get a chance to be on the hill, so we had no idea what the conditions were heading into the race. It was a situation no racer wants to be in. It was the World Championships, so I know there was a bunch of money and politics involved in this particular decision. But the number-one priority should have been—and should always be—the athletes' safety. Period.

Up at the start, we were all ready, but it was never time to go. They kept delaying every fifteen minutes . . . for four hours. It was a hurry-up-and-wait game. We were all ready, but it was never time to go. I kept texting my sister Laura updates so she wouldn't have to wait in the cold. It was a very long, very draining day.

Finally, it was time. I was racing nineteenth, so I had the advantage of watching the other racers go down the hill. It was dicey. Maria Riesch and Anna Fenninger didn't finish. The course was delayed another time because a course worker got injured and needed to be airlifted off. When you look back it's obvious, no one should have raced that day. No one in their right mind would have gone down that course with those conditions. But for a downhiller, there's no room for what-ifs. You second-guess yourself once and you either go back the way you came, or you go down the mountain and risk your life.

Years later, after many more injuries, the voice in the back of my head that would tell me not to do stupid things grew louder and more forceful, but at this point in my career, it just didn't exist. All I knew was go. That was my mentality on that day—there was no bad omen big enough to stop me. So I focused in the starting gate.

I was in the lead after the first split, or the first timed stage of the course. In the second split, I was just twelve hundreths of a second behind the leader, Tina Maze. I could easily make that up in the bottom section. I went off the first jump pretty direct, and when I landed, it was into a pile of soft, sticky mush. The snow had softened up considerably since the start of the race, and it stopped one of my skis in its place. My momentum hurled my body over my right knee stuck in the snow, and I did a cartwheel onto my back. I'd crashed before, but never like this. I knew immediately that it was bad. After the fact, people told me they could hear me screaming from up and down the run; hours later, I would check my phone to find a text from Laura. "Please be okay" was all it said.

I was crying as they strapped me to the stretcher to airlift me off the mountain. As I was being airlifted, I remember staring into the sky, tears streaming down my face, praying that I would be okay. There's nothing quite like being strapped to a toboggan a couple hundred feet in the air and thinking about all the decisions you made that got you to that place.

They helicoptered me to the hospital, where Laura came to meet me. Lindsay was also there, along with Patrick Rottenhofer, my Red Bull physical therapist, whom I called Ricky. Laura held my hand as we waited for the MRI results to come back. I knew it was bad, but they all tried to keep me calm and help settle my mind. After what felt like a million years, the results came back. I had torn my anterior cruciate ligament (ACL), I had torn my medial collateral ligament (MCL) clear off the bone—which is pretty damn hard to do—and I had a tibial plateau fracture.

The Olympics in Sochi were a year away almost to the day, and when I heard the extent of my injuries, my only thought was *How long am I out?* Lindsay and Ricky walked me through the injuries, explaining exactly what they meant, and what I could expect in terms of recovery. I would need to get back to

the U.S. to have surgery, since I wasn't about to do that in this tiny hospital in Austria. They told me that, after my surgery, we were looking at a six-to-eight-month recovery time. (The whole truth is, they told me normal recovery time was eight to ten months, but I'm not most people, so in my head I cut it down to six to eight.) That meant the Olympics were still possible.

I immediately flew back to Colorado for my surgery, which took place four days later. The plan was to take part of my hamstring tendon from the same injured leg and use it to reconstruct both my MCL and my ACL. Leading up to the procedure, I couldn't be on my leg, of course. But I kept doing everything else I could. I was in the gym every day—including the day after my surgery—doing core, biking, doing one-legged rowing. I would not let this set me back.

It was a slow recovery process, because my injuries were complicated, especially where the MCL came off the bone. I was very restricted in movement, so for the first four weeks, I had to stay in bed, hooked up to this machine called a CPM, which stands for continuous passive motion. It would slowly bend and straighten my leg—continuously, hence the name—to keep the ligaments from scarring or tightening too much, and the blood flowing to prevent a blood clot. It's literally the worst machine, because it's almost impossible to sleep through.

Lindsay gave me great advice and helped me make a recovery plan, and after my surgery, Ricky came over from Austria to help me with my rehab. Six weeks later, I went back to the doctor for my post-op checkup. The U.S. Ski Team happened to be wrapping its season at the same time, so Lindsay was back in Colorado as well, and she came to my appointment with me. While we waited for the doctor, Lindsay checked me out, and she wasn't happy with how my knee was progressing. It was stiff, and I had a pretty limited range of motion.

"Can you fix me?" I asked her. She promised that she could.

The truth was, it also wasn't working with Ricky being away from home. He has three kids, and being away from Austria for six weeks was long enough. So we decided to have Lindsay take over my rehab. Lindsay continued to work for the U.S. Ski Team during the 2013–2014 season, but we spent a lot more time together. The team would even send her to my house so we could get things done. And that's how we started working together so closely.

Before the crash, I'd been winning, and I was determined to keep winning, so Lindsay and I were at my therapy for six to eight hours every day. When I wasn't working on my knee, I was recovering from working on my knee. We mostly focused on range-of-motion exercises, muscle activation and patella mobilization, but we also did cardio and weight training. In part because of the Olympics, but also because this was the worst injury I'd ever had, I was able to show up for the recovery workouts without feeling overly down about the skiing I was missing.

It's easy to imagine that if the accident had happened a few years earlier, before I'd started being honest with myself and confronting some of the issues around my confidence and my depression, my injury would have derailed me in a much more dramatic way. But mentally, I wasn't the same person I'd been just a few years earlier. Going public with my depression didn't change how I went about my day-to-day life, and it certainly didn't make the recovery process any easier. But once my depression was out in the open, it changed my own perception of things, and on those days when I did feel low, I was now able to normalize it.

I'd never had a challenge like this before, so in a way, that made it novel, almost like I was training for something new. For years, I'd found success on the hill by focusing on one-upping myself, rather than dwelling on my competitors or medals. Now, instead of doing that with races, I was doing it with rehab; even

though my goals were smaller for the moment, they were all laddering up to the biggest goal of all. I was determined to carry my Olympic momentum from Vancouver straight into Sochi. Hard work had gotten me so far in my career, and now it would get me back to the Olympics.

I started skiing again that September, seven months later, at a training camp in Chile. Camp was really strong, and it felt amazing to be back on snow. From there, I headed to the next camp, at Copper Mountain in Colorado. While I was training there, I blew my knee out again, just one month before I was supposed to start racing. And that's when things got complicated.

When I crashed, it wasn't clear to my doctor from the MRI that my knee was totally blown out, so I kept skiing on it, because I still intended to race and was given the clearance to do so. I didn't ski as much, and I continued doing rehab, but at this point, I still thought I would be fine for the Olympics. That belief carried me for a few weeks until December, when I arrived at Lake Louise, for what was to be our first race of the season. In the first downhill training run, I knew something was wrong. I could feel my bones shifting on top of each other. Even with a knee brace on, it felt bad. The only way I can describe it is feeling like your joint is dislocated, as if your lower leg isn't entirely connected to your upper leg. It was disgusting. I went to Lindsay and said, "Something is really, really wrong. I don't think I can safely ski down."

We got more opinions on the MRI—blind opinions, from doctors who didn't know who I was, or anything else about the situation—and all of them said that my knee was completely gone. We needed to change our plan. The best bet seemed to be to go ahead and race in Lake Louise in order to qualify for the Olympics, then take some time off before the games. In order

to race, I had to get the inflammation out of my joints, so we taped my knee with Kinesio tape. I also had to get Toradol, a really strong anti-inflammatory, injected in my butt every night. I skipped my training run and wound up taking a fortieth-place finish in the downhill, more than three full seconds off the pace. Then, somehow, I managed a fifth-place finish in the super G, which was enough for me to qualify for the 2014 Olympics.

At this point, I decided to deviate from our plan. Instead of taking time off, I headed to Europe, to continue racing. Going into Lake Louise, I thought I had 50 percent of my ACL. Coming out of it, I knew that I didn't, and that was a lot to wrap my head around. The way I saw it, I needed at least one more race to get the feeling of skiing with no ACL. The next race was in Val d'Isère, a course I'd skied and won so many times by this point that I thought I could perform there. A couple of reps seemed like it would be enough for me figure it out. Once I had that extra preparation behind me, I'd give myself some time to rest and get ready for the Olympics. In hindsight, I can see that I should have rested right after Lake Louise. I'd already qualified, and one more race wasn't going to make or break my performance. But at the time, going to Europe seemed like the best decision.

My knee held up fine in the first two training runs, but in the race, I hit a compression and it buckled, completely giving out. I had no choice; I pulled the plug on the Olympics. My season was officially over. Apparently hard work can't overcome everything, as I had always believed it could.

CHAPTER EIGHTEEN

When the curtains in my room were drawn, it was total darkness. They weren't just blackout shades, they were *really* good blackout shades. The kind so good that not only do they block the daylight, they make you wonder if the sun is ever going to come up again.

Which made it so much worse when the door would burst open and the curtains would suddenly be thrust apart, the light shocking me out of my hibernation. And then I'd hear Lindsay's voice.

"Get the fuck out of bed."

In many ways, all the hard work of recovery and rehab I'd done in 2013 was easy. If that sounds like a contradiction—easy hard work—well, that's exactly what it was. Sure, the work itself was painful and exhausting, but it was the easiest kind of work because I showed up mentally ready every morning, because I knew why I was there: to get to the Olympics. It was my singular focus. Every day, through every step of rehab, that was all I

could see, and it got me through my days and anchored my life. And just like when I was training for the '02 games all those years earlier, that was what got me out of bed every morning. I had a purpose.

After pulling the plug on the Sochi games and going through my subsequent knee surgery in early 2014, it was a different story altogether. When I missed the Sochi games, I felt aimless and unmoored, and I started to spiral. Without a tangible goal right in front of me, I struggled to find my purpose, and I had a lot of dark days. Oftentimes, I wouldn't wake up until midafternoon. I would stay in bed, feeling isolated, not wanting to talk to anyone. And then, Lindsay would come into my room, open those curtains, blare music, and drag me out of bed.

"Get the fuck out of bed," she would say again, louder this time.

"What's the point?" I'd ask. "I'm just going to get injured again."

She refused to accept this answer. Sometimes she would physically drag me out of bed to do my rehab.

I'd get so mad at her, but I would listen, even as I struggled to find a reason why. And once she'd made me get to work, I felt better. The experience couldn't have been more different than the previous year. The only commonality between those two years was Lindsay, which, not coincidentally, is the only reason I made it through those years and back onto skis.

Soon after I withdrew from the Olympics, Lindsay and I started working together full time. Even though Ricky was great, I couldn't have multiple therapists—I needed one person who was really in charge. From that point forward, she was with me for every injury and every surgery. We'd show up at the doctor's office and say, "The Lindsey's are here!" Making jokes is my way of making the situation less stressful, and I always gave

the doctors a hard time. I'd stage-whisper, "I think they're going to kick us out," and she'd reply, "Ehh, not yet. But you're getting close."

Because I needed to do therapy all the time, Lindsay and I did pretty much everything together. We went to Wimbledon; we went to Formula One races. We were together through many relationships and just as many breakups. Any time it got to the point where I was ready to say, "I think I'm good, we can go back to just being friends," I would get injured again, and we were right back at it.

Before my second surgery to repair my ACL, Lindsay helped me through the process of finding a new doctor and going through recovery. This time, I went to Dr. James Andrews, a Florida-based orthopedic surgeon who specialized in working with athletes. He had an incredible success rate and a super impressive client list, including a ton of football players, like Adrian Peterson, Von Miller, Robert Griffin III, aka RG3, and Rob Gronkowski, aka Gronk.

Dr. Andrews is quite a character. He's very fatherly, and he makes it clear that every patient is extremely important to him. One day, when I was doing my rehab in Pensacola, there was an insane ice storm—an ice storm, in Florida! The bridges were closed, and no one could get anywhere. So Dr. Andrews drove around town in his wife's little Fiat, checking in on all his patients, since none of us could get to our hospital appointments. While I was down there, my sister Laura was in town helping me, and Dr. Andrews invited us out to dinner along with his wife and two daughters. Not a lot of people would go out of their way to be that welcoming. I also loved his Southern accent.

Thankfully, the surgery itself was a success. While he was in there reconstructing my ACL with a patella graft, he also repaired my medial and lateral menisci, which were completely shredded. Dr. Andrews told me later that he had to call an

audible when he opened me up and saw the condition of my menisci. He said, "I looked at it as if you were my daughter, and if you were my daughter, I had to try to save 'em."

And that's exactly what he did. He put eight sutures in my medial meniscus and seven in my lateral meniscus and hoped they would hold and heal back down correctly. He also gave me platelet-rich plasma (PRP) injections. Those sutures were a bit of a wild card when I began rehabbing, because they caused a lot of swelling and made my progress slower. But in the end, Dr. Andrews did me a great service by trying to save my menisci, most likely saving my career. They're kind of like shock absorbers, which are definitely a necessity when you're skiing.

Despite having worked on so many athletes, Dr. Andrews knew nothing about skiing—just that I'm crazy and enjoy going fast. It was actually pretty entertaining. But he's obviously incredible at what he does. My dad told me to go to Dr. Andrews the first time around, and I probably should have listened. (He loves a good "I told you so" moment, and he was definitely right on this one.) The list of people he's fixed is insane. While I was doing my rehab at the Andrews Institute, I met Von Miller and Gronk, who had also just had surgery. It was pretty hilarious. There I was, trying to walk again, while Gronk was doing bicep curls and Von was doing banded glute walks. There are some things you just can't make up.

That rehab tested me mentally in a way that nothing had since Monaco. Everything that had happened the previous year had been the warm-up to this—and let me tell you, this was tough. I remember sitting with my legs extended on the floor, just staring at them. It was as though maybe if I focused enough, I could move my legs with my mind. My only exercise that day was to pick my leg up off the ground, and even with all my concentration, I couldn't make it happen.

Without a doubt, watching the Sochi Olympics in the middle of my recovery was the hardest part. I was back in Vail by that time, and my brother Reed was with me. He made me dinner, then we sat side by side on the couch and watched everyone else race for a few minutes before I got overwhelmed and had to change the channel. Seeing them all there getting to experience everything I was missing was excruciating. I had done well at the very same venue at the World Cup, and as I watched the other racers succeed, of course it made me wonder how well I would have performed had the circumstances been different. That was a real emotional low point, a futile exercise in what might have been.

After all my injuries, people always ask me, "How did you come back? What's the key to rehab?" and it was with this injury that I really began to piece together what worked for me in recovery. But it was painful—physically and mentally, these were some real low points.

There is no secret to bouncing back, but perhaps the most important thing is that you have to work hard every day. I defaulted back to one-upping myself, focusing on my day-to-day improvements—doing everything I can today so that I'm better tomorrow. I'd spent 2013 learning this strategy, however, this year I came to understand it to my core. But what I discovered during this recovery is that I'm like a goldfish—I have a short-term memory. When you're coming back from major surgery, it's often two steps forward, one step back. Wherever I am in the process, I'm totally focused on that moment. "Staying present" and "physical therapy" seem impossible to fit together, but if you can puzzle it out, it helps the entire recovery. You fall, you brush yourself off, you keep going. Just like I don't worry about crashing, I didn't worry about coming back after surgery. Because rehab always has its setbacks, devoting yourself to the

moment actually brings resilience—it prevents you from dwelling on the frustrations of yesterday or worrying whether tomorrow will show progress.

To the outside world, I just snapped back from these gnarly injuries, but there was a reason for that: I worked damn hard at it. I focused my efforts and I put in the time. When you are a professional athlete, you don't have a nine-to-five job, so when you're injured, rehab *is* your job. Of course, we come back from injuries faster than most people, because we have the time to focus on it, 24-7. I would do two therapy sessions a day, plus my workouts.

It also helped that I confronted each injury as it happened, and immediately pursued whatever treatment was necessary. Some people think surgery will be much worse than whatever they're living with, so they put it off, but for most people, it helps. My dad needed a knee replacement, something he put off for like twenty years. Ever since he was nineteen years old, he couldn't bend his knee more than fifty degrees. After his surgery, he's back to skiing every day. He has a new lease on life and wonders why it took him so long to just do it. In reality, recovery is a whole process, and surgery is only step one. You cannot outsmart the doctors or the physical therapists. You can't skip ahead or cut out any of the steps. Physiologically, you need them, so take the experts' advice. For what it's worth, I definitely wouldn't have come back from all my injuries if it hadn't been for Lindsay Winninger. One or two of them I could've skated through, but all of them? Not a chance.

The biggest test for me with this injury was also the hardest part to be consistent with—staying positive. It can be hard to be positive when you're doing the same thing over and over. You move your kneecap around and do some quad activations, which is just sitting there squeezing your quad. It's so repetitive. You're stuck in the same place, often confined to your bed.

You're also in pain. So you take small steps to feel better, focusing on little things that bring you comfort. For me, I watched a lot of *Law & Order*. Even better if it was *Law & Order* plus Ben & Jerry's.

Still, staying positive was incredibly difficult—which was why Lindsay often found herself dragging me out of bed. Managing my depression had always been easier when I was on the road, because even with the lonely hotels and the long nights, I still had skiing. If I ever did start to get depressed, I had something to focus on—the next hill, the next run, the next race. Plus, I could always work out to get out of my head, and that kept me from getting too down.

When I was injured, my feelings became a lot darker, and they only built up as time went on. Every day was a struggle. When your goal is so much further out in front of you—or worse, when you aren't quite sure what it is—you feel like you'll never get there, and it's hard to see the why. Every now and then I'd see pessimistic headlines or hear commentary about how I wouldn't be the same skier when I came back from two consecutive years of knee surgeries, and I'd feel that same fire come back, that desire to prove people wrong. And it would get me going for a bit. But only for a bit. Because before long, I'd be straining for something else, something positive.

A huge psychological boost and recovery tool during this time was my dog. Right before my second ACL surgery, I thought, *I cannot do this without a dog.* I needed someone who would always be there to comfort me, and who would be just as happy to see me whether I win or lose. So, in December 2013, I adopted my first dog, Leo.

I was on crutches at the time, and I went to the local animal shelter and made my way through the line of dogs. Shelters can be intense, and all the dogs were freaking out, sizing me up and getting protective of their spaces. Leo was the last one in

the lineup. While the other dogs were barking up a storm, there was Leo, quietly looking at me. He seemed genuinely happy to see me, and he had an innocent positivity about him that drew me in.

The woman at the shelter noticed us connecting. "I don't think you want him," she said. "He's had a lot of health problems." She explained that Leo had had a rough go of it. He was adopted by a drug dealer and fell out of the back of the dealer's car, where he'd gotten hit by another car. They fixed him up, but as a result, he had all kinds of screws in his knees and his X-rays were crazy. I gestured toward my crutches as I told her, "I don't know if you've noticed, but I have some things going on as well. So this sounds perfect." And that was that.

When I had my surgery in Florida, Laura brought Leo to be with me. He slept in my bed every night. Whenever I'm hurt, whether I've had surgery or I'm just icing my knee, Leo comes and lays his head on my lap. He doesn't always cuddle with me. But he knows.

Later in 2014, once I finished up my rehab in Florida, I went back to Colorado, so I could start skiing again. The more I skied, the more depressed Leo seemed, because he was by himself a lot. So I got another dog to be his friend and keep him company. My initial plan was to get a Newfoundland, because they're big and calm. Leo's a pretty chill dog, he sleeps most of the day, and that seemed like a good match.

Instead, I got Bear.

Bear is part chow and part retriever, which is basically the opposite of chill. When I picked him up from his foster family, I was pretty worried, because right off the bat he was so vocal. But he and Leo got along really well, and Leo seemed happier as soon as he had a friend. Bear was mistreated earlier in his life, so he had some issues to overcome, but I got him some doggy training and discovered he's a very, very quick learner.

Around that same time, my brother Reed came to live with me for a while. For years, he had tried to be a ski racer, but had just come to the decision that it wasn't working out. At the time, I was living by myself, so I welcomed the company. Reed helped me with the dogs and continued to take care of them when I traveled. We got much closer during that time, and I loved coming back from the tour and finding him in my house. After all those weeks on the road, it felt so nice to come home to family.

Reed is an interesting bird. For starters, he doesn't like communicating. If I call him, he won't answer, so I'll text him and get a response about half the time. But he's also the most reliable. Here's how he works: I'll text him and say, "I forgot my ski pants, I need you to send them to me. Here's my address. Please, can you let me know that you got this?" Then I'll hear nothing. He'll never reply, but three days later, my ski pants will show up in Europe.

Personality-wise, he's a lot like my dad, but funnier. He thinks he knows everything and likes to spew random facts. He's like an encyclopedia that's right around 70 percent of the time, and the rest of the time he's making shit up. He'll have us peeing in our pants laughing as he shares random facts about cities and geography and crime rates. "What?" he'll say. "I know things." He also likes to tell my dad—the lawyer of forty-five years—about the law.

"You're telling me you know more about this than I do?" my dad will say.

To which Reed replies, "On this subject, yes."

During that year, he was there whenever I needed someone to pick me up at the airport or help with the dogs or make me food when I couldn't move. One silver lining of my injuries was the way my family rallied behind me when I was down and out. My siblings could tell the difference between a routine recovery—routine for me, at least—and when I needed someone

to help. I didn't always love being taken care of—it's hard for me to ask for support, and even harder to rely on people. But I always appreciated their efforts, even if I didn't show it.

"You stay there," Reed or Laura or Karin would say, leaving me in bed while they went off to do something in another part of the house. They'd turn their heads for one minute and I'd suddenly be in the kitchen. Laura especially would get really upset with me.

"You're not supposed to be up!" she would shout. "You're like a toddler! Go back to bed!" But as with all things, there was no stopping me from doing what I wanted.

When I was down, my injuries became a bridge that bonded me with others—not only with my family, but also fellow athletes and especially my fans. (Lil Wayne even tweeted at me during my recovery once, which was a high point as far as I'm concerned.) Being injured is humbling. It's an equalizer. Anyone who's ever been in an accident or come back from a physical setback knows exactly what it's like. When you're knocked down to zero and building yourself back up, and someone reaches out to say they've been there, too, it's a real point of connection. Much like I'd discovered when I went public with my depression, my injuries showed me that, more than anything, it's our flaws and our obstacles that help us relate and endear us to one another. And as I was about to discover, they can also make the successes that much sweeter.

CHAPTER NINETEEN

I paced around my hotel room in Cortina, Italy, gnawing at my nails. Whenever I raced there, I always requested the same room—a big, open space decorated with heavy, old-school Italian wooden furniture. The familiar surroundings were a comfort to me, especially in light of everything that was happening just outside.

For thirty-five years, the women's record of sixty-two World Cup wins had been held by Annemarie Moser-Pröll, and for a very long time, that was something the media loved to talk about—*will she break the record?* Before I was anywhere close to it, it had already become this dragged-out thing, the source of an enormous amount of pressure. And now, finally, that record was staring me in the face.

It was January 2015, and my family—Karin, Laura, Laura's husband Paolo, and both of my parents—had traveled to Italy to watch me race and hopefully break the record. While their presence would have been momentous on any occasion, this was

the first time my mom and dad had both been at a race since their divorce, and the first time they'd been in the same place since the triplets' high school graduation. Though I knew they could put their differences aside to celebrate the moment, my siblings and I felt a lot of anticipation around it. My mom had only been to Europe once before, to see me race in the 2006 Olympics. Between my family and the media, tensions were high. Once again, skiing became my rock, my quiet place. It was one of the biggest race weekends of my career, but ironically, it felt like skiing was the easy part. "You just need to do your job," I told myself, "and the rest will fall into place."

The women's record wasn't something I ever specifically set my sights on. The truth is, I didn't even start *thinking* about beating Pröll's record until I got to fifty wins, in Garmisch (the day after Laura and I nearly froze in the RV). It was more that the races started accumulating, and suddenly I looked up and discovered the record was in reach.

My injuries in 2013 and 2014 had really derailed me. My focus during that time had been on my rehab, my goals all centered on making a comeback. It's pretty rare that someone in ski racing has back-to-back major surgeries and comes back from it. But somewhere in the back of my mind, I always trusted that if I got back to a place where I was strong enough and healthy enough, I would continue to rack up the wins. And that is exactly what happened.

By the time I got to the World Cup races in Cortina d'Ampezzo in January 2015, my wins stood at sixty-one. I had a feeling this was going to be it. Sometimes an athlete will tie a record and then it will take a minute before they actually break it. But I had three races that weekend, and I was really rolling in all disciplines, so I knew I had a good shot. I was always comfortable at Cortina. The conditions were great, I felt healthy and back in my rhythm, and everything was working in my favor.

On Sunday, January 18, I tied the record with win number sixty-two, a downhill where I finished .32 seconds ahead of the field. The next race, a super G, was scheduled for the following day. Everything was all lined up. I just had to execute.

When I broke the women's record—my sixty-third win on the circuit—it was one of the best runs of my career. I came in a full .85 ahead of the second-place finisher, Anna Fenninger of Austria. I was finally back in my zone. After two knee surgeries and a long recovery, it was like I'd gotten over this giant hurdle and was back in a big way, all over the course of one magical weekend.

Breaking that record was a big deal—both for me and the sport. It had stood for thirty-five years and no one else had even come close. When you're approaching a record like that, it's the only thing the media wants to talk about. *When are you going to break the record? How's it going to feel?* Before I broke Annemarie's record, I'd already talked about it so much that it almost didn't seem real. But as soon as I broke it, everyone immediately jumped to asking when I was going to break the next one—the all-time record of eighty-six World Cup wins, held by Ingemar Stenmark. Virtually overnight, this became the new goalpost. The press moved on so quickly that the huge mountain I'd just climbed became a false summit; the actual peak remained in the clouds above me.

Still, I tried to savor that moment as much as I could. After my record-breaking win in Cortina, I took the time to go out to dinner with my family and my coaches—a quiet night at a local restaurant where we could all enjoy a nice meal and a glass of wine. That's one thing I changed as time went on. Early in my career, even when I won, I was always so focused on the next race that I never allowed myself to celebrate. When I was really on those rolls—especially in that 2008–2010 time period, when I won the three consecutive overall titles—I just kept on going without allowing myself to truly experience it. My innate need

to keep moving forward, to keep one-upping myself, didn't leave a lot of space for anything else. There was no room for friends, there was no room for enjoyment, there was no room for satisfaction. There was no room for anything but the next race. On paper, I had accomplished so much, and yet, in my mind, it never felt like I had done something great. I felt lonely during that time, even though that was some of the most successful racing of my career. When you win a race, you feel this incredible sense of elation at the finish, and then right afterward, everyone rushes home, and you're suddenly back in your hotel like the whole thing never happened. Even now, I'm not good at congratulating myself, or even just taking a moment to think, *Hey, you did well.* It seems obvious to celebrate your successes, but for years, I'd neglected to do this.

In the aftermath of my injuries in 2013 and 2014, my view of success began to shift. Having those difficult times off-snow gave me a different perspective about my life on-snow, and I came to regret never letting myself slow down and digest those victories. For so long, I had been laser focused on winning, because it allowed me to block out everything else. When I was injured—and forced to move at a different speed—I had no choice but to answer the big questions I'd always managed to avoid. Slowly, I came to see that winning isn't what makes you a good person. Winning doesn't mean you deserve to be happy. Winning doesn't assign your worth. Even though I love winning, I came to understand that it is just one small part of life. What does winning matter if you're not having fun? What does any of it mean if you don't enjoy it?

Even if it was only for one meal, I allowed myself to relax, to have some ice cream, to take time to enjoy the moment. It was all part of trying to take better care of myself, mentally. I'd worked hard, I'd won a race, so I deserved the time and space to appreciate it.

Whenever I was in Cortina, my favorite spot was El Brite de Larieto, an out-of-the-way, farm-to-table restaurant largely populated by locals. It's housed in a chalet-style home nestled in the mountains, not far from the hiking trails that are popular in summer. At the end of my record-breaking weekend, a group of us gathered in the back room, a charming little space with rustic wood-paneled walls and an antler chandelier hanging overhead. I gazed around the table at my family—both my immediate family and my skiing one—their faces lit by candlelight, eating and talking and enjoying themselves, and felt so grateful they could be there to celebrate with me. Their presence forced me to slow down and savor the moment. My trainer, Martin Hager, whom I called by his nickname, Hagi, ordered a dish with cow tongue, and Laura joked, "Does it taste like it's tasting you?" which made everyone erupt with laughter.

We stayed so late we closed the restaurant. It was a wonderful, memorable night. From that point onward, I tried to approach that divide between my professional and personal life differently. Slowly, I learned how to celebrate myself.

When everyone immediately started asking me when I was going to beat Ingemar Stenmark's all-time record of eighty-six wins, I was caught off guard by how quickly the question came up, but not by the question itself. I had already been asking myself the same thing.

In the privacy of my own mind, I always wanted to be the greatest of all time, so by that point of course I was hoping I could one day beat his record. But I didn't like to set my sights on a goal until I felt that it was within reach. I wouldn't let myself think something like that was possible until I was almost close enough to touch it.

As distant as Ingemar's record felt in January 2015, in some ways I'd been preparing for this new focus for a while. From the

beginning of my career, I never set out to break gender barriers. Honestly, that wasn't even on my mind. I just wanted to be the best and the fastest. At every step of the way, I just kept asking, "Why not?" When I saw something interesting, I decided to do it. But in service of becoming faster, and in trying things my own way, I did end up doing things no female skier had done before.

Going after Ingemar's record wasn't the first time I'd been in the conversation about competing with men, albeit in a much different way. A few years earlier I'd raised the possibility of actually skiing against men in competition. To me, it seemed only natural that eventually I would want to race against men.

I raced on men's skis. I trained with men. I beat men.

So why wouldn't I race with them?

Unlike a lot of other sports, in ski racing, men and women's pay is pretty even. But there is a pervasive attitude that we're "less than" the men, who ski on courses that are both technically and physically more demanding. It varies from course to course, but on the whole, men's races are more challenging— steeper and icier, with bigger jumps—which often make them more dangerous, as well. It's true that based on pure technicalities, the men *do* more than we do, but it doesn't mean that we *are* less. That's also not to say that women as a whole can't take on the same physical challenges, but very few could. I know that I couldn't physically keep up with the men in the gym.

The place where I encountered sexism most often was in training, and not very often from male skiers, but mainly from the coaches. The men would say, under their breath, that women couldn't keep up, or that women ruined the line. As time went on, more guys became open to training with me, but that gain was hard won. Once I had earned enough respect that the men would let me train with them, racing against them seemed like a logical next step.

The idea had really crystallized in the summer of 2011,

when I was training with the Norwegian skier Aksel Lund Svindal at Portillo, in Chile. There are two sides of Portillo: There's the Rocka Jack side and then there's the plateau side, which is pretty much in the shade until late afternoon. It's all very challenging; there are no jumps, it's really steep and not very fun. Just a grind the whole way down.

While I was skiing with Aksel, the coach took a video of each of us going down the mountain. When you put them side by side, it showed we were neck and neck throughout the entire course. I ultimately wound up beating him, the best downhill skier in the world, on a very technical, challenging course. Granted, I think he was skiing reserved since the light was so flat and the weather wasn't ideal, but still, I took it at face value. Afterward, I posted the video on my Facebook page (which he wasn't super psyched about) because I wanted to prove that I had speed, not necessarily to start the conversation. After I shared the video, the idea became more real.

Seeing that video, something clicked into place for me. *Holy shit*, I thought, *I'm training next to men, so why can't I race with them?* People started asking me about it, and all along, I said I would love to have the opportunity to race against men. But as soon as the words were out of my mouth, I got shut down.

The other women racers immediately said, "We don't want to race against men!" Everyone's attitude was kind of like, *Oh shit, that's scary.* Which it is. But that's why I specifically wanted to race with men at Lake Louise, where the men's course is essentially the same as it is for women, albeit icier. I was being sensible—it's not like I wanted to throw myself down Kitzbühel (a classic Austrian course so difficult and dangerous that most men can't, and wouldn't attempt to, ski it). Plus, I thought Lake Louise would give me the best chance of performing well, since I had a strong history of winning there and it was a slope that suited me.

I think some of the men were nervous that I would beat

them. When I trained with the Canadian men in Vail, they would have a running bet that whoever I beat would have to do the dishes that day. Of course, I beat quite a few of them, and it was hilarious. Not the top guys, but enough of them that a bunch of dudes were always doing the dishes. They would come up with excuses—they weren't trying, or else they were testing out new skis. None of them wanted to be embarrassed that they got "beat by a girl." But I don't think it's embarrassing. I had proven my worth, so to speak. It's not like they were getting beaten by just anybody, so why should it matter if I was a woman?

As I made my case, a small group of people were actually in favor of it. It was nice to have the support of Aksel, the Norwegian skiers, and a handful of others on the World Cup, because I respected them so much. Some of the organizers and officials of the World Cup races at Lake Louise as well as some Canadian skiers definitely wanted it to happen, because it would be amazing both for them and for ski racing at large. But everyone else thought it would open up a huge can of worms. The pervasive attitude was that it just wasn't natural. Women shouldn't be racing with men, people said, because it's a men's sport. Almost like we were secondary, and we couldn't commingle.

The point everyone seemed to miss is that it's not like I just woke up one day and thought, *Hmm, racing against men. Wouldn't this be fun!* I put a lot of thought into it, and I had very legitimate reasons. I wanted to race against men as a sign of respect and as a way to improve my own skiing. Men are bigger and they're faster, and that's exactly why I wanted a chance to see where I stacked up. At Buck Hill, the best always trained together, with no distinction between boys and girls. The only thing that mattered was your points, which determined your ranking. If you were under a certain amount, you made it into the first group, which was the one you wanted to be in. The question was always, "Who is the best person? I want to beat

that person." At one point, I was better than all the girls. So how could I push myself? Beat the boys. I didn't know it at the time, but that was a question I would ask for my entire career.

Plus, it's not like it hadn't been done before. Annika Sörenstam did it in golf. Billie Jean King did it in tennis. I actually talked to Billie Jean about it, because I wanted her advice as to how I could make this happen. "It's an uphill battle, my dear," she told me. "You just have to keep trying." Annika also told me about her experience, and she shared my sentiment—she did it as a sign of respect. She said she wanted to compete with the men solely to improve her own game, not because she was out to prove she was better than anyone.

Throughout my career, I always toyed with the ideas of strength and power and finesse on the snow. How do you glide? How do you let your skis accelerate when you don't have any fall line to push you down the hill? There's a certain finesse you need to have in downhill. Men have it for sure, but I would say few men rely on that finesse, because they generally use their strength and power to overcome the mountain. Men tend to ski a much straighter line, since more weight equals more gravity and speed to carry them down the hill. It was always my feeling that, because I had a good feel for the snow, I could compensate for any lack of power by using my finesse. But I never got to put my theory to the test.

I pushed for it for several years. I brought proposals in front of the ski federation. I made my case to anyone who was willing to listen. But all along, there were so many roadblocks. Eventually, my body wasn't going to hold up on any men's track, so I had to let it go.

As my dad once told me, ultimately, it's about your impact. Throughout history, athletes have made a huge impact based not on their numbers, but on the mark they left on a sport. Look at someone like Billie Jean King, who was an activist on

so many levels, and used her voice in so many ways. Maybe she didn't win the most Grand Slams, but she changed the game. A lot of women stand out not just because of their victories, but because of the possibilities they created, the ideas they inspired, and the path they paved for the next generation. When it came to racing against men, I may not have won that one, but I do think I changed the game for women in skiing in a lot of other ways. I spoke my mind. I used men's skis. I did things my way.

In many ways, going after Ingemar's record was the most logical, and ambitious, extension of this approach. To show what I'm capable of when held up against both women and men. It gave me a chance to take that instinct as far as I possibly could.

I'd never met Ingemar when everyone started asking me about his record, but I ran into him in the winter of 2016. We were at a city event in Stockholm, which is like a pro-style World Cup, where two skiers go head-to-head, side by side. The International Ski Federation puts them on each season, and they're great promos for the sport. I wouldn't go so far as to say they should be a full-time event on the tour, but they're really good for fans. They're fun to ski, and even more fun to watch.

I was so pumped to hear Ingemar was there, because he doesn't make the rounds as much as a lot of other former athletes. He's a fairly private person, so a meeting like this was rare. He doesn't really do interviews and he's known for his short (but always polite) responses. At a party, he's the kind of person who won't talk very much, but when he does, he'll deliver an amazing one-liner. He's also a freak of nature when it comes to athleticism, he's so incredibly gifted. As I write this, he's sixty-four years old and in incredible shape. A few years ago, he was a contestant on *Let's Dance,* a *Dancing with the Stars*–type show in Sweden, and he crushed it. He and his dancing partner won the whole thing.

Over the years, I've heard so many stories from European

skiers about how the whole world seemed to live or die on his wins. "He was our hero," they would tell me, their faces lighting up. "When we were in school, they would wheel the TV into the classroom so we could watch him race." He's more than just the record holder; he's something of a national treasure.

After my run, I found him hanging out at the bottom of the course with a bunch of other skiers. I was happily surprised to discover that he knew exactly who I was—as I said, at this point the media was already reporting that I hoped to challenge his record—and he graciously told me he was rooting for me. That day, and in all our interactions since, he couldn't have been kinder or more sincere.

The following year, I ran into Ingemar again, this time at an Under Armour event at the World Championships in St. Moritz. We had both been invited to participate in a panel discussion in front of an audience, in celebration of my medal in the downhill. Once again, he was kind and gracious, and honestly hilarious. He may not be a man of many words, but when he does offer them up, they're always perfectly timed. Throughout the conversation, he promised that he would be there when I broke his record—he didn't say *if*, but *when*—and I took his words and his faith in me to heart.

Once I finally made up my mind that I was going for the all-time record, I let myself believe it was going to happen. I fully invested. From that point forward, I treated it the same way I treated every meaningful goal I'd ever had—it became my singular focus. I stopped thinking that it *could* happen and started saying that it *would*. That was the moment I committed to making it real.

By the end of the 2015–2016 season, I was skiing so well that my crashes seemed distant in the rear-view mirror.

A lot of things had fallen into place for me that year. For one

thing, I was finally back at full strength, able to move forward and stop thinking about my knee. Between my injuries and my personal life, I'd spent the last few years in a constant battle, always playing catch-up between my body and my mind. Finally, I felt calm enough to focus on skiing.

At the very start of the season, I won three races at Lake Louise—two downhills and a super G—making it the third hat trick of my career. After that, I didn't look back, winning the GS at Åre, the combined at Val d'Isère, the downhill and super G at Altenmarkt, the downhill and super G at Cortina, and another downhill in Garmisch. With those wins, I felt powerful, and once I got that confidence going, I didn't look back.

Everything was going so well that with a few weeks still left in the season, I'd already compiled enough points to win the season-long downhill title, and I was on pace to win the overall title as well. Unfortunately, my great run came to an end following a crash in Andorra, a tiny principality in the Pyrenees. It had snowed a ton the night before the super G, and I was maybe six gates from the finish when I got caught in some soft snow and leaned in. I hyperextended my knee, causing it to lock up. It wasn't a dramatic crash—I didn't flip, I didn't catch any air. It was just another one of those occasions where we shouldn't have been racing until they'd had a chance to clear some of the snow.

They have pretty limited medical facilities there, and the doctor didn't have access to an MRI, so when it came to a diagnosis, we had to wing it. The X-ray looked okay, and the ligaments checked out fine, so I figured it was just a bruise. There was a super G combined scheduled for the following morning, so I said, "I think I can ski."

Later that night, my knee got super swollen, so we drained two vials of fluid from it. The next morning, it got so big during my warm-up that we needed to drain it again. We ran out

of needles, so the doctor would fill the syringe, empty it into a coffee cup, screw it back onto the needle, and do the whole thing all over again. Normally, when you pull fluid out of your knee, it's this yellowish pee sort of color. But if you fracture your bone, it bleeds. What we pulled out of my knee was really bloody, which meant that I had a fracture. That's how we knew that something was broken that hadn't shown up on the X-ray.

The morning of the super G, by the time we finished draining my knee, it was just in time for me to say, "Let's do it." I almost missed my inspection because of it. I had to call the FIS official and plead with them not to close it. But I made it in, I raced, and I won the super G portion.

In between runs, one of my competitors complained, "Lindsey's so dramatic. She always has something wrong with her. She's constantly saying something is injured, but she's obviously faking it, because she keeps winning." In the moment, her words pissed me off, but they didn't surprise me. They were a version of something I'd become used to over the last couple of seasons.

Ever since I'd returned from my knee injuries, this would happen often: Competitors or people in the media wouldn't believe my injury or my pain and accuse me of pretending I was injured to add drama to my run or heighten TV interest. I wish it could go without saying, but I would never do that. I didn't want to be injured in the first place, and even when I was, my preference was for nobody else to know. In fact, there were plenty of times I was injured and didn't tell anyone, going out of my way to try to keep the problem under wraps. Whenever it was possible, I just kept right on skiing. The way I saw it, if I didn't need surgery and I didn't miss any races, why would I want anyone to know? From a psychological perspective, you want your competitors to think you're stronger than you are. So I skied through injuries that would have ended other people's

seasons, but I kept it to myself. Was it always the smartest decision? Maybe not. But I put my head down and I did the work, because that's just how I operate.

I've always believed that in an individual sport like skiing, it should be up to the athlete whether or not they want to compete. When it came to injuries, there was some testing to make sure you were all right to ski, especially where concussions were concerned, but if you sandbagged the test, it was really easy to pass. The protocols are stricter in a sport like football because there's more money at stake. If a skier gets a concussion, no one is going to get sued over it. In skiing, it all comes down to what an athlete is willing to risk—it's never the coach or the doctor who is putting their life on the line, it's you. So you need to make that decision for yourself.

Of course, there were plenty of times that keeping word of my injuries out of the press was impossible. And that's when my private choice about whether to push through an injury became a public spectacle—something that none of the skiers, myself included, wanted to deal with. The problem for me was that usually, once I'd set my mind on a goal, I didn't see quitting as an option, and that led to me racing in a wide range of circumstances—not all of them advisable. Don't get me wrong, I wouldn't deliberately do anything to hurt myself, or blatantly go against my doctor's advice. But after a couple of years of fending off injuries, it got to the point where I'd proven everyone wrong enough times that even my doctors would say, "I don't know, Lindsey, what do you think? Do you think you can ski on it?"

At different points in my career, some of the other athletes didn't like me, but I never felt that the dislike came from who I am as a person. Instead, I think a lot of it was due to all the hoopla that was created around me—all this drama built up around my injuries and my recoveries and my performance—

attention I never sought that nonetheless became a part of how the sports media covered me. Understandably, the other girls on the team got sick of answering questions about me. *How is Lindsey? Is Lindsey racing? What is Lindsey up to? Is Lindsey hurt?* I get it, it's annoying—it was annoying for me, too. *If I could just ski, that would be awesome,* I would think. That's all I ever wanted to do.

A certain amount of tension is natural when you're competing against people, but the worst was when the skiing media exploited that tension in ways that hurt my personal relationships. The German skier Maria Riesch and I had been friends since we were thirteen. In fact, for a long time, she was my only real friend on the World Cup tour. Yes, we were competitors, but we loved to talk about our lines and our equipment, often over hot chocolate. She always invited me to spend Christmas in Germany with her family—her parents, her sister, and her brother—whom I loved. As an American skier, being away from home from October until March, with the exception of a couple of weeks in November to train in Colorado or Canada, can be difficult. Having Maria as a friend, and spending the holidays with her, made me feel almost like I had a European family. I always felt that I had someone to lean on.

For a number of years, Maria and I would always finish first and second—I think we must hold some kind of record for that—but it was never a point of contention. We actually liked that. It was the definition of a friendly rivalry, and for twelve years, nothing could come between us.

Then, in 2011, the year that Maria won the World Cup overall title by three points over me, during the finals, tons of articles came out that were filled with speculation about my equipment and a bunch of other weird, made-up things. Among them were some nasty quotes—things she allegedly said, and things I allegedly said—that weren't true. As the first round of rumors

were circulating, I told her I'd never said any of it, and she replied, "I didn't think you would." But then it just kept on coming. It grew exceedingly hard for both of us to differentiate what was fact and what was fiction. Eventually, we were able to mend our friendship, but it was hard. We needed to work through the damage that all those stories had caused.

Throughout my career, I felt misunderstood at many points, for many reasons, and it usually was related to how my story was being covered by the media. In the U.S., the media loves drama. Readers are used to dramatic sports coverage, and salacious headlines are regarded as normal. Controversy is everywhere, to the point where the media almost celebrates it. We understand that half of what gets printed is sensationalized, and when it comes to celebrity gossip, it's common knowledge that half the time what you see isn't only exaggerated, it isn't even true. So it wasn't surprising that the reaction stateside to my injuries was more forgiving. They were covered, and they were dramatized, but the idea that an athlete would get injured and choose to share things about their experience wasn't anything new.

In Europe, the coverage was similar, but the reactions it garnered, from both the ski world and the public at large, were quite different. The expectation for European athletes is to show up, do your job, and represent your nation—not to vocalize your feelings and expectations. There, everyone found it unbelievable that I posted an image of an MRI on my social media or openly discussed my injuries. As far as I was concerned, I had nothing to hide, but the collective reaction was akin to "How could you?" In a culture where skiers have to answer to their federation, they are held to a very different standard. No one in Europe, including the other athletes, could fathom my openness, because for them, that kind of behavior simply wasn't an option.

Amid all the accusations of "Lindsey's dramatic, Lindsey's

flamboyant, Lindsey's just doing this for attention," I would think: *Can I just be who I am?* Any time a competitor accused me of faking an injury to get airtime, I couldn't believe it. Did anyone truly believe I would go off and say, "Oh, let me fake this tibial plateau fracture"? That's insane. I never asked for that attention. I never asked to be covered as though every medical update was a press release. I didn't choose to be dramatic. I didn't choose to have injuries and comebacks. I don't even like drama. All I ever wanted was to focus on skiing. Believe me, I would trade all the attention my injuries brought me for a healthy pair of knees.

The truth is, your competitors don't have to like you, but that accusation of being "dramatic" touches a nerve in part because it's just not a word that gets thrown at men in the same way. I always suspected that if I were a man, my injuries would have been covered for what they were, rather than for the distraction they caused.

If I had been a man, and behaved the same way and achieved the same things, everyone would have believed me when it came to my injuries. No questions asked. They would have taken me at my word instead of second-guessing me or accusing me of faking it. If a man had come back from some of my injuries, everyone—the press, fellow athletes—would have been like, "Wow, that's fucking gnarly. Respect." Instead of doubting it, they would have celebrated it. When it came to people's expectations around toughness and resilience, there was definitely a double standard that wasn't in my favor. One of the hardest things is to fight like hell through a lot of pain to compete, only to have people stare you in the eye and tell you they don't believe you're in pain.

After Andorra, Ricky and I headed down to Barcelona, where I was able to get an MRI. That's where I learned I had fractured my tibial plateau. It was a major fracture, a pretty big chunk, in fact. It had displaced a bit, so my tibia had sunken in,

almost like a little step. I was told if it got any worse, I would need to have surgery—a rough surgery where they'd need to reconstruct the bone. I thought about it for a couple of days and decided it wasn't worth it to lose another year of skiing. We pulled the rest of the season, which was disappointing. I had been in the lead of the overall standings as well as downhill and super G, and there were only three weeks of racing left. In the end, I wound up third in the overall but was still able to hang on to the downhill title.

One of the things I get asked the most is, "What would you go back and do differently?"

My answer is always the same: I wouldn't change anything. When I made a mistake, or when I was injured, I would think to myself, *It's okay. Just learn.* Every misstep is a lesson you can improve on, so that when it really matters, you know the right thing to do. I try to trust that everything works out the way it's supposed to, because it helps give me peace of mind.

But pulling the plug on that season is actually one of the few regrets I have—that maybe I should have pushed through that one. There were only six races left in the season, and that could have been my fifth overall title. I was trying to be smart and think long term, and normally that would have been the right play. How was I to know the coming years would be full of injuries? If I knew then what I know now, I would have willed myself to keep going. It might not have been the best decision, but at least I wouldn't regret it.

CHAPTER TWENTY

The biggest worry I've ever had is that I'm not good enough. I've always been afraid of setting my sights on a goal only to come up short. I've always had anxiety around failure, but more so in life than in skiing. For a lot of my career, I hardly ever ran up against this fear. I was consistently getting better. I was winning, I was advancing, I could see progress. As long as I kept learning and moving forward, I felt fine. When I started to get injured, though, all of that changed. My progress became hindered. Whenever I stood still for long enough to listen, the fear of failure was never far away.

Despite these injuries, in many respects, I had been lucky— the injuries themselves had been just a matter of pain, recovery, and mental strength. They certainly weren't easy, but they were relatively straightforward—my body was a machine that needed fixing, so I did my part to fix it, just as the surgeon had done his. I knew exactly what to expect, including that if I did the work and stayed focused on a comeback, I could make it happen.

What came next was entirely different, and it forced me to confront failure more than anything I'd experienced.

It was November 2016, and by this point, my knee had fully recovered following the abrupt end to my season the previous spring. I'd had a great summer training season down in Chile and I was excited to be back at Copper Mountain in Colorado gearing up for the upcoming season. Looking back, though, I realize that half my injuries took place at Copper. Maybe I should never have skied there. In those early-season camps, sometimes there was barely enough snow to cover the training slope, so we were out training super Gs using half the course. This crash wasn't on a difficult part of the hill; I just caught my edge funny.

When I try to describe crashing to people, I tell them it's like if you jump out of a moving car. Sometimes you hit a wall. Sometimes you hit the grass. In the moment of a crash, you don't really have time to think about it—it happens so fast. The important thing is to try to relax as you're going down, because if your body is tense, you're going to do more damage. Where and how you land will dictate how you're going to feel the next day. This time, as I crashed, I got twisted around and I fell directly onto my right arm, which was bent behind me.

Whenever I crash, it's the same series of events. If I'm in extreme pain, I freak out. Then I calm down and analyze: Where is the pain coming from and how bad am I hurt? Next, I do a self-check, and based on how that goes, I hang on to every sliver of hope that it's not as bad as it feels. I check my knees first. This time, I was relieved that my knees felt fine. I had gotten my legs all twisted up, so I tried to get untangled, pushing myself back up with my arms, but my right arm didn't respond. I tried to move it, and though my shoulder moved, the rest of my arm wouldn't budge. There was nothing there. It was just twelve pounds of dead weight. That was definitely the most disgusting feeling I've ever had.

I started screaming for help. Ski patrol was on the hill that day, but I didn't want anyone to touch me until Lindsay got there. I've been through so much with all my injuries, I'm always afraid to let anyone move me until we know what's going on. I was so far off to the side of the trail that at first Lindsay didn't see me and actually skied past us. I sat there, panicked and crying, until she found us. There was no med pack on the hill that day, which meant there was also no legitimate pain medication.

The one good thing about this experience was that it forced the team to reevaluate their evacuation plan. After this crash, I would learn to always sit down with my doctor and my physical therapist before every training camp and every race, and say, "Who's on the hill, where's the helicopter, where's the nearest hospital, what is the plan?" I'm shocked how often we didn't have a good enough evacuation plan. I learned to always stay ten steps ahead and to be forceful when necessary. A lot of athletes don't really think about these things and just trust somebody will be there to help them. But you can't assume that someone is going to take care of you when you're the one that could die.

Because, in this case, there was no evacuation plan, they put me in a toboggan and sledded me down the hill until the snow ended, then painfully transferred me to a pickup truck. Yes, a pickup truck. At that point, the pain was really severe, so they gave me some oxygen and some Tylenol that Lindsay had on her. Honestly, I don't know how I would have made it through this without her. I sat in the front seat, delirious with pain, almost passing out, while Lindsay kept slapping me in the face to keep me conscious, and trust me, she didn't hold back. I still had my ski boots on, because I couldn't move my body in order to take anything off. Every time the truck hit a bump it was excruciating.

It took about an hour and a half to get to the hospital, quite

possibly the longest ninety minutes of my life. When I arrived, they wheeled in a portable X-ray machine to see what was going on. The technician lifted my arm to place it on the machine, and then dropped it. I've never felt such pain—or screamed so loud—in my life. At that point, I passed out.

The next thing I remember is waking up after surgery. I asked the doctor what happened, how the procedure went, and tried to get all the details. He told me it was a spiral fracture of the humerus, which meant the bone that runs from the shoulder to the elbow was fractured all the way around. It had basically broken into three pieces, and because of the way it was twisted, the radial nerve popped out. What's more, they put a plate and eighteen screws in my arm in order to fix it. If this sounds like the bad part, it's not.

After he was done walking me through the procedure, I said, "Well, you must have put a nerve block in, because I can't feel my hand."

The doctor paused for a minute. "No, we didn't put a nerve block in." Another pause. "You can't feel your hand?"

That was the bad part.

That moment was the most scared I've ever been.

"Your nerve was exposed," the doctor continued, "and it was definitely damaged. At this point, I can't tell you when or if it will come back, or what's going to happen to it."

I know Lindsay really well. After spending so much time with her on the road and through all of my injuries, I can read her expressions. She never gets worried. But as the doctor spoke, I could see on her face that she was really concerned. The second I saw her, I was like, *Oh, fuck, I'm screwed.*

"Buddy?" I said. "Are you going to be able to fix me?"

"Yeah. I got this, I got this." She nodded. "I'm going to go home and I'm going to figure it out."

The next day, she came back to the hospital room and I

could tell she hadn't slept. "You didn't sleep at all, did you?" I asked her. She said she'd slept a little, but I knew she was lying.

"Buddy, I need you to fix it," I said.

"Buddy, I got you," she replied. "I've been researching, and I've been studying, and I think I've figured it out. I just need you to trust me."

And I did. I knew that if anyone would be able to do it, it was her.

Normally after surgery, the standard protocol is to ice your injury to keep the swelling down. But in this case, Lindsay suggested we do the opposite and use heat to increase blood flow and keep the circulation going, to speed up the nerve healing. It was an unorthodox approach for sure, but Lindsay had brought me back from every other injury, and I trusted her completely. Standard protocol also dictates that you're supposed to rest, but Lindsay knows me well enough that that wasn't part of her plan, either. As soon as I could go in water, we got me to a hot tub, where we hoped that the heat would encourage the nerve to wake up and get some of the feeling back.

Before, my injuries were always just a matter of pain. Pain is pain; it's nothing to be afraid of. In fact, studies say the more pain you experience, the more tolerance you build up. With most injuries, recovery is pretty straightforward. It can be a lot physically and mentally, but at least you know what to expect. If you do your rehab and work out every day, it might be painful, but you'll see progress, you'll get better. Pain I could deal with—I wasn't scared of pain.

This was a totally different story. As it turns out, the absence of pain—of any feeling at all—is much, much harder to deal with. This was more of a mental game. Nerve damage is one of the slowest things to recover from, and nothing is a given. I had no idea what would happen, no clue when or if I would be

able to come back, or even write again. Without that concrete goal to focus on, my mind drifted to worst-case scenarios, and I had to keep reining it back in. It was the most psychologically taxing thing I've ever gone through. Even thinking of it now is difficult, as it brings a flood of those old feelings back to me.

I couldn't hold a pencil, I couldn't eat food, I couldn't brush my hair, I couldn't brush my teeth. My hand—my dominant hand, no less—was completely useless. It drained me like nothing else. I focused so hard on trying to wiggle my fingers, and nothing would happen. I just stared at it, waiting for it to move. Would I be able to write my name again? Would I be able to function normally in life?

Every day, I would sit in the hot tub, and Lindsay would bring me things. She brought me an empty cup and I tried to hold it. Once I could do that, she filled the cup with water, and I tried to hold that. I progressed to holding a fork, holding a pen, trying to write my name. It's still so hard to think back on that time. Something as small as flicking your thumb and your index finger, which before had seemed like such a minor thing, would take everything I had. At the end of those sessions, I would feel every bit as drained as I would after the most grueling workout.

Whenever I'd encountered a new hurdle—my divorce and my knee injuries chief among them—I had to ask myself the question, *Can I still be successful with this new challenge?* The answer in the daylight was always yes. Yet if a journalist wrote something about me that planted a seed of doubt, suddenly I was a teenager back in my hotel room listening to those coaches talk about me. Whenever I saw awful headlines about whether I'd be the same skier after an injury, or if I could come back at all, they infuriated me. I felt that fear of failure rise, but if I'm being completely honest, it's not like I wasn't asking myself those same questions during low moments. I'm a human being;

I worried about those things before anyone said or printed a word. Still, having *other* people point them out made me angry. For my earlier injuries, I'd largely been able to use that anger to my advantage, to turn doubt into incentive—much the way I always had. After all, I'd always found so much success by changing a negative thought from someone else into a positive result on the hill.

The truth was, for much of my career, turning doubt into fuel felt good. When I was able to convert others' words into positive results, it felt like a positive thing, but that was its own problem. As time went on, it became harder to do. That approach started to feel old, like it was time I moved on. The more I examined the direction of my life, the more I saw that this kind of thinking no longer fit into my plan. My physical body kept telling me it was time for a change, and now my mental process did, too. With my second knee surgery, I'd pushed up to the boundaries of what an approach fueled by negativity could give me. If I was going to bounce back from this injury, as I had from so many others, I needed to find the will somewhere else. I had to tap into something new inside me. It couldn't be external—neither negative comments from reporters nor Lindsay kicking my ass would work on its own. I had to create the will myself.

Whenever I was injured, I thought of my mom, about what she went through after my birth, how she had to relearn to walk, how she managed to remain so strong and positive throughout it all. Like so many subjects in my family, my mom's stroke, and her resulting struggles, were not discussed. For better or worse, we're not a family of communicators, never ones to openly dissect the difficult, emotional issues. But I always carried my mom's experience with me. When I was hurt, my mind returned to her. For years, I'd taken strength from her struggle, that sense I'd carried that her refusal to quit meant I couldn't,

either. With this arm injury, though, I came to understand a small part of her experience on a much deeper, physical level. I literally felt it in my bones now.

My mom's experience gave me a reference point—one that put my own struggles squarely into perspective. As aggravating and demoralizing as this arm injury was, there was something almost poetic in the fact that I could now, in my own smaller way, empathize with what my mom had experienced after her stroke, when she'd had to relearn to use a body that she'd once taken for granted. It stirred up a feeling of gratitude, both for her incredible model of strength and for my position of privilege. Here I was, with access to the best medical care, the best therapy, and the chance to keep fighting to do the thing I loved. Anytime I started to feel sorry for myself, one thought of my mom was enough to stop me in my tracks. I now understood what it was like when physical movements you'd never given two thoughts about become victorious feats. When you're working your way back from zero, small failures aren't just possible, they're inevitable. But just as my mom had, I tried to stay positive and to keep getting back up.

You have to have the confidence to look failure in the eye and just say screw it. I'd always been able to do that on the hill, but in life? Well, those are harder failures to contemplate. If crashing is an art form, I should have been a master by that point, but in so many ways that expertise ended when I got off the hill. In a way, every crash in skiing is a failure because you don't finish your run. But I never saw it that way. A crash could also be a chance to learn, to improve, to make myself the skier I wanted to be—whether I popped right up or left in a helicopter, crashing wasn't failure if I was learning. I'd perfected the art of the crash in skiing, but in life, I was still figuring it out.

Thinking of my mom as I struggled to hold a cup of water made it impossible to quit. She could have given up, but instead,

she'd not only raised me—she'd had four other kids. If that's not the ultimate badass move I don't know what is.

The more I looked to my mom as inspiration, the more I came to see failure, and indeed my whole approach, differently. Suddenly, one-upping myself became, *I can use my hand. I can feed myself. I can write now.* Before I could hold a pole, I had to hold a pencil. It took three weeks of nonstop work until I was able to open my hand, but the feeling when I finally did it was unlike anything I've ever experienced. I'd felt failure in my fingertips and I'd let it go with ease.

Somehow, Lindsay got me back, as always. Six weeks later, I was on snow.

It was a quick return, for sure, but I needed to get back out there if I wanted to salvage anything from the year. This speedy return was definitely enabled by the fact that the entire time I was working on my hand, I was still working out with the rest of my body. I had to maintain my fitness in case I was able to come back that season. We worked on my core, my balance, and my leg strength. Because my legs were still fully functional, we got a squat rack bar, which went over my shoulders so I could do squats without using my hands. Through all my injuries, Lindsay and I always needed to get creative, whether it meant floor exercises, biking, rowing, or weight training with just one leg. Toward the end, she told me, "Honestly, buddy, you're always hurt, so you always make me use my brain."

By the time I was back on snow, my arm was still far from perfect, but it was just barely good enough. When I got cold, I would lose the feeling again, and one time I lost my pole. So, after that, I just duct-taped my hand to the pole, like I had when I'd sliced my thumb on the champagne bottle years before. This time, though, I caught a bunch of shit for it. There was even a move to disqualify me, ostensibly for my own safety. My thinking

was, if it's more dangerous for me, that should be my choice. In the end, they let it go, after I reminded the officials that I had taped my hand to my pole years before, back when I was the underdog and nobody paid any attention to me. Why should I catch heat for it just because I'm coming off a dominant season?

I got a bronze medal in the downhill at the World Championships that February, and won the downhill in a race in Garmisch the week before. That was my comeback, perhaps the most hard-won of them all. I don't think many people could have accomplished what we did, and I definitely could never have made it happen without Lindsay.

In terms of time missed, it was the least impactful of my serious injuries, but the psychic scars from this one lasted far longer. I had found something positive to push me through, but the mental toll had been much more grueling than anything I'd experienced before. And I continued to feel its effects in the weeks after I was back on the snow.

Perhaps it's not surprising that my depression started to creep in again that season. Easy, everyday tasks—talking to friends, eating a proper meal, going to the gym, even just getting out of bed—started to feel hard. As an athlete, spending months of your life away from your friends and family starts to take a toll, and it's only compounded when you're injured. No matter how well you do, no matter if there are thousands of people cheering for you and wanting your autograph, when you go back to your hotel, you're alone and the night stretches out ahead of you.

The truth is that for much of my teenage and adult life—and if I'm honest, until after my retirement—I was afraid to be alone. On my own, the silence was deafening. Whether I was on the road or at home recovering, I couldn't face myself; the thoughts and emotions that threatened to bubble up were too much. I hated solitude in the literal sense, the nights alone in

a stark hotel room, but also in a romantic one. Everything felt harder outside the confines of a relationship. Just as I relied on ski racing to bolster my sense of value, I sought a partner to fill in the emotional gaps. I wanted someone to love me, to make up for the ways I didn't yet love myself.

Of course, this isn't the best criteria for entering into a relationship. Whenever I met someone, I had a tendency to ignore any red flags. Instead of being discerning and trying to figure out if they were a good fit, I welcomed the distraction. I hoped that hearing someone else say they loved me would make up for the ways I wasn't happy in my own skin. (Spoiler alert: It didn't.) We've all heard the old adage about how you can't love another until you love yourself, and I can attest that it's true. But it would be years before I figured this out (and even then, it would take many hours of therapy to truly process it).

Even in the best circumstances, sustaining relationships proved difficult. Trying to date as a ski racer was tricky from a sheer logistics perspective, because there was always the constant backdrop of travel, training, and competing. When you factor in the press and the paparazzi, the pressure sometimes made it impossible to think clearly. Even as an adult, I never had those "normal" dating experiences of going out to dinner, talking and gradually getting to know someone. Instead, my relationships were punctuated by weeks of distance, phone and FaceTime conversations, flying to see one another whenever our schedules allowed, or living together too early simply because it made sense logistically. Throughout my entire career, I went on a traditional dinner date only one time.

That's not to say life after my divorce was without meaningful connections. In fact, it was quite the opposite. I dated a handful of people—sometimes very publicly—and had a string of long-term relationships. I also experienced heartbreak. There were people who were happy for my successes and others

who weren't. People who were attracted to the idea of having a strong, successful woman by their side, but couldn't handle it in practice. People who lost interest as soon as the shine of their new toy wore off. Then there were those who simply weren't a match for one reason or another. I have no desire to place blame or point fingers, nor do I want to spread any salacious, juicy gossip about my past. My only hope is that sharing my experiences may resonate and help others not to make similar mistakes, and perhaps show that it's very possible to be strong and confident in one area of your life, and struggle with those exact same issues in another. When you get a reputation for being tough, for being strong, it becomes so deeply intertwined with your sense of self. It can be incredibly empowering and invigorating. But it makes it that much harder to admit to yourself and to others, that maybe there are times when that toughness fails you. That those quiet, lonely moments that haunt others and fill them with self-doubt about their choices do that for you as well. That ultimately, you're just as susceptible to the same failings that everyone else is—and that's not just okay, that's human.

After plenty of self-reflection, I came to see that throughout all my partnerships, there was a similar dynamic at play—I didn't like who I became. Despite my confidence on the hill, in my personal life I had a tendency to recede, conforming to my partner's needs and preferences in an attempt to please them. But compromising who you are is never a sustainable, long-term solution. Simply put, for many years, I really didn't understand how to value myself. The time on the clock was always the clearest measure, but it wasn't the only one. Relationships, regardless of whether they were good or bad, became another metric for judging myself, judging my success. The relationships where I bent over backward for my partner—where I tried to mold myself to fit into their world and lost sight of who I was—were the ones that hurt the most. They left me feeling aw-

ful, like not only had the relationship failed, but I compromised my self-worth in the process.

The first step in changing this pattern was to recognize it. (As my mom says, "If you don't want to be walked on like a doormat, get off the floor.") I've since learned that relationships are a two-way street, with each person bringing their own baggage to the table. Every relationship has its own dynamic, and you are responsible for your role in this. You cannot make another person happy. You cannot change or fix someone, and you can't change yourself to please someone else. Your happiness is your own responsibility—no one else's—and in the best of cases, your partner amplifies that. But those lessons were sometimes hard-won.

For a long time, the only thing scarier than solitude was the thought of breaking up. Breakups are one of the most excruciating experiences. I would honestly rather have knee surgery than have my heart broken. (Although in my case, I've had my fair share of both.) That overwhelming sense of disappointment, coupled with the loss you feel at the end of a relationship? That, to me, is harder than any crash or injury. But there can also be silver linings. For me, the period following a breakup is a time of self-reflection, of reinvention, of defining who I am and how I want my life to be. (Though this, too, was something I learned after a fair amount of time and therapy.) If skiing taught me anything, it's that nothing good in life comes easy. It would take a number of years and a lot of work before I could feel comfortable on my own, able to see my own value and set healthy boundaries. Until then, there were plenty of empty hotel rooms awaiting me, plenty of long nights spent avoiding my inner monologue.

Whenever I could, which is to say, whenever the difference in time zones allowed it, I called my best friend, Vanessa. I was immediately comforted by her familiar voice on the other end of the line. "How are you?" she asked. "How are you feeling?"

I'd met Vanessa back in 2006—she's the one who resembles a character from *Law & Order*. Ours was one of those rare connections where she always felt familiar, and from the first day I met her, I was instantly at ease. Unlike so many of my loved ones, Vanessa isn't a skier. She followed skiing because I skied, but beyond that, she didn't know anything about it. It was one of many reasons I loved speaking to her, because it meant we could have a normal conversation about everything but the thing that dominated my life. We talked about how her kids and her husband were doing. We talked about my family. But the most helpful part was always that simple question: *How are you feeling?*

Whenever she asked, it felt both comforting and unfamiliar. Not many people asked me that question. Maybe they assumed that I was fine, that whenever I won, or whenever I broke a record, then of course I must be feeling good. But the answer was never that simple. Sometimes I wasn't. Vanessa, much like my sisters, validated my feelings and helped me feel connected to the world outside of skiing. Miles away, she helped give me a sense of normalcy.

When it came to my depression, it was a largely unspoken thing, even among people I was close to. I didn't actively shy from it, but I didn't discuss it, either. As far as my team was concerned, Lindsay knew me so well that she intuited what I was going through. She would react and respond to my actions, and she knew how to counter them and help me through. After spending the majority of five years together, including some really intense times, we reached a place where, even if I didn't say so, she knew everything about me. I'm lucky she was there—that season after my arm injury was one of the many times when she was a really good friend to me.

Still, in the majority of my waking hours, I was by myself and I was struggling. I'd been on the road for a long time and it

was getting to be too much. I needed a partner. I needed some-one to share my days with, someone who would wake up next to me and be there to greet me at the end of the day. And that's how Lucy came about.

My dogs, Leo and Bear, were back home with Reed and were not travel size. So I decided to get another dog—one who could be with me on the road. At that point, I would have gladly adopted any dog that needed a good home. Seriously, I went around to so many shelters in the countries I was racing in and was like, "Hello, I will take the ugliest dog. They've got one gan-gly tooth? Knotted fur? Great, just hand them over." I actually saw a dog in Austria that perfectly matched that description. He was *so* ugly. "I'll take that one," I said. They told me he had already been adopted.

I kept going to shelter after shelter, all over Europe, and most of them wouldn't let me in the door. Part of the standard adoption process was to do home visits for any potential adopt-ers, and because I didn't live there, it wasn't possible. So finally, I asked my Italian friend Enrica, who was helping manage my press on the tour and was married to one of the coaches, to do some research and help me find a good breeder in Italy.

My original plan was to get a Pomeranian, because they seemed like cute little snowballs I could cuddle with. But when I arrived at the breeders', all of them were so yappy. There were around twenty of them, all running in a circle, stam-peding and barking. They looked like they belonged in Paris Hilton's purse. They just weren't *me*. But there, in the center of the Pomeranian circle, sat Lucy, a Cavalier King Charles spaniel. We looked at each other. "Do you want to come home with me?" I asked her. She turned her head. That was it. I told them, "That's my dog."

I knew nothing about Cavalier King Charles, and I had no idea what to expect. The breeders wouldn't even let me meet or

hold her until I had committed. But the answer was clear. From that day forward, we were on the road together.

It was pretty tricky to potty-train a puppy while living in hotels. If a hotel didn't allow dogs, I would have to smuggle her inside one of my bags. I'd take her out a side door to go to the bathroom. When I was skiing, I would sometimes come home to find her "presents" around the hotel room. I'd do my best to clean it up, but it was challenging, to say the least. But Lucy is one of the best things that's ever happened to me. She doesn't care if I ski well or win races. She has no idea what ski racing even is.

Dogs are an excellent psychological crutch. I didn't like being alone with my thoughts. That's part of why I tend to thrive in chaos; I like being busy, when there's a lot going on, so I don't have time to sit and get caught inside my head. When you have an animal who relies on you, you always have to think about their needs, which means your own needs can take a back seat.

After a while, Lucy got used to being on the road and became the perfect travel companion. When I'm driving, she's like my navigator, and she also loves to fly. Lucy has two passports, which I recognize is more than most people. She's gone to Norway, Sweden, Germany, Canada, Chile . . . she even came to the 2018 Olympics in Pyeongchang. (Which was kind of scary because historically, some people eat dogs there. I was constantly like, "No one let Lucy off-leash!") I also took her down to Chile for our summer ski camps, where there's just the hotel, with nothing else anywhere near it. After around a week, you start to lose your mind, so everyone on the team would volunteer to walk Lucy. She became the team support dog.

Lucy even came to a bunch of my races wearing a child's onesie. I'd have to stick her tail in, and she would shoot me a look that said, "Mom, I hate you." My dad came to one of my races and kept her with him at the bottom of the hill. She

walked out to the podium with me, wearing a little sweater. One of the other girls complained that the dog took away from her results, because all the cameras were focused on Lucy. (Can you blame them?) After that, dogs were banned from the finish area. But, you know, it was fun while it lasted.

Through the struggles with my arm and the depression that followed, I had a constant awareness that the 2018 Olympics were on the horizon, and it felt undeniable that no matter what happened, I was going to arrive at those games a different person, or at least a different competitor. I wanted to find a way to represent that change physically, but also lift my spirit, a visual reminder of that transformation. So it was only natural, I suppose, that I would get a shark tattoo.

The backstory here is that I love sharks. I'm obsessed with them. I think they're amazing, misunderstood creatures. My fascination with sharks started when I went diving with some of them in the Bahamas. Have you ever seen one in person? When you look into their eyes, it's like you're both sizing each other up, trying to determine who's the dominant one. It's intense. Everything about them is so instinctual. But here's the thing about sharks that really spoke to me: They can only swim forward. They can't swim backward, and they can't stop moving. They go after what they want, and they always keep moving ahead—nature's one-upper.

Forward motion is a need that's innate within me, an impulse that drives nearly everything I do. I can't sit still. It's not that I can't relax. In a way, it's almost like I embody that shark energy, in that I always have to be building. I think it's a combination of my personality with the example that was set by my parents, and my grandparents before them. Wherever it comes from, it's a part of me. No matter what I've accomplished, I have to keep swimming forward into new things.

That was exactly where I was in my life: wanting to move forward without letting anything distract me. The tattoo was like the sticky notes I used to put on my skis—a kind of permanent sticky note to remind me of my goals and encourage me to keep going. At that point, I'd been in a bunch of romantic relationships that hadn't worked out very well, and to be honest, I didn't love how that relationship drama was distracting from my career. I wanted to memorialize this on my body, find something that symbolized moving forward, but I didn't know what to choose. Then one of my good friends suggested, "Why don't you get a shark?" and I thought it was a great idea.

I put it near the base of my ring finger on my left hand—the wedding ring finger—as a reminder to myself that if I were ever to get married and cover that tattoo up with a ring, my partner and I would need to be going in the same direction.

When it came to the design of the tattoo, I wanted two things. The first was for it to be tasteful. The second was to not look like I had a goldfish on my finger. In the end, I decided to make it just the outline of a shark, almost like a shadow of it. I pulled a bunch of pictures together and brought them to an artist, who created the design. Once we finalized how it would look, the whole process took fifteen minutes.

I love it; I think it looks sick. My dad always said that if I got a tattoo, he would carve it out of me, but I had it for years before he even realized. It's small, so he never noticed. Then one day, he saw it and said, "What. Is. *That?*" When I explained what it meant, he said, "Oh, that's kinda cool."

After I got the tattoo, I actually participated in Shark Week on the Discovery Channel. I got to dive with oceanic whitetip sharks, which are some of the most aggressive sharks there are. They're attracted to bright colors, so I wore these bright pink flippers. I'd nudge the sharks so they'd come over to my feet where I could check them out. We got really close—within an

arm's length—and stared at each other. I may be insane, but I loved it.

The following summer, in 2017, I got my second tattoo. With my last Olympics, in South Korea, coming up, I wanted a reminder to believe in myself. I didn't want something typical like the Olympic rings, and I thought it was even better if the meaning was hidden and no one else would immediately know what it was.

I decided to get the word "believe" on the middle finger of my right hand. It's written in Greek, since the Olympics began in Greece. Quite a few Greek people have seen it and said, "Whoa! Are you Greek?" And no, I'm definitely not. To be honest, I don't even know how to pronounce it, because I can't read Greek letters. But I love it.

Just like with my shark tattoo, I was very tactical about where I placed it. In this case, if you don't believe in me, I can give you the middle finger.

We're not quitters. You can't go out like this."

My dad's voice is on the line. It's like I'm fourteen years old, calling him from competition out West when he's back home in Minnesota. Only, I'm not fourteen, I'm thirty-three, and at fourteen, I never would have said what I just had: "Maybe I should retire."

I was in Lake Louise, alone in my hotel room, feeling beat down. No matter how hard I tried, I kept getting knocked down. As I looked down at my legs stretched out before me, my knee huge and swollen against the white hotel sheets, I felt overwhelmed. I needed someone to offer me perspective, and I knew just who to call.

When it came to the question of my retirement, my dad had gone both ways. Sometimes he would say he was worried about me, that he didn't want me to keep getting injured. Then, just as quickly, he would remind me that we aren't a family of quitters.

"You've made it this far," he said. "You can't show them your weakness. You're gonna get back up there and show them how tough you are."

He was right. And I knew he was right. We're not quitters. Of course he was right. Still, I wasn't convinced I was wrong, either. As much as any part of me was still on the fence, my dad knew just the thing to say to coax me back to solid ground. "You owe it to yourself to keep fighting. If you don't do it for me, do it for Grandpa."

The 2018 Olympics were approaching fast. The opening ceremony was roughly two months away, a distance that suddenly felt both immediate and impossible. I'd just raced in the downhill at Lake Louise—the start of the World Cup season—where I was in the lead by five-tenths, when I crashed right before the last jump. It was a weird one. It honestly came out of nowhere. I was in a turn when my ski caught an edge. I did the splits and flipped around, only to become tangled in the fence like a fish. My legs were contorted, and my arms were pinned behind my back. Comparatively speaking, I wasn't in an extreme amount of pain, given what I had been through in the past, but still, it was an Olympic year, with the games only eight weeks away, and I was trapped in a fence. With my arms still pinned, unable to move in the netting, I kept telling myself, *This isn't happening, this isn't happening. You're fine, you're fine, you're fine.* My brain had become intent on saying, *I got this, I'm good,* until the moment the doctor would say, "No, you're not."

This was a harsh crash, I knew that much, but somehow my body felt pretty good. At least, it did at first. But as I was walking—first from the finish to the car and then from the car to the hotel—I could tell that something wasn't right. It didn't feel like I had torn any major ligaments, but something was definitely wrong with my knee. It wasn't my ACL, it wasn't my MCL. Whatever it was, I figured it was probably fine to ski on

it, so Ricky and I worked on it and did whatever we could to try to make it better.

But even though the injury seemed manageable physically, a hidden impact was immediate and unavoidable. A thought arrived, quietly at first, but then louder. *Should I be doing this? Maybe I should just retire.* The first time I considered retiring—seriously turned the thought over in my mind—I was alone, in my bedroom in Vail. To one side, Picabo's framed poster gazed back at me from the wall, its inscription still telling me to follow my dreams. On the other, windows offered a view of the mountains outside. I sat, confined to my Tempur-Pedic bed, my legs elevated like one of the senior citizens from the commercials. When I first bought my house, never in a million years did I picture I would need an elevator or a Tempur-Pedic bed. But the last few years had been full of surprises. That's when the thought hit me: *Maybe it's time to retire.*

Up until this point, skiing had never felt like a choice. It was like breathing; there was no other option. Skiing was the thing I loved more than anything else, the nucleus around which my entire life revolved. The glue that kept everything together. *Should I retire?* I had not entertained the thought since my career took off, but once it was there, it was hard to dismiss.

Back in my hotel room in Lake Louise, it only grew louder. I took stock of where I was and where I'd been: I'd had a major surgery every single year since 2013. And now, for the first time in my career, it felt like the risk outweighed the reward. I felt broken down—physically, mentally, emotionally. I wasn't sure what to do, so I'd called my dad for advice. *Should I retire?*

"We're not quitters," he said. "You've got the Olympics coming up, and you've trained so hard." My dad was right. I couldn't quit. Not yet, when I was so close to the Olympics. I needed to keep going. "You get in that starting gate and you show them how tough you are," he said. It's what I had always told myself,

but at this moment, when there wasn't a lot left in me, hearing it from him was what I needed.

So, I raced. I got in the starting gate, and I proved to everyone—including myself—that I could do it. But my next race didn't do much to quell my doubts. I finished twelfth. For my whole career, I'd usually won at Lake Louise. I had eighteen total wins there, including every single year from 2004 to 2015, aside from the years I was injured. From the time we used to visualize the course back at Ski Club Vail, I was always comfortable there, and this had been a less than stellar showing. It put me in a rough place. I'd had such a great prep period, and was in such good shape, but then when I crashed, I lost all that confidence I had worked so hard to build. I'd been derailed.

I called my dad again. "I'm still struggling," I told him. "It would be great if you could come out and help me."

"Okay," he said, without hesitation. "If you need me, I'll be there."

This suggestion was a really big deal. I'm not one to ask for help. I pack my own bags and load them in the car myself. I don't like gifts or favors or even borrowing things. I am a lone wolf about most things, preferring to do it all myself. My dad was aware of this, and he knew me well enough to understand what was at stake. Without my saying another word, he knew exactly what I needed.

A lot of times, my dad tells it like it is. He's not one to sugarcoat things. When I'm overreacting, he'll give me tough love and say I'm being a wimp. If I'm skiing well, he tells me. If I'm *not* skiing well, he tells me. He is a perfectionist, as am I. He expects a lot of me, just as I expect a lot of myself. It's a high standard, and one I don't always meet. But at the same time, he can be very reassuring. My dad agreed to travel to Europe with me, and I knew I could trust him to tell me the truth.

Heading into Val d'Isère, my dad watched me train and

offered his opinion. Almost immediately, his presence, at this stage in my life and my career, made me feel like a kid racing again. That feeling of him carrying me in my sleeping bag to the back of our already warm car and driving me to my races—having him there brought back that same feeling of comfort. We may have had our personal struggles over the years, but now we were back in a good place, and it felt like we had come full circle. He was that missing piece of home and stability I needed in that moment.

One day, there was too much snow to race, so my dad and I went skiing together, taking a couple of free runs like old times. I took off ahead of him, just like I had when I was a kid. Reliving those old times, if only for a moment, everything felt okay.

On the hill during the day, I remained focused on skiing, but in the evenings, my dad and I would go to dinner together, a welcome change from nights spent alone in hotel rooms. I can still picture him sitting across the table, in one of his Dale of Norway sweaters, with Lucy seated next to him, perched on a chair like a person. Though I typically hated leaning on anyone, it was comforting to have him there, both as my dad and as a witness to my life. I didn't need to ask for support, and he didn't need to say anything. His company was enough.

At any stage in my career, my dad being there for me would have meant something, but at that particular moment, the significance was immense. I needed someone to remind me why I was there, and why it made sense to keep going. He grounded me, helped quiet that voice in my head. His presence alone brought me back to the root of why I loved skiing. Just when I needed it most, it felt like we were back where it all started. I could feel my confidence returning.

Skiing is often characterized as an adventure, but I never saw it that way. Maybe the first time you go down the mountain, and you feel the rush of the wind in your face, the world

blurring past you, that feels like an adventure. Or when you take your first run at a new location, absorbing the brand-new scenery and unfamiliar terrain. But that aspect goes away once you've done something enough times. After that, racing becomes all about the challenge, the game of chess, albeit a much more physically taxing one. Your focus becomes about pushing yourself every day, hovering at your limit, always under different circumstances, with different variables.

No matter how seasoned you are, every day, every hour, even down to the minute, there are different conditions, different competitors. It's constantly coming at you, and whenever you think you have it down, the switch flips again.

Skiing is not a riddle you can solve. It's not something you can ever fully figure out, because the minute you do, the variables will shift. Skiing loves to remind you that you're not the one in charge. No matter how in control you *think* you are, in ski racing, there is no such thing as control. On the contrary, it's a sport that asks you to push yourself to the brink of losing control. In that way, it never stopped being a thrill for me.

Just seeing my dad there dusted off that thrill and helped me get back on track. I won the first race at Val d'Isère, a super G. And then, that night, I was in the gym when my knee gave out. I heard a pop and then fell to the ground. I knew something had happened, but I couldn't figure out what.

Before the 2014 Olympics in Sochi, I had tried to ski with a knee injury, and ended up ruining my chances because I pushed too hard and had no choice but to end the season. I didn't want to make the same mistake again in 2018. The following day, I was at the start of the second super G and ready for inspection when my coaches and I made the decision to go home and figure out what was wrong. It was a tough call, but it felt like the right one.

I went home to the U.S. and got stem cells injected in my

knee, which, let me tell you, is not a pleasant experience. You're totally awake, and you lie there while they basically take a power tool to your body. The doctors drill into your back, pull out the healthy stem cells and bone marrow, spin it down to extract the stem cells and platinum rich platelets, and then inject it wherever you're injured. This wasn't my first experience with the procedure—I'd done it many times over the years—so I knew what to expect, but that didn't make it any better. It felt like every time only got more and more painful.

After I had my knee injected, I took a few days off. There was absolutely something wrong, but they couldn't really see it on an MRI. The doctor said I probably had a meniscus tear and a new cartilage crack, but it seemed like it was well enough to ski on, so I kept going. I didn't ski GS or slalom. I toned back my schedule and just focused on speed.

The more I got injured, the smarter I needed to be. I couldn't rely as much on my physical ability, so I had to learn how to outsmart people. I think that happens with a lot of athletes, where they start off with all this physical talent and ability, but as they mature, they find ways to compensate for their changing bodies by learning to make their game more whole. In training, my approach grew more deliberate, my efforts more measured. When I was younger, I pushed myself to the limit, trusting that my body could handle whatever I asked of it. Now, my workouts became as much about handling my body as they were about pushing myself. As an all-or-nothing person, this was an adjustment. (If only I could have skied in my twenty-two-year-old body with the knowledge I had at the end of my career. Now that would have been something to behold.)

I had to be able to mentally outwork everyone in order to compete, so I put more energy into that work off the hill. Earlier in my career, I didn't care about what anyone else was doing, because I knew I could beat them. Now, I had to pay attention

to what the others were doing. Who could I beat right now because they were nervous? What risks did I need to take, and how much risk? I became even more hyperprepared, because the more I knew about the course, the less I worried about crashing. (To be totally honest, I never worried about crashing, but at least this way I knew I had minimized the risk.) I had to ski a cleaner line, so I needed to inspect the course meticulously. I had to be more calculated in my approach. It was fundamental that I adapted. The question was always: *How can I win this race without risking my knees (or my life) but still be fast enough to win?* Then I raced accordingly. Maybe I didn't win by huge margins like I used to, but I still won, and that's all that mattered. I didn't become a better skier as time went on—I just became a smarter skier. And I hoped that this would be enough in South Korea.

This was the approach that worked after the stem cells. The World Cup races in Garmisch, in early February, were my last before the 2018 Olympics. There were two downhill races and I won them both, bringing my total World Cup wins at that point to eighty-one.

I couldn't straighten my leg and I was limping. I wasn't even close to 100 percent. But with the help of my dad, I'd found my center of gravity again on the hill. I could do my best, even if the definition of what that meant kept changing.

CHAPTER TWENTY-TWO

The morning of the super G race at the 2018 Olympics, I woke at the same time as always. I put on the same uniform as any other day—my race suit, jacket, and pants. But on this day, as I'd long intended, I gave myself an extra ten minutes before inspection. There was something I needed to do.

On top of a mountain in Jeongseon, the area in Pyeongchang where we competed, there's a spot where you can see for miles and miles. It's a stunning vista of snowcapped mountains like something out of *National Geographic*. I'd discovered it the summer before, when I'd traveled to Korea as an ambassador for the games and hiked to the top of the hill. It was so beautiful that I committed it to memory.

I took the chairlift to the top of the mountain and made my way back to that same spot. It was a gorgeous day, cold and clear, the sun shining down on the mountains. No one else was around. I took my skis off and sat down in the snow. And then, I started talking.

From the moment I'd arrived in Pyeongchang—and even before that—I was aware of two things: This was my last Olympics, and my grandpa wasn't there.

For a long time, Grandpa Don was holding on just to make it to these Olympics. As his health started to decline, everyone said the upcoming games were what kept him going. Months beforehand, I met with the ambassador to South Korea and made arrangements for my grandfather to travel there. The embassy said they would get an emergency transport to take him to the games. But it wasn't meant to be. His mind was still sharp, but his body couldn't hold on.

My grandfather died on November 1, 2017. He was eighty-eight years old.

Sometimes, when you haven't seen someone for a long time, there's a tendency to remember them exactly as they were at some distant point in the past. In that same way, Grandpa Don remains frozen in time for me. I recall him exactly as I knew him in childhood, still hold him in that same esteem. I see him on our family ski trips when he could still ski with me. I can hear our many conversations, including all the times I called him from Mount Hood using my collect-calling card to share how I was doing. I can feel how excited he always was to hear from me, to celebrate my victories, to talk about this beloved thing we shared.

King of the one-liners, Grandpa Don was the most hardcore, yet softest, person. Some people in my family didn't always see the soft parts of him, but they were there. He loved his family more than anything else—that much was always clear. To me, his strength never diminished, and he never stopped being the ideal. I'll hang on to him, that same Grandpa Don, forever.

After he died, I had these necklaces made for my mom, my sisters, and me—heart-shaped lockets that could hold a bit of his ashes inside. I wore mine everywhere that season, as a reminder that he was watching over me.

I also got a tattoo on my ribs that reads, "Still I Rise." My dad and my grandpa had very similar handwriting—a thin, beautiful cursive—and the words are written in a script that looks just like theirs, to honor them both. (I couldn't very well ask my dad to write it out for me, because then he would know I was getting another tattoo. He still doesn't know about this one . . . and I guess he won't until he reads this.) The words are scrawled in a very thin line, almost like a pencil. The tattoo is my own personal reminder that no matter what happens, no matter what obstacle I face, my grandpa is always with me. I can still pick myself up and keep going, just like he did.

When Grandpa Don served in Korea, he was stationed very close to Jeongseon. I thought of him the entire time; I felt him with me everywhere. His connection to this place made an already emotional experience overwhelming. There was a clip of us skiing together in the pretaped athlete profiles that NBC ran during commercial breaks. I mentioned him in every interview and every press conference. Throughout my career, I'd always talked about him in the media, but even so, I was caught off guard by how strongly I felt his presence since arriving in Korea. Even the weather was exactly how he described it. I remember him telling me Korea was colder than anything he'd ever experienced—even in the Midwest, where winters frequently get into negative temperatures. The North Pacific Ocean brings arctic temperatures, and every time I was out on the mountain I would imagine him building roads for the army, freezing his ass off.

That morning, up there on that mountain in Jeongseon, I talked to my grandpa for a while, and I know that he heard me. I felt him there with me that morning, and I know he was looking out for me. As much as I knew he hung on to watch me in Korea, I think I hung on for him, too. It could have been just me racing and just him in the stands watching, and if I made him proud, I could have ended my skiing career happily.

When I had told him everything I wanted to say, I took my heart-shaped necklace off, unscrewed the little cap, and sprinkled some of his ashes there.

My entire time in South Korea was marked by tremendous pressure. I wanted to win a gold medal to honor my grandfather, and I wanted to have it mean something. His connection to this country and the fact that it was my final Olympics added these additional layers of weight that I was carrying on my shoulders. I was also still dealing with the fallout from something I'd said a few weeks earlier in the run-up to the games.

After the disappointing run at Lake Louise, I'd headed to St. Moritz, where I got into a battle with Donald Trump. Well, not directly with Trump. I was doing an interview for CNN when this reporter totally teed me up. We sat down for what I thought was supposed to be a puff piece about the upcoming Olympics. Instead, she asked me, "How does it feel to be representing President Trump in the opening ceremony?" It was totally unexpected, and I just kind of went off.

"Well, I hope to represent the people of the United States, not the president," I replied. "I take the Olympics very seriously—what they mean and what they represent. What walking under our flag in the opening ceremony means." I went on to say that when it came to positive representation, there didn't seem to be a lot of people in our government who knew how to do that.

"Will you go to the White House following Pyeongchang?" she asked as a follow-up.

"Absolutely not. No," I said.

Shit. Hit. The. Fan. It was insane. I got vicious comments, hate mail, death threats . . . you name it, it probably happened. They threatened to get my sponsors to dump me, and just when I thought it had finally stopped, the FBI called. My name was on the mailing list to receive some sort of pipe bomb. It was unlike

anything I had ever seen. I found it particularly amusing when the haters said I wouldn't get asked to the White House because I wouldn't win a gold medal, since tradition holds that every U.S. team member (not just the winners) is invited to the White House on the heels of the Olympics.

In retrospect, I admit that it wasn't my best moment. To be clear, I don't regret saying it, but the phrasing could have used a little work. I could have made my point a little better. It reminded me of an interview I gave when I was younger, where a reporter had asked if Julia and I were friends. I said something like, "We're friendly, but we're not friends." It became a thing. Everyone on the team saw it and made fun of me forever. In a way, though, I appreciated when people picked apart what I said, because it made me realize how important every single word is.

So of course, when I spoke out against Trump, the media had a field day. Honestly, as polarizing as my comments were, it was also a good reminder that my voice could be heard. A lot of athletes build up a platform and don't use it in any positive way. I like knowing that when I want to stand up for (or against) something, I can.

Even now, many weeks later, this thing with Trump was still a talking point for the media, and combined with all of the emotions around Grandpa Don, my knee injury, and my final Olympics, it meant that I wasn't nearly as dialed in as I wanted to be. There were just too many distractions, I was being pulled in too many directions, and it showed. From the outset, the games didn't go as well as I would've liked.

The first race was the super G, and I drew bib number 1, which of course nobody wanted. It's very difficult to run with early bib numbers. You want the benefit of watching other people on the course, so you can see where there are problems. Some jumps are big, there might be some trouble spots, and

you have to adjust your line. If the snow is wet, or granular, you want to know that. Nobody wants to get to the Olympics and be the one leading off the race. Still, someone has to do it, and this time that person was me.

On the top half of the course, I skied phenomenally, but at the bottom I made a mistake six gates before the finish. I didn't have enough direction heading into a big left-footed turn, and I took a line that was a little too direct. It pushed me low, killing my speed before the jump and costing me precious time. I finished in 1:21.49. If I hadn't made that mistake, I probably would have made it onto the podium, but as it was, I ended up in sixth place.

When it came to the downhill, I felt better. I'd skied well on this track at the World Cup the year before, and my training runs leading up to the race were strong. This time, I drew bib 7, so I had the benefit of watching a handful of the other skiers before me. As I slid into the starting gate, I felt good. As I took off, I realized I wasn't pushing the line as hard as I should be. From a tactical perspective, I was a little round in a couple of places. I skied a clean run, but it could have been cleaner. My time of 1:39.69 put me in second place, .47 behind my friend Sofia Goggia of Italy. My time held up until Ragnhild Mowinckel of Norway put up a 1:39.31—out of nineteenth position—and bumped me into third.

I want to tell you that when I won the bronze in the downhill, I felt proud to win another Olympic medal, and there is some truth to that. But if I'm being completely honest, I was also extremely disappointed, and this mixture of emotions added up to something bittersweet. If you had told me back in December, when I'd crashed in Lake Louise, that I would win a bronze at the Olympics, I would've said, "That's amazing!" because at the time I didn't even know if I'd be able to ski that season. But my team and I had worked so hard to get me to a place where I could ski

well in Korea, and I felt like I had fallen short of what we all knew was possible. I'd put everything I had into this race, and I was left feeling like that still wasn't enough.

My family had all flown out to be there. By this point, it was well established that I didn't talk to anyone in the lead-up to the games, so aside from my conversation with my late grandfather, I didn't see or speak to them until after my races were finished. But I knew they were there for me, could feel their presence bolstering me from afar. My sisters came into the finish to give me a hug, and all my teammates joined them. Then, the fact that Sofia had won made it somehow more meaningful. I see a lot of myself in Sofia—her discipline, her work ethic, how she skis so aggressively, and how she was always unapologetically Sofi. We had become good friends over time, been through injuries together, inspired each other. In a lot of ways, it felt like I was passing the torch.

Looking back, I think I let my emotions get the better of me. I knew this was my last chance, and I let that get in the way. I was confident in my skiing, but I wasn't in the right headspace, not with everything that had been going on. In hindsight, it's so perfectly clear. All throughout my interviews, the waterworks were on. I couldn't keep it together. It was so raw and so fresh. Standing on the podium, as the Italian anthem blared, I sobbed like a baby. My grandpa wasn't there, and I didn't win it for him. I felt like I had let both of us down. All along, I had always told myself that if I did my best with what I had, I could live without regrets. Now I knew that sometimes, my best still wasn't enough to avoid them.

On the plane going home, I found myself thinking back to that moment on the mountaintop in Jeongseon. In my head, I could still see the peaks and valleys of those mountains in the distance, even as I'd sat there atop my own. My connection to Grandpa Don had felt so profound up there, I was still working

my way through it all. I'd been able to persist through every-
thing to that point because of the model he'd set for my whole
family, and I would continue to do that for as long as I could.
And yet, seated on the plane, waiting to return to whatever un-
certain diagnosis waited for my knee, it was clearer now than
ever before that eventually hard work wouldn't be enough. There
would come a moment soon—exactly when I didn't know—that
I would say the words and my time in the snow would be over.
Not because I'd lost the will to work, but because I didn't know
how much more my body could take before it gave out.

From here on out, I was still chasing a goal, even though it
wasn't gold—I was chasing Ingemar. But I was no longer racing
against competitors, or even the mountain; now I was racing
against my own body.

When I got back to Colorado after the season was over, I said
to Lindsay, "I skied so well with my knee like this, maybe I
should just keep going." But she wasn't having it.

"I don't know how you skied on this knee for a whole sea-
son," she said. "You need to have surgery."

After another MRI, we discovered that a huge chunk of my
cartilage had become detached, back when I crashed in Lake
Louise the previous December. The crash itself wrecked the car-
tilage, and then when I heard that pop and fell to the ground
the night I was working out, that's the moment it dislodged. It
had been floating, detached, in my knee that entire time. This
explained why I couldn't straighten my knee, as well as why
it was so unstable and rickety. Thank God the dislodged piece
didn't move into a worse position, even though where it ended
up wasn't great.

So I had yet another knee surgery, in which they removed a
chunk of cartilage the size of a silver dollar. While I was under,
they also resurfaced the underside of my patella and cleaned

up my meniscus tear. That same year, I saw some other athletes post photos of their injuries, where they lost pieces of their knees that were maybe the size of a small pebble. I would see them and think, *Oh, you have no idea.*

A lot of athletes might have called it quits after this diagnosis—another surgery, another rehab, another year of question marks. But after the surgery, honestly, I was pumped. My aim was clear. That entire spring, I just had to work on my rehab and get ready for the next season.

In truth, it wasn't just Ingemar's record that got me out of bed and onto the hill in the morning, although that was certainly a big part of it. It was also a question of my purpose. It's easy to look back on our greatest successes and see them as foregone conclusions. The harder part is looking at them for what they are—thousands of small choices that ended up culminating in something personally meaningful. My World Cup victories meant so much to me. They were different than the Olympics or World Championship medals. My World Cup wins weren't about how good I was on a single day, at one shining moment. They were about what made me great as a skier—consistency, hard work, resiliency, purpose. Showing up every single day and trying to better myself.

A career is about the stuff you do when you're paying attention and keeping score—and that's how I felt about the World Cup. That's why it was so hard for me to step away. I kept showing up because I fucking loved it, I loved all those little choices I had to make in the service of training, every day, every week, every year. I love going fast—there is nothing like it in the world, and nothing can ever replace it. I feel the calmest and most in control of my life when I'm going eighty miles an hour down the mountain. That's when I am most sure of myself. That's when I feel the most at peace.

As soon as I stepped off the snow, the deep questions were

there to greet me. They'd been in the background for years, but suddenly they were more present than ever before. *Who am I without skiing? What am I doing with my life? What is my purpose? Am I washed up? What is my worth?* Over the years, I'd become a much more confident person, but facing the end like this? Let's just say that everyone is entitled to a crisis of confidence. I was haunted by a lot of the same questions everyone has, but somehow, I had managed to make it this far without ever confronting them. When I skied, everything was simpler. When it came to any problem I had in life, my attitude was always, "I can't address that because I'm focused on my career."

Without skiing, the course of my life became uncertain. If I stopped skiing, I would need to ask, "Who am I?" Outside of my sport, I didn't know the answer. That was harder to process, and I wasn't in any hurry to confront it. There weren't many things I did outside of my training and racing schedule, a contrast that became even more apparent when I was injured and unable to train. So I rehabbed my knee, and I figured out how I could ignore that escalating drumbeat in my head.

Our next camp started in August, in La Parva, Chile. After missing so much time on the snow, I wasn't at the same stage in preparation as the other girls, and I was playing catch-up. Those first couple of days couldn't have gone better. I was skiing well and feeling strong—I could finally get back into a low tuck again, so my range of motion was right where it needed to be. By the second day, I was skiing super G, and hanging in there with some of the guys on the Slovenian team who were training there. Everything was looking up.

Then, on the third day of training, I crashed again. It was my right knee, the same knee. Always the same knee. I couldn't tell exactly what it was this time, but I knew it was another bad one. I finished out the rest of the camp—walking was a bitch, but skiing was tolerable, which is just how it is sometimes—

and then Lindsay and I went to see a doctor in Santiago. The MRI machine there was outdated, and we couldn't really see anything. The doctor suspected a meniscus tear, but he couldn't say so with any certainty.

When I got back to Vail, we went to the doctor, who confirmed that I tore my meniscus and that it was a flap tear. With a flap tear, if it gets stuck in the wrong position, there is a chance your knee can get locked out. The idea of my knee getting locked out while going eighty miles per hour was obviously a bad scenario, so he told me I had two options: I could do stem cell therapy and hope the flap healed itself, or I could go under the knife again. Typically, most people would want to avoid surgery, but I didn't have time to go through the stem cell treatment and then still have surgery if it wasn't effective—it was one or the other. The start of the 2018–2019 season was just a couple months away. So I went into surgery yet again, this time to remove the chunk of meniscus.

My knee didn't respond well to the surgery, and honestly, neither did I. I remember sitting in my bedroom in Vail, with ice on my knee, wondering how the hell I was back here. The only time I stayed at my house in Vail was when I was recovering, but I had gone under the knife so many times in recent years, it almost felt like I was living there full time. I was drugged up and in pain, and I looked around the room and thought to myself, *Why am I always here? How many surgeries can I really go through? Why am I putting my body through this? Why am I fighting so hard to be here if I'm just going to keep hurting myself?*

I felt like I had reached the maximum of what I could take.

Before this point, I had always tackled every injury, every surgery, every rehab, one at a time. When I focused on each as an isolated incident, it felt possible to overcome. When I set my sights on what was ahead of me, that need for forward motion took care of the rest. But now, the collective weight of all these

injuries had accumulated. *How long can I continue to do this to myself?*

My plan had been to keep working as hard as I could, trying to break Ingemar's record until my body gave out. Now, it appeared that my body was rapidly approaching that point. It was yelling at me to stop, and much as I tried not to hear, it was impossible to ignore. All along, my dad had said that every athlete reaches a point where they shouldn't keep going, and that some of them keep going anyway. I didn't want to be part of that latter category. I said to myself, *This is it. This is my last season.* I couldn't keep hurting myself and taking chunks out of my body. Enough was enough.

I hadn't yet given any thought to when or how to announce my retirement when I accidentally blurted it out during an interview. It was at an event celebrating my partnership with Chase Bank, where I announced that I was going to build a beauty business. Someone asked how much longer I was going to ski, and I accidentally said, "This is it. This is the last season." It was completely unintentional. But as soon as it was out, I felt so much better. I was flooded with relief, like I could finally exhale for the first time in months. I knew it was the right decision.

Five races. Five wins. Five more moments when I was the best. That's it.

When I pictured that final season, I had a vision of how I wanted it all to play out, a perfect storybook ending of breaking the record and then retiring. It was a fairy tale for sure, but honestly, it also felt somewhat practical. I had won five races the previous year. All I needed was to win five races again this year and that would do it. And *then* I was ready to call it a career.

After my knee surgery, my next training camp wasn't until November 2018. I was only five days into training when something really started to hurt. It was my knee again (of course), but it felt different this time, stranger than any of my previous injuries. I could tell it wasn't my meniscus; it was definitely something new, almost like a grinding. "I'm getting a weird pain in the knee," I told Lindsay, and we went to investigate.

I suspected it might be a bone bruise, and as it turned out, I was right. There was no cartilage left in my knee, which meant

there wasn't much of a bearing surface, and my bones were clanking together. As my doctor said, it was remarkable that I was racing at the level I was with a knee like that.

More than ever before, we had to make sure every day of training was optimal. Our plan was to do fewer runs, but to make them really high quality. I started skiing one day off, one day on, one day off, one day on. To put it in context, someone like Mikaela Shiffrin, who was twenty-four at the time, was probably skiing twenty-plus runs a day. I was skiing two runs, every other day. I had reached a point in my career where I didn't need to focus on my technique as much. But no matter how long you've been in the sport, you still need to train. When I was younger, I would get this feeling at the end of the day, where I was tired, and my body hurt, and that was my signal that it was time to stop. Now, that's how I felt all the time.

Still, I kept training. After all, this was my final push. When you've worked your whole life for something, the last thing you want to do is give it away because of pain. Just say I'm done? No, thank you. No matter how much pain I was in, I could force my way through it. I just made it work. I had to. And then, I crashed again.

It shouldn't have been that big a deal, but I caught my inside ski. I slid backward toward the lift tower, thinking, *No no no no no. This isn't happening, this isn't happening, this can't be happening.* At that point, I'd already had five surgeries on my right knee. One crash could end everything. When I came to a stop, I immediately checked my right knee. It seemed fine. Then I tried to stand up, and something was wrong with my left knee. *How does this even happen?* I thought. How did I continually do this? All I was trying to do was stand on my own two feet.

They brought me down the hill in the sled. Whenever Heinz, my technician, saw me get taken down the hill in a sled, he would cry. "I am afraid for your life every time you go down

the hill," he told me. Which obviously put things in perspective. If everyone else on my team was scared for my life, all the signs were clearly saying it was time to stop. Still, as scared as they were for my safety, it was scarier for me to think about giving up the thing that I loved so much.

It was ten days before the World Cup opening races in Lake Louise, and there I was, back in another hospital room, waiting for yet another set of results.

"Your ACL, MCL, PCL are all fine," the doctor told me, itemizing the ligaments. I breathed a sigh of relief. "It looks like you have a couple of nondisplaced fractures, and I have to take a closer look at your LCL."

He told me it was hard to say whether we were looking at a two-week or a six-week recovery time, but that he didn't think he could get me back in ten days. Lake Louise was in ten days, the start of the World Cup season. Normally, starting off well in Lake Louise would be a good indication for the rest of the season. I looked forward to racing there every year, since I had such a strong track record, and because the fans there were always so welcoming. I had won eighteen times in Lake Louise, and I was depending on this one last shot to help me get closer to Ingemar's record. The thought that I would never race there again was heartbreaking.

"I can get back in ten days," I told Lindsay, as soon as the doctor had left the room. "I'm not missing Lake Louise. Zero chance."

I don't like anyone telling me what I can or cannot do— including my own knee. As I've said, I'll believe I can do anything until the doctor explicitly tells me otherwise. But I was about to be told otherwise. After the swelling had gone down, I had another MRI and it turned out that I tore my LCL completely and had three major fractures in my tibia. Lindsay called early January, which meant I had no chance of skiing at Lake Louise.

I started to cry.

"We're not throwing in the towel," Lindsay said. "That's not what we're about."

Lindsay and I didn't know what we would be able to salvage from the season, but I wasn't ready to stop yet. I had come so far, and this was my last push. I wanted to give it everything I had. Together, we made a plan to come back one final time.

Part of our plan meant we had to do the one thing I never wanted to do again, which was to be in a pool doing therapy. Every day, we'd go to the rec center in Vail, where they had the only deep pool in the city. I had to wear this sleeveless one-piece suit that keeps you afloat. If there's one thing I hated the most about all my time doing therapy, it was that fat suit. We did an hour and a half of pool time every day, plus weight training, trying to keep some sliver of hope alive. We weren't sure if I'd be able to ski again, but we worked all day, every day, for a full month to get me back to racing in Colorado.

Knowing the World Championships were in February made me think that even if I lost the rest of the season, that would be a good place to go all out. Lindsay was great at keeping me in a positive state of mind. "You've come back every single time," she reminded me. "Every single time."

During that last season, everyone in my life had their own opinion about what I should do, and though they all tried to be supportive, no one was particularly helpful. The trajectory of my career was rapidly becoming less and less of an emotional decision and more of a physical one. Should I try to come back? Had my body had enough? The more I talked to people, the more confused I became. The one exception was my friend Claire Brown, who I've known since I was eight years old. My final season, she came on board to help me manage my media, and she was there for some of my most intimate moments. She was with me in the hospital, in my hotel rooms, on the

hill. She saw me cry many times behind the scenes, out of pain and frustration.

"You need to do what's best for you," she said, as she sat on the bed, watching me pack my bag for the millionth time. "It's your life and your career and your body. Your decision is the only one that matters."

Claire and I grew up skiing together—she was a D-1 racer, the highest level of college athletics in the U.S., and later the publisher of *Ski Racing* magazine—and it was always something we connected over. She's hardworking, dependable, kind—the embodiment of "Minnesota nice"—but one of the best things about her was how neutral she was when it came to my career. I'm sure, much like everyone around me, she had her own thoughts about what I should do. But instead, she told me, over and over, "You need to do what's best for you." In a sea of conflicting advice, her words were the most helpful. She didn't force an opinion, she just helped me believe in my own decision making.

I planned my belated season debut for St. Anton, in Austria. When we flew over to Europe to start racing again, I was still on crutches. I made my way to the gym on crutches, worked out to make sure my muscles were still firing, and then got back on crutches to walk down to dinner. Heinz carried my ski gear. Because I had injured my left knee this time, I was now wearing braces on both knees. We took it one day at a time, building back a little more each day.

I didn't really know what to expect once I was back on snow, but it felt great. We ran an aggressive show. If you can't tell by now, I'm definitely a little nuts. I thought if I could just get back, I would ski well. If I could get myself into the starting gate, I trusted that I would be fine.

The race in St. Anton was canceled because of the weather, which meant my next race would be in Cortina. It felt like there

was an unfair expectation on me to win, at a time when I had barely skied in months, and I had no LCL. Since I was skiing without an LCL, my leg was loose, so the training we were doing wasn't difficult. There were no jumps. It was like running a mile every day to get ready for a marathon—I was training, but not quite enough. Still, if I willed myself to ski a fast run, I could do it.

I felt okay in the first training run, but the last jump was really abrupt. My skis slapped and it tweaked my knee a little bit. I wasn't prepared. My knee wasn't back to where it should be. I wasn't mentally or physically confident. I finished fifteenth. All things considered, it was an encouraging run, but I was nowhere near where I needed to be if I was going to keep trying for that record.

I thought I could do better. After all, this was Cortina, one of my favorite places to race. It's where I got my very first podium at the World Cup, in 2004. It's where I broke Annemarie Moser-Pröll's record with sixty-three wins. It had seen some of the biggest moments of my career, and I always had a lot of confidence there.

The next day, I willed myself to be strong. To be clear, I wasn't physically strong, but I tried to force it, hoping that my mind would be enough to carry me through it.

The second run was really bumpy, and the jumps were pretty big. Nothing under me was stable—I felt like I was skiing down on marbles. Everything was off. That performance just wasn't me. At least, not the person I was accustomed to being. Looking back, I can see that none of that last season was me. I'd come back from a lot of things before, but all those other times I had always been pretty healthy. This time, I felt like I was putting duct tape on every part of my body to try to hold it together.

I finished ninth.

"There's something wrong," I told Lindsay, that old familiar

refrain. "When I'm bending my knee, something isn't right." There was pain shooting down my leg, out of my knee, which I thought was from my bones hitting together. But when we looked into it, we discovered it was a larger issue. I was getting complete muscle shutdown. My right knee had become so swollen that it was putting pressure on the peroneal nerve, which provides sensation to the lower part of your leg. The worse it got, the more the nerve shut off, and the less I could feel. My entire lower leg was shutting off—obviously a problem, since in skiing you kind of need your legs.

Once we understood the swelling was causing my nerve to shut down, we gave my knee a lubrication injection to calm the joint, and some strong anti-inflammatory injections to keep the swelling at bay. The next day, Lindsay and I taped it and massaged it, trying to jury-rig it to counteract the nerve as much as possible. (One tiny silver lining was that toward the end of my career, everyone finally saw how broken down I was. Finally, those same competitors who had once accused me of faking it started to see the situation for what it was. Some of them even offered up an, "Oh, you weren't being dramatic." That was refreshing to hear.)

I slid into the starting gate, hoping that my leg would hold. We had done so much to get it to this point. I needed it to keep on fighting for just a little longer.

"It's an all-new day, Linds," Lindsay told me. "Take it all the way."

The start of that last race in Cortina was some of my best skiing so far that season. I started off so well, but I didn't finish. I made it through the most difficult part of the course, and then I skied out. I tried to make a turn, and there was nothing there. I had no power. I had nothing left to work with. When I got down to the bottom, I burst into tears.

Sofia Goggia, the Italian skier who had just won the gold in

downhill at Pyeongchang, was out with an injury at the time, and she drove from her home a few hours away to watch me race that day. She was waiting in the finish area with a bouquet of flowers. As I hugged her, I fully broke down. "I can't do this anymore. I just can't," I cried into her shoulder.

I was devastated, but no one could understand why I was crying. All around me, everyone offered up some version of "You've done so much in your career!" or "Retirement isn't the end of the world!" or "You've got so much ahead of you!" Nobody, including the other skiers, understood what I was going through. Knowing that I could never ski here again was heartbreaking.

The crowd in Cortina started to chant my first name.

"What's so bad if you stop?" Sofia asked me.

"I love it," I said to her, through tears. "I love it."

I was still crying when Lindsay found me in the finish area and came to offer me a hug.

"Buddy, I'm done," I told her.

I pulled out of the races in Garmisch the following week, so I could take some time to myself. It was clear that some big decisions had to be made. I needed to rest, and I needed to think.

I took a few days to figure out what came next. I shut myself in my room. Lindsay, of course, wanted to talk and cheer me up, but I didn't want to see or speak to anyone. I didn't want to leave. I just sat there alone, eating protein bars in place of real meals.

I had been visualizing my future for my entire career—runs, wins, medals. For years, I saw things happen in my mind long before they happened in the snow. Likewise, I'd had such a clear vision of how I wanted it all to end, how I was going to rally one final season to beat the record—for myself, for my team, for my family. To establish myself as The Best. But reality painted another picture, and I had to accept it. I wasn't going to

get there. Most days, I felt like it was all I could do just to make it down the mountain. I wasn't going to grind it out for no reason if I couldn't ski the way I wanted to. All along, I'd always said, if there came a time when I couldn't win anymore, that's how I'd know it was time. I was no longer able to one-up myself. It was finally time to say, enough is enough.

It was scary—downright terrifying—to think about no longer having something that I loved so much. But I wanted a future where I could ski with my kids someday. The thought of not being able to do that definitely outweighed trying to reach eighty-six wins. Also, the people in my life were worried about me. "You're going eighty miles an hour on a body that's destroyed," my friend told me. "You keep getting back up, but one of these times, you're not going to." I always hated when people said that. As a skier, you always know that death is a risk, but no one really likes to talk about it. When I was twenty-four, I could crash a ton, and nothing ever happened to me. Now though, those words hit way too close to home. I'd been crashing so much over those last two years that I could no longer control what my body was doing. I'd reached a moment I never imagined would come: I had more confidence *off* the hill than on it. It wasn't just my body that had changed, my mind had as well—I could finally trust in myself enough off skis to say that I was done.

The record had become all anyone focused on. Every time I didn't win, it was like I wasn't doing what I was supposed to. Every time I got further and further away, it felt like I was letting people down. That was especially true when it came to everyone on my team, past and present, who wanted it just as much as I did. In the end, I couldn't have done any part of those last few years without them—Heinz, who made me ski fast and had been my champion at every step of the way; Claire, who made sure I didn't have to do a million interviews so I could

focus on skiing; my trainers Alex and Hagi, who kept me in the best shape; my therapists Lindsay and Ricky, who put so much of themselves into getting me healthy and helped get me back again and again and again; all my coaches, including Erich, who rooted for me at every stage of my career. Having their support was amazing, but it was also difficult, because it added another layer of pressure. That was the final hurdle that had kept me from making my decision. I couldn't fathom an outcome where I ultimately let them all down.

I'd always known I had a fear of failure, but staring at retirement, I discovered that this fear isn't actually rooted in the idea of disappointing myself, it's about disappointing other people. As it turns out, I'm afraid—very afraid—of letting people down. I developed such strong relationships with my team, and they became so thoroughly invested in my success. I wanted to break the record for them as much as I did for me.

I did everything humanly possible to break that all-time record, and I made it closer than anyone else. I wound up with a career total of eighty-two wins. (I beat Moser-Pröll's record by *twenty* wins! It's not like I barely squeaked by.) There are a million things I could say about my injuries and how they continually derailed me. If I had been healthy, there is no doubt in my mind that I would have done it—but that is neither here nor there. Maybe it wasn't the fairy tale ending I imagined, but who really gets that, anyway?

Still, I couldn't end with that last race in Cortina. I needed to try one more time. I owed it to myself, and to my team, to try to go out on a high note. After discussing it with everyone, I thought maybe the World Championships would be a good place to retire. I felt so lucky to be in a position where I could plan my exit.

Despite my insistence, my coaches still didn't understand the gravity of what was happening. Right after the downhill race

in Cortina, I was making my way through the parking garage, still holding my equipment, when my coaches descended.

"You'll come back. You always come back," they said.

"No." I shook my head. "I'm done."

"Next year it might be totally different. We'll help you get there."

"No," I said, over and over. "I can't do this anymore."

"We gotta keep on trying, right? Never give up."

They kept right on talking at me. That was one of the few times I'd ever been disappointed in the way my coaches spoke to me. I wasn't being heard and my words weren't being respected, which wasn't the norm. Beyond that, it was the wrong thing at the wrong time. They more they insisted, the more frustrated I became.

They didn't grasp that this wasn't about quitting, and it wasn't about giving up. No one understood what I was going through. I had done all I could do. I had tried—was still trying—everything I could, but I had reached a point where it was like I was skiing on one leg. But Claire was right: This was *my* decision. At the end of the day, it was my body, and I was the one who would have to live with it.

Finally, I spelled it out for them, so there would be no room for questions: "You need to understand. This is it. I'm going to the World Championships, and then I'm done. That's my final race."

My coaches fell silent.

"Okay! I'm going to go now!" said Heinz, breaking away from the group.

"Where are you going?"

"I have to wax! I have to wax!" he yelled, as he hopped in his car and drove away, off to prep my skis so they'd be good and ready for the World Championships. You could always count on Heinzi. At least someone was listening.

I climbed into my car, Lindsay and Claire piling in after me.

"Did you hear what they just said?" I asked. I couldn't believe it, and neither could they. They knew I was in pain and that I was frustrated. They knew I was already giving it everything I had. Thankfully, they rallied around me, reaffirming that the decision was mine to make. "Whatever you do, you need to do it for you," they told me. "For you. Not for anybody else."

Despite how it sounded, my coaches didn't mean to be hurtful. No one wanted this chapter to be over. We'd been working together for so long, we had all come to feel like a family. I was the captain of the ship, and without me, there would be no ship. Because I'd come back so many times before, I think they honestly didn't realize this was different. But to me, that was even more evidence of the gravity of the situation. I never said I couldn't do something—those words had never exited my mouth. If I said, "I'm done," I meant it. They of all people should have known that.

Once I had made the decision, I felt relieved. I would race just once more. Most athletes don't get the opportunity to go out the way they want to. In skiing especially, a lot of them get injured and that's it, their careers are ended for them. In a way, I was getting more than most—one good, final race, and the chance to write the end of my story.

Two weeks before the big day, I called my agents and asked if they thought Ingemar would come as a spectator for my final race at the World Championships. "It would mean the world to me if he could be there!" I said. They told me he wouldn't be in Sweden until after my race was over. This wasn't the answer I wanted. So, I did what I had to do—I superfan-stalked him. I got his phone number and texted him a message in all caps that read: WILL YOU PLEASE COME WATCH MY RACE?!!! And it was worth it, because he immediately wrote back and told me he would be there. As soon as I saw it, I was thrilled.

From the moment I arrived in Åre, I felt lighter than I had in months. A weight had lifted, and my anxiety was replaced by excitement. At that point, I thought, *Let's do this*. I had nothing left to lose. My plan, in a nutshell, was to throw myself down the mountain, try to get a medal, and go out on a high note. I was either going to go out in a blaze of glory or eat shit and be helicoptered off the mountain. But at least I could go out without regret. I've always said I ski best when I've backed myself into a corner, when I have no choice but to give it my all. This was the ultimate version of that. I might as well go for it.

The super G was first, and I don't want to toot my own horn here, but I skied really well. I was in the hunt, but then I was a little too aggressive on a left-footed turn with a small roll and my ski hooked up funny. I went off the jump a little too directly, ran into the gate, and got caught up in the fence. I also managed to hit my face with my arm and gave myself a black eye, which was a good look. After they untangled me from the fence, I assessed the damage to find that my knees were okay, and I was still in one piece. They brought the sled over, but I picked myself back up and skied down on my own. It rattled me a little, and it took the wind out of me, but thankfully, that was the extent of the damage.

Now it was down to the second and final race. I just needed to focus on Sunday, five days away.

As I approached that last race, I tried not to repeat what had happened at the 2018 Olympics, where my emotions got the better of me. After this, there would be no more races. There would be no second chance, no redo, no "I'll try again next season." This was it. That knowledge was a tremendous amount of pressure, so I needed to keep my feelings in check.

In honor of my last World Championships, I had rented this amazing house outside Åre, for me and my team. My family and friends were all there, along with my trainer, Alex Bunt, and of

course Lindsay, my physical therapist. The idea was to gather to-gether under one roof one final time, like one big happy family. They were all there to celebrate my career, but I hoped we would also have the chance to toast to one last win.

The night before the final race, my adrenaline was so high. My family milled around the house, offering a mix of space and emotional support. Before I went to bed, I talked to Erich Sailer on FaceTime. "*Of course* you can do it!" he said, in his melodic accent, his confidence never wavering. "It's nothing! What's a minute and a half? I'm ninety-three!"

I was so nervous that I had trouble falling asleep, a rarity for me. I'm usually a pretty good sleeper, and I typically never had trouble sleeping the night before a race. But if I ever did, there was another thing good old Jacques Choynowski taught me to do, back when I trained with him in Monaco. He'd have me lie back in a chair—in the gym, where it's really noisy—and then he'd walk me through this sort of body scan meditation. You start from your toes, one toe at a time, and visualize warm water being poured from your feet all the way up to your hips, one leg at a time. Then you visualize the same thing happening on your upper body, starting with your fingers all the way up each arm. If you relax and try to picture it, you can feel the sensation making its way over your body, and before you know it, you'll be fast asleep.

From the moment I woke up, I had difficulty controlling my emotions. To find my focus, I needed the right levels of adrena-line, aggression, and calmness, at the correct intervals, at the correct moments. You don't want to have too much adrenaline before a race, because if you expend too much energy, you'll wind up exhausted in the starting gate. Over the years, this was something I had mastered, but the morning of my last race, I gave up trying to control it. I couldn't remember a time when my adrenaline had been so high for so long, but I reasoned it

wasn't like I needed to conserve anything for tomorrow. Like everything surrounding my final race, I did my best to embrace it.

The previous day, a reporter asked me how I felt preparing for the downhill knowing that I probably wouldn't win. I felt that old fire returning, from back when I was the underdog still fighting my way onto the podium. "Who said I won't win?" I asked him. "Don't count me out." Given my experiences with the media, the question was both frustrating and fitting, but it had also provided a spark.

Leading up to this race, I was as prepared as I could be. I analyzed my video a million times, as though it was my first World Cup. I overanalyzed every last detail. I was ready. The hardest part of the prep, besides the massive amount of adrenaline, was that everyone wanted to give me a hug, and it kept making me cry. It got to the point where I finally had to be like, "I can't cry anymore, guys. No more hugs. I have to focus."

The morning of the race, I headed down to where my trainer Alex had set up shop, to do my morning activation. Afterward, I drove over to the hill with Alex and Lindsay and Claire. It was windy and cold that day, and there had been talk that they might lower the start to escape the worst of the wind, but as I headed out for my warm-up runs, no decision had been made. I did my best to feel my body position, to take it all in before I headed back to the lodge to do my warm-up and visualize the course.

As I completed my warm-up, we got word that the start had been moved down the hill to the third reserve start—where we started the super G on Tuesday. This was a dramatically shorter course, which was better for my knees. If we'd started from the top portion of the course, I would have encountered some bumpy turns, and any jump was like a death sentence for my knees. It was a sign. Everything was coming together. It was going to be good.

In typical fashion, I got to the starting gate way too early. I

was so amped up, I arrived long before anyone else, even though I had drawn bib number 3 and two skiers were starting ahead of me. Ever since I'd missed a start time many years before, I usually got to the gate fifteen or twenty minutes early, but on this day, it was more like forty. That only meant I had more time to obsess.

I cranked my heated pants to the max, trying to get the blood circulating in my legs. And then, I focused. I zoned in. Whenever I closed my eyes to visualize the course, it was like I had a weird superpower. I was no longer there; I was on the course. I was gone. I was invisible.

As my start got closer, I was deep into all-or-nothing mode, ready to give it everything I had. I acted as though it was the Olympics, and this was my moment. *I'm going to take it*, I thought. *I'm not going to let it go to waste.*

Just before it was my time to ski, I was handed a really big gift by the weather gods. The sun came out just as I slid into the starting gate.

This is it.

For the last time, the clock counted down.

My team cheered.

And there I went. Full throttle. I pushed as hard as I could go.

While I was on the course, I wasn't thinking about my knees or what my legs could handle. I wasn't thinking about crashing. I wasn't even thinking about what this race meant.

I just skied.

I nailed the section that had me worried, carried a ton of speed into the bottom, and threw my hands in the air. When I got to the finish, I felt so happy. Overwhelmed, but happy. I was grateful and relieved to finish on such a good note. To finish my last race and see my name first on the leaderboard.

I took a bow. I held my skis up for my Head sponsors one final time. I spotted my family, watching from the sidelines. My

dad and Karin, whose faces were both flooded with tears. My brother Reed, with a stowaway in tow—Lucy, in a pink puffer jacket, riding in his backpack. I waved to the crowd, and to my fans—whose cheering and support always meant so much to me. It was the perfect ending. I couldn't have asked for anything better.

Shockingly, I didn't cry. It was a lot to take in, and I think I had cried so much in the weeks leading up to that point that my body was all cried out. Now it was time to process this moment and try my best to appreciate it.

A huge crowd gathered at the bottom of the hill. Viktoria Rebensburg, who skied just before me, knelt on the ground doing that bow-down, "we are not worthy" move. "You're embarrassing me!" I yelled. She was now in second place—I'd shaved three-tenths of a second off her time, which, for that moment, put me in the lead. Now I just had to wait for someone to try to knock me from my spot. I knew I probably wasn't going to win, but I hoped I could hang on for a medal.

Then I spied Ingemar, making his way toward me holding an enormous bouquet of white flowers. I knew he would be there, of course, since I'd more or less begged him to come. But it meant the world to me to have a legend like that at my last race. He offered me a hug. "Thank you," I told him, as I was engulfed by his arms and all those flowers. It was an emotional day, and having him there made it all the more special. In his typically sweet-yet-hilarious fashion, Ingemar wrote me a note that said, "Thank you. Because of you, I'm much more famous now!" Apparently, my attempt to break his record had thrust him back into the limelight.

I headed over to the winner's chair, a place I'd occupied more than a hundred times over the course of my career. But this time felt different, because it would be the last. I've always thought it was cheesy, how you sit there in front of the entire

stadium until someone else knocks you off. Now, I wished it would last forever.

When all was said and done, I won the bronze medal. I stood on my final podium, waving to the crowd and just trying to take it all in. "I'm going to keep this one with the gold medals," I told a reporter. And I meant it. That bronze is gold to me. It's not perfect. It's not winning. But it's success—success that I found in places I wasn't looking, in my crashes, in my injuries, in my setbacks, and in the lives of people who cared about me most. From the beginning, winning was the ultimate goal, but it took that bronze to show me what success meant. It meant losing. Losing your hopes and goals, so you can find new ones. Losing your confidence and your strength, so you can find them again. Being broken down again and again, so you can find the courage to keep getting back up.

I lingered in the stadium, soaking up the moment, signing autographs one final time. Sometimes, over the course of their careers, athletes can lose perspective. They look at it as a job and they get complacent. But it was never a job to me, on that day or any of the days that came before it. Even now, I don't feel like I've ever worked a day in my life, because I loved every moment.

It's hard to describe all the emotions I felt that day. Overwhelmed. Elated. Exhausted. Relieved. Thankful that I didn't have to crash anymore. But more than anything, I felt so incredibly grateful—for my career, for my body, for my team, for the tremendous outpouring of support. It took everyone's effort and hard work to get me to that point, to squeak that last little bit of success out of my career. And it was worth it.

I glanced back at the stadium one final time. I made it out. I survived.

I made it forty-eight whole hours before calling my agents.

"Book me!" I said. "I'm ready to work!"

My request was met with laughter. Knowing me as well as they do, no one on my team was surprised by this. They knew this call was coming.

"Are you sure?" they asked. "We thought you'd at least take a week or two."

"Yes," I said.

"Then here we go. Round two."

In theory, I expected retirement to be pretty easy. I had a plan: After the World Championships in Åre, I'd return to the U.S., where I was going to take two weeks off to decompress. Then I would jump into media and events. Simple enough. But when I woke up at home that very first morning, nothing felt simple. "Holy shit," I said, out loud. "I have nothing to do."

In practice, retirement was anything but easy. It was harder than any of my injuries, harder than anything I've done. As I'm

sure many other professional athletes would agree, the process of easing into retirement can be akin to jumping off a psychological cliff. That mental adjustment, from every day being so driven and focused on just one thing, to starting all over again, was unlike any challenge I'd ever experienced.

Since I was nine years old, I'd always focused on the next thing—the next step, the next goal, the next race, the next title, the next record. Even during the times when I was injured and unable to train, I could still rely on skiing as my crutch. It was always there, waiting for me, giving me something to work toward and a familiar place to land. My strength, my confidence—hell, even my identity—were inextricably tied to the mountain. Now, I'd come face-to-face with what I'd avoided all along: I would need to find these things somewhere else.

"I need to do stuff, now," I told my team, who wasted no time booking me for speaking engagements, TV and film projects, new business ventures. I knew it wasn't the answer to discovering my new purpose, but I hoped it was a step closer to figuring it out.

Early in my retirement, I heard a lot of advice from people, both solicited and not, about how I should spend my time. Fellow athletes, family, and friends were all too happy to weigh in with everything from "Doing nothing is the best!" to "Keep on grinding." But the more advice I heard, the only thing that became clear to me was that no one knew the answers.

I've heard it said that any big change, including a positive one, inevitably comes with its own grieving process, and in my experience, that definitely rings true. Over that first year in retirement, I traveled through all the stages of grief—denial, pain, anger, bargaining, depression, reconstruction, acceptance. In a way, though, it only seemed fitting, because it was like part of me had died. I needed to fully mourn the chapter that was closing before I could embrace whatever came next.

As I tried to find my footing, my old friend depression started to creep in. I could no longer compartmentalize my feelings and just focus on training, and most days, I woke up feeling blue. I resented skiing—both the athletes who could still compete and the imaginary storyline of what could have been. Without my playing field, my competitive side had nowhere to go. I desperately missed the mental cycle that athletes exist inside—preparation, hard work, feedback, performance. You win or lose, then you get back up and do it again. Without that singular focus, I felt aimless. I worried I would never find that same feeling again.

In a way, that was a good thing, because life forced my hand. Since I no longer had skiing as a crutch, I was left with no choice but to confront—and actually work through—my issues. In the fall of 2020, I started working with a new psychologist, Dr. Amando Gonzalez (I call him Dr. Mondo) who takes a much different approach to therapy than anything I'd encountered before.

Our meeting was serendipitous. I had just told Karin that I wanted to find a new therapist, to help me with my struggles since retirement. I was looking for someone very specific—a person who understood sports and what this transition is like. The next day, one of Karin's business associates told her about this platform he was working on, an app to get mental health out to a wider audience, in conjunction with a doctor who sounded exactly like what I'd described.

Dr. Mondo is a kind soul with a calming presence. It was clear from the moment I met him how much he genuinely cares about helping others. I'd never worked with a male therapist before, so I wasn't sure I'd be able to open up to him, but I was happy to discover that he quickly came to feel almost like a big brother.

On our first call, we talked for over an hour. I learned that

his framework mirrors an athlete's approach—you assess your strengths and weaknesses, there are goals and check-ins to track your progress, and he even keeps score. A lot of times in traditional talk therapy, you skim the surface, by venting and sharing stories and patterns. That can feel good, and often it does help, but in my experience, it never solved the problem. Dr. Mondo practices something called brainspotting, a more focused method that helps you identify your unprocessed emotions and trauma and actually release them. If talk therapy is like the leaves of a tree, brainspotting is like its roots. At first I thought it sounded like hocus-pocus, but in practice, I've found that it's not only fascinating, but has worked incredibly well.

Brainspotting is very immersive, so much so that at the beginning of our work together, Dr. Mondo actually came to my home for three days to oversee the process. The idea is that every time you experience emotional trauma, your body retains it, almost like a tally in your brain that won't fade away until you fully work through it, by opening up your neurological pathways and clearing it away. Practically, it means you sit and actively focus on your stored traumas, sometimes for hours at a time. It can be very, very hard, and emotionally intense. Some days, I would feel so mentally drained, I would need to immediately sleep it off, but it really does work. On the other side, I've found it did allow me to fully process and move past some of those stored narratives.

"Injuries can be some of the most traumatic experiences, and people really hold on to them," Dr. Mondo said, prompting me to talk more about my crashes.

I shook my head. "That's not a thing that bothers me."

"I think we should really talk about it," he said. He wouldn't let it go.

"You want to watch the videos?" I said. "Go for it. We can pull them up."

We did. Eventually, he saw I was telling the truth.

"You're the first person I've ever met where that isn't the thing that bothers you!" he said. What can I say? That's just the way I am.

For six months, Dr. Mondo came to my home once a month for three days, and we spoke a few times a week. Now, I'm on a maintenance program, where we talk a couple of times a month and I'll see him every eight weeks or so. I can say without hesitation that this is the best I've ever felt.

I've been all over the spectrum, from thinking I didn't need a therapist, to having a difficult time opening up to someone, to where I am today. Eventually, I came to realize that you won't just wake up one day and discover that all your problems are gone. No one can do everything on their own—not even someone as independent and stubborn as I am. When it comes to mental health, I've found it's good to be open minded. Mental health *is* your well-being. Therapy can be such a useful tool, a place to unpack who we are and how we can best live our lives—just as important as a dentist or a trainer when it comes to maintaining a baseline of health. We can all benefit from having an extra support system, because sometimes life is hard and it's important to have someone you can talk to.

In the early days of retirement, everyone kept asking, "Why are you doing so much? Why are you working so hard? Just relax!" But through my work with Dr. Mondo, I've since discovered that being engaged in life—embracing the gym, leaning into my business projects, spending time with friends and family—is what brings me joy.

After I retired, it took me a minute to figure out where I wanted to land in the business world. I met with a lot of people, including other retired athletes, and learned about what they pursued, what they liked and didn't like. But slowly, the pieces started coming together.

The seeds were planted six years ago, at a celebration for the *Forbes* 30 Under 30 list where I met Ashton Kutcher and Guy Oseary, who run their own venture capital (VC) firm, A-Grade Investments. At the time, they were vetting different companies to invest in, kind of like they do on *Shark Tank*. That's when the idea for investing first got into my mind, and when I retired, it became more prominent.

Then, in 2019, I attended a business event in Park City, where a number of prominent CEOs were in attendance. All during the presentation, I was the only audience member to keep raising my hand and asking questions. I don't know if that was good or embarrassing, but either way, they saw I was interested.

I wanted to learn all I could, so I completed a two-month internship with Paul Kwan, the managing director of a VC firm who has worked in tech banking for twenty-five years. He worked closely with me, educating me on how venture capital works and sharing everything I needed to know. I learned a lot during my time with Paul, and soon after, a couple people reached out to me about investing. I think initially they were interested in my name recognition, but once we spoke, they discovered I was smart and asked me to become an advisor of their funds, which was a big compliment.

In a way, entering the business world feels like a natural progression. There's a similarity between venture capital and my process for selecting brands to partner with as an athlete. I've never worked with companies I didn't believe in, and in a way, I was betting on companies when I partnered with them. When I first signed with Under Armour, they weren't the company they are today. They didn't yet have women's apparel; they didn't have shoes. But when I met with the founder and CEO, Kevin Plank, I thought, *This guy is going to do great things*. I knew he was going to create something amazing.

Investing in companies is very much the same, but most of

the time, I'm also putting money into the company, making a literal bet. There's the adrenaline of the risk, and the challenge of figuring out who you want to bet on and who you don't. When it comes to choosing businesses to invest in, you need to have a great product, but you're also betting on people. A lot boils down to who runs the company, and over the years, I've gotten pretty good at reading people, both in sports and in business.

It all goes back to how my dad always taught me to take care of myself, because skiing can only last so long. I've always looked at the business side of skiing in addition to the athletics, and that continues to serve me well. I've been fortunate to meet a lot of people over the course of my career, but up until recently, I didn't utilize those relationships. And now all the connections I've made through years of hard work are paying off in new ways.

Since retirement, I've met two former pro athletes who now work in the business sector, managing billions of dollars. They are both men. There aren't a lot of athletes that do this, nor are there a lot of women. But it's not unattainable. A 2021 global study found that 60 percent of elite athletes do not consider themselves financially stable. We need to create more education for athletes to learn to market themselves and use their platforms to make money. I hope that by sharing my experiences, both here and in the future, I can encourage other athletes and other women to enter this world.

I recognize that it's one thing to be successful in sports and another to be successful in business, and I want to earn my place. My goal is to be able to walk into any boardroom and have them say, "That's Lindsey Vonn, a successful businesswoman." I want to establish myself in the business world, to the point where I can honestly say I am as successful in business as I was in skiing.

It feels great to have a fresh, new challenge, but at the same time, I'm not searching to replace anything. I'll still have my

existing partnerships and sponsorships. I'll still be designing skiwear. And I'll continue to work on my own ventures.

Over the years, I've always loved playing around with makeup and experimenting with different products, both on and off the hill. I know from experience it can be difficult to find formulas that work well, especially eyeliner and mascara that stay in place. That's part of what inspired me to start my own beauty line. I'm still developing it as I write this, but I have a clear vision of what I want and am excited to see it come to life.

I like being in motion, discovering new skills and activities I enjoy. A big part of developing confidence comes from knowing who you are, which is something I didn't fully figure out until retirement. I didn't know who I was—or what I wanted—off the hill until I wasn't on it anymore. Now, those feelings of value I once attributed only to skiing are a part of my life without it, and that's been really nice.

Life without racing is certainly interesting, because there are suddenly so many avenues available to me, all these events and holidays I never got to be present for. When I'm not working, my days are spent doing all the low-key, normal things I never got a chance to do while I was skiing. Karin, Laura, her husband Paolo, and I will often spend our days together, which usually means sitting at different tables or countertops working. I'll get on the bike for an hour in between calls, or I'll watch *Law & Order* until everyone gets mad at me for having the TV too loud. In a lot of ways, it's just like when we were kids visiting our grandparents for the summer. We're all together, and no matter what we're up to, we always find a way to have fun.

One of the biggest and most welcome changes I've seen since working with Dr. Mondo is that these days, I love being alone. I used to hate it. I used to fear it. I used to do everything I could to avoid having to sit with myself, from living with friends to having my siblings join me on the road. I'll admit, in the last

year there were times when I almost said, "Hey, Karin, do you want to come live with me?" But ultimately, I understood that would be a deflection, and it was time for me to face my issues. Now, I really value my me-time—cooking, snuggling with the dogs, going to bed early. I'm through running away from myself, or anything else.

I can definitively say that the shape of my life is okay—and in many ways, better—without ski racing, words I couldn't have fathomed before. But life is full of surprises. These days, I'm carrying so much less, literally and figuratively. As I go about my days, even when they're packed with work and responsibilities, I feel freer and lighter than I ever thought possible.

I know that I will always be a work in progress. There will always be more to uncover, more to explore, more to understand. But right now, I'm exactly where I want to be.

I may not always show it, but I'm a deeply sentimental person. I keep everything—every race suit, all my bibs, the medals and the trophies. I still have all my dinky medals from when I was a kid in Minnesota, along with my first-ever trophy, a fifth-place finish from Afton Alps in 1992. Maybe I get that urge from my grandparents—Grandpa Don and Grandma Shirley saved every single clip ever printed about me. An AP piece gets reprinted several times across different channels, but they would print them all out and highlight every single one. I now have thirty-eight enormous binders documenting my career, which I cherish.

Some of my trophies are on display in my office, but the rest of the stuff is packed away. Eventually, I'll go through everything and frame some of it. One day, after enough time has passed, I'll be ready to see it all again.

People always ask, "What do you want your legacy to be?" and it's weird to think about, because a legacy is ultimately out of

your control. As an athlete, I did the best I could and tried to be the best competitor and the best person I could be, but it's not up to me how or if people remember me. At the end of my career, I was so fixated on numbers, I thought if I could just surpass one number, I could cement my place as The Best Skier of All Time. But my dad told me, "It's not about how many medals you have, it's about the impact you have on the sport." I hope I'm remembered as one of the best, but my sincerest wish is that what I've done for skiing goes far beyond any number. I hope I changed the game and paved the way for women in skiing to be more than just racers. I hope I showed that you can be outspoken, you can be feminine, *and* you can be a badass, all at the same time.

For a while, I did everything I could to avoid skiing. I didn't watch the races; I didn't follow the results. Just the thought of it was enough to make me sad. Inevitably, I would wind up seeing someone's video anyway, and it only magnified how much I missed skiing.

Then, in early 2020, I watched my first race as a spectator. I was with Aksel Lund Svindal, who retired on the same day as me. He's always been such a generous, positive sportsman, especially when it came to talking technique and helping other skiers, and he's brought the same attitude into his retirement. As we watched our fellow racers, now from the other side, he shared such a great perspective. "I love the sport, and I want other people to love it," he said. "Even though I can't do it anymore, I still want to share that passion."

When I heard his words, I felt my resentment of skiing begin to melt away. Aksel helped me remember why I did it in the first place—because I loved it. That epiphany brought me to a more balanced place. Now I know I can still appreciate skiing, that I will always have that same love for it. No one can ever take that away.

CHAPTER TWENTY-FIVE

On a cold, clear day in November, I stepped into my skis for the first time since my retirement. I stood at the top of the hill in Deer Valley, with the sun above me and that perfect Utah snow beneath me, taking it all in. It was a place I'd been so many times before—for a long time, it was practically my home. But this time, everything felt different.

"Are you ready?" asked Claire, who had joined me to lend her support.

"Yes," I said, and I meant it. "Let's go."

And then, for the first time in nearly two years, I let myself ski—just ski. I didn't have expectations. I didn't really know what would happen. But as I made my way down the mountain, all those old feelings flooded back to me. Not my memories of racing, but the love I've had for this sport since I was a kid. Going fast. Feeling free. The sound of the wind rushing by and the feel of the snow beneath you. I ripped some turns. I raced to the bottom. I couldn't wait to do it again.

Right up until that very moment, I still couldn't imagine skiing without racing, which meant I couldn't picture myself skiing at all. The two remained inextricably linked in my mind, to the point where any time I thought about skiing, in any capacity, it only magnified how much I desperately missed my job.

Even after that day with Aksel, I continued to avoid watching races or following results. If anyone ever brought up skiing, I deflected, pretending my resistance wasn't a problem, when deep down, I knew just how hard a time I was having. Part of me thought maybe I could ignore the sport forever. But of course, that was never going to be sustainable. I come from a skiing family—this sport is as ingrained in us as our shared traits. And in the end, it still was—and always will be—my great love.

Before I got back on snow, it felt almost like I was going to see an ex for the first time in years. I wasn't afraid, but there was a sense of nervous anticipation around it, because I didn't know what to expect. Had skiing changed? Had I? I had to become reacquainted with skiing, to adjust my relationship to it and recalibrate my expectations. But once I forced myself to confront it—once I made myself actually ski—I was surprised to discover that its new role in my life was a positive one.

From the very first moments of that first run, it was clear: I still love skiing, just as it is. I don't need the competition in order to love it. (Even though I still race people to the bottom.) Skiing isn't the same as it was, but neither am I.

Since that day in Deer Valley, I've skied with so many people, from celebrities like Hugh Jackman to business associates to friends. I skied with my sister Karin for the first time since I was twelve years old. I skied with my longtime agent, Mark, whom I've worked with since I was seventeen. It's incredible to think that for so many years, I'd never shared this activity with those who are closest to me. Ever since I first set out to achieve

my goals at age nine, skiing had been something that pulled me away from everyone. It separated me from friends and family, because I was always away, training or racing. It hindered me from making connections, because I was always so focused on competition. It got in the way of living a normal, balanced life. And now, in a surprising turn of events, skiing has become the connective tissue between me and so many of the people I love.

I've also met so many new people through skiing. Not everyone enjoys racing, but I've been shocked to discover just how many people like skiing, and how convivial a sport it can be. It's all been a wonderful surprise.

Standing at the top of the mountain, I feel clarity. Just as my career was divided into seasons, I now see that life is, too. The shape of my existence has changed so much over the last two years, and I know that it will only keep on shifting. Opportunities come and go. People come in and out of our lives. And some things remain the same. I'm still the same driven person I've always been, with my hand in a million different ventures. I still one-up myself all the time, though now I mostly reserve it for the gym. I will always try to get better, but these days, I don't put too much pressure on myself.

Part of what I always loved about being on the mountain was the feeling that anything could happen. I would stand there before every run and think, *Anything is possible.* I believed that I could win, that I could be whatever I wanted to be, if I put my mind to it. That optimism—the potential to work hard and succeed—never failed to excite me. Now, that's how I feel about life. It's taken me a long time to get here, but now I see that the promise of the mountain is everywhere.

ACKNOWLEDGMENTS

This book is the result of the hard work of many people, to whom I am incredibly grateful.

My biggest thanks go to my family—my father, Alan Kildow, who first got me on skis and who passed down his passion for skiing to me. My mother, Lindy Lund, who taught me what positivity can do, and to my siblings, Karin, Laura, Dylan, and Reed—for your support and sacrifices over the years. Thank you for believing in me. My story is your story. A special thank-you to Laura for her invaluable contributions to this book. You are an immensely talented writer, and I know this is only the beginning. Once again, I don't know what I would have done without you.

Thanks to my grandparents, Don and Shirley Kildow, for their love, enthusiasm, and guidance. Grandpa has passed and Grandma doesn't remember, but I cherish the time I had with them every day.

To all of my extended family, especially those who helped

my parents when I was born and my mom was in the hospital. Thank you for rallying around us and taking care of me. To all of the Kildows, Krohns, Millers, Hummels, and Rudisills who have helped me and the entire family over the years, always without hesitation. Your support has never gone unnoticed, and I am lucky to have such a family.

To my team on and off the hill, including Lindsay Winninger, Heinz Hämmerle, Alex Bunt, Claire Abbe Brown, Robert Trenkwalder, Martin Hager, Patrick Rottenhofer, Oliver Saringer, Nicolas Cronsel, and many others, I couldn't have made it here without you. Special thanks to Erich Sailer, my Buck Hill coaches, and Ski Club Vail coaches for all you've taught me.

Thanks to the U.S. Ski Team, including my coaches Alex Hödlmoser, Enrica, Chris Knight, Patrick Riml, Chip White, and many more who believed in me and guided me along the way. To all of my teammates over the years, those I still talk to and those I don't, I will forever be your teammate. I am indebted to Picabo Street, who paved the way and inspired my dream all those years ago. To Ingemar Stenmark and his record of eighty-six wins, which inspired me to keep going after so many surgeries. To Aksel Lund Svindal and the Norwegian team for the many years of training but mostly for all the respect and kindness you have always shown me. To all the men who believed I could race with you, thank you.

To my day-one friends Alexandra Hyman and Hilary Lund, the Minnesota motley crew, love you guys. Vanessa Cella and the whole Cella family, thank you for your unwavering support and always having my back. We may not be blood, but I am so thankful to call you family.

Thanks to my agents, Mark Ervin and Sue Dorf, who I have had the privilege of working with since I was seventeen. You both have always guided me and believed in me through thick and thin. This is the house we built together.

I wouldn't be where I am without the belief of my long-term sponsors, who saw my potential, invested in me, and remain supportive to this day. Thank you especially to Dietrich Mateschitz, Kevin Plank, Johan Eliasch, and Arnaud Boetsch. To Thor Verdonk, for giving me my first pair of skis. To all of the new partnerships and relationships I am building, I can't wait for the future.

I owe a great deal to the team at Dey Street Books, especially Lisa Sharkey and Matt Harper for their belief, patience, and dedication throughout every stage of the process. To my literary agent Jay Mandel and the whole WME team for making this and many other amazing things happen.

Thank you to Caroline Donofrio for helping me find the words.

To my fans, who have rooted for me, shared your stories, and offered words of encouragement—thank you. Your support means more than you know. *Danke zum meinem Europischen* fans. *Ich liebe dich. Danke.*

Last but certainly not least, thank you to my dogs, Lucy, Leo, and Bear.